DESIGN
FUTURING

HAVERING
COLLEGE

LEARNING
RESOURCES
CENTRE

HAVERING
RESOURCES
CENTRE

HAVERING
COLLEGE

DESIGN FUTURING

SUSTAINABILITY, ETHICS AND NEW PRACTICE

Tony Fry

BERG

Oxford • New York

745.2 FRY. A9. 135846

English edition
First published in 2009 by
Berg
Editorial offices:
First Floor, Angel Court, 81 St Clements Street, Oxford OX4 1AW, UK
175 Fifth Avenue, New York, NY 10010, USA

© Tony Fry 2009

All rights reserved.
No part of this publication may be reproduced in any form
or by any means without the written permission of
Berg.

Berg is the imprint of Oxford International Publishers Ltd.

Library of Congress Cataloging-in-Publication Data

Fry, Tony.
 Design futuring : sustainability, ethics, and new practice / Tony Fry.—English ed.
 p. cm.
 Includes bibliographical references and index.
 ISBN 978-1-84788-218-9 (cloth)—ISBN 978-1-84788-217-2 (pbk.) 1. Design. I. Title.

NK1510.F77 2008
745.2—dc22
 2008035114

British Library Cataloguing-in-Publication Data

A catalogue record for this book is available from the British Library.

ISBN 978 1 84788 218 9 (Cloth)
 978 1 84788 217 2 (Paper)

Typeset by JS Typesetting Ltd, Porthcawl, Mid Glamorgan
Printed in the United Kingdom by Biddles Ltd, King's Lynn

www.bergpublishers.com

Contents

Preface

This book is part of my ongoing project trying to advance how design is thought about and practised in the contemporary world in the face of serious challenges that confront us all, individually and collectively. These challenges confront us no matter where in the world we are, whatever our occupation or socio-economic status. My project commenced several decades ago and, although it has undergone many transformations, it has also remained the same. Here, for instance, are the concluding words of an article that I published in the British journal *Block* (Number 5) in 1981: 'Design has to be understood not just as an object of historical study and contemporary cultural and economic practice, but also as an object of current cultural politics inside and outside education.'

My project has been nurtured by two interconnected actions: bringing theory to design so as to be able to think design in new ways in order to develop new design practices; and then bringing these new practices to engage the pressing and complex problems of a world made unsustainable. I would venture to say that although one does not have to be a design theorist in order to produce 'good design' in a formal(ist) sense, it is now no longer possible to be a responsible designer and act ethically as such without being theoretically literate. What this actually means will become clear as the book unfolds.

One of the consequences of taking design seriously as a field of political action has been to evolve a practice that refuses to locate it in a single design discipline – this means, for instance, working across visual communication, industrial design, architecture and urban design. Another consequence has been to dispose such a hybridized practice to the service of the sustainment of viable futures before subordinating it to the requirements of clients. There is a third consequence: striving to broaden the scope of what actually becomes recognized as design means that who actually becomes recognized as a designer is itself extended.

The perspective that I have adopted in the book is that there is another position between claiming that: (1) all human beings are designers (the ability to prefigure being *de facto* one of the characteristics that defines the nature of being human) *and* (2) some human beings develop their ability to design, make it elemental to their identity and in many cases earn their living so doing. What this intermediate position (3) acknowledges is that designing is an intrinsic component of numerous practices and/or a very wide range of practitioners: artists design, plumbers design, farmers design, foresters design, gardeners design, bricklayers design, structural engineers design – and so on. Now the point of this observation (besides serving the general objective of the entire book, which is to expand how design is understood and practised and what it is mobilized for and against) is to say that whenever an appeal is made to the reader as a designer, it is based on the notion of the reader as equally (1) the designer (the 'I' that calls itself a designer) and (2) anyone for whom design is, or becomes known as, an important intrinsic object of their practice conceptually or practically.

Strategically, this appeal to a wider community of designer-readers is part of the larger ambition of the book – to have the importance of design understood by more thinkers, disciplines and practitioners. Currently, the various forms of design studies and research do not do a good job of demonstrating the ever-increasing importance of design as directive of the material artificial and denaturalized worlds we inhabit and their futures. The enormous power of design for good and bad has to be brought out of the shadows.

Having said a little about how the reader of this book can be understood, there is something to note about how the book has been structured typographically to assist its reading. The main argument of the book appears in a serif book typeface; all material that puts forward methodological suggestions is italicized in the same face; and all case studies are presented in a sans serif typeface. The aim in making these distinctions is to assist a continuous reading of the text, but with the reader always knowing what element of it they are reading.

This book stands on much of what I have learned from my previous writing and from projects like the online journals *Design Philosophy Papers* and *Design Philosophy Politics,* which do not just attempt to lift the level of writing on design but also seek to invite writers from other interests into the field. Equally it points to further projects.

It has benefited from the support and solidarity of colleagues and friends, not least Eli Blevis, John Calvelli, Drea Howenstein, Frances Whitehead, Keith Armstrong, Jim Gall and Jason Grant. The contribution in time, mind and spirit of my partner Anne-Marie Willis has been immeasurable. I also want to acknowledge my friend of many years, Frank Lowe. Frank died while the book was being written. He was a Chinese New Zealander, an architect and publisher who, remarkably, over the years encouraged me to write scores of articles for his print and web publications on whatever topic I chose. In his humour, generosity and unstinting enthusiasm for his causes and mine, he was a *chün tzu* (an exemplary person).

Tony Fry

Introduction

Collectively, across all our differences, we human beings have reached a critical moment in our existence. It has always been recognized that individuals, communities, races and even nations can be fated or made to disappear but we are now at a point when it can no longer be assumed that we, *en masse,* have a future. If we do, it can only be by design against the still accelerating defuturing condition of unsustainability (which is the essence of any material condition of unsustainability as it acts to take futures away from ourselves and other living species). We human beings unwittingly have created this condition through the consequences of our anthropocentric mode of worldly habitation, which has been amplified by the kinds of technologies we have created and our sheer numbers. Effectively, what we have done, as a result of the perspectival limitations of our human centredness, is to treat the planet simply as an infinite resource at our disposal.

When we were small in number and our technological means of appropriating resources were very limited, the impacts of our actions were low. But now we are numbered in billions, have extractive and materials processing

technologies of absolutely enormous capacity coupled with an economy with an insatiable appetite, we are confronting our nemesis – a defuturing condition of unsustainability. For all the celebration of human intelligence, the culture of Western rationalism that came into global dominance totally failed to comprehend and respond to the innate and subsequently amplified propensity of human centredness toward being unsustainable.

Even now, in our collective moment of criticality, a moment in which damage to the planet's climatic and ecological systems is still increasing and exposing life as we know it to growing dangers, our species' auto-destructive mode of being is neither fundamentally recognized nor redirectively engaged. Myopically, the guiding forces of the status quo continue to sacrifice the future to sustain the excesses of the present. In the face of this situation, the possibility of another kind of future begs to be articulated, as does the way to bring it into being by design. Two immediate questions follow. How is the future being understood? And what is meant by design?

The future is not presented here as an objective reality independent of our existence, but rather, and anthropocentrically, as what divides 'now' from our finitude.[1] In other words, we exist in the medium of time as finite beings (individually and as a species) in a finite world; how long we now exist – the event of our being – is determined by either an unexpected cataclysmic event (like our planet being hit by a massive meteorite) or by our finding ways to curb our currently autodestructive, world-destroying nature and conduct.

Design, in the first instance, has to be understood anthropologically. It names our ability to prefigure what we create before the act of creation, and as such, it defines one of the fundamental characteristics that make us human. As has been said by many people in many ways – 'we all design'. However, this innate capability became objectified and was turned into a consciously formed and mobilized practice to which technical and operational definitions have become applied (by 'the design community'). Generally, professional and quasi-academic definitions of design obstruct it being widely recognized as something of vital importance to each and every one of us. Such definitions of design are usually territorial, instrumentally narrow, extremely reductive, or free-floatingly abstract. So said, this book speaks to two constituencies.

It says to the design community 'forget design as a territory and practice that can be laid claim to (the drive of professionalization), stop talking to yourselves (the internal dialogue of design events), give up on repackaging design within design (codesign) and start talking to other people, other disciplines; broaden your gaze (beyond the design process, design objects and design's current economic positioning), engage the complexity of design as a world-shaping force and help explain it as such.'

To people at large the book says 'irrespective of how you currently think and feel about design, you need to measure your own understanding against what follows and the fact of design's continually growing importance as a decisive factor in our future having a future. Nature alone cannot sustain us: we are too many, we have done too much ecological damage, and we have become too dependent upon the artificial worlds that we have designed, fabricated and occupied.'

Design – the designer and designed objects, images, systems and things – shapes the form, operation, appearance and perceptions of the material world we occupy. Design, as an anthro-directive, profoundly secular and omnipotent practice, has displaced the 'invisible hand of God'. While unequivocally bonded to a human-initiated act, design takes on a determinate life of its own – designed things go on designing (be they designed to do so or not). Yet most designers have so far failed to recognize, or take responsibility for this fundamental quality of design. This means that they have not been in a position to grasp the ethical implications and issues of designing and the designed. Of course this failure is mostly structural rather than individual. Design ethics is massively underdeveloped and even in its crudest forms remains marginal within design education.

Giving recognition to the proposition that we only have a future by design obviously takes us to the question 'how can a future actually be secured by design?' This book aims to begin answering this question. It is vital to understand that this is not a question with a straightforward instrumental answer. It is not a 'how to' question – we are not talking about an activity than can be based on a set of procedures – it is not akin to learning how to grow mushrooms, build a boat, create a website or construct a hang glider.

Answering the 'design futuring' question actually requires having a clear sense of what design needs to be mobilized for or against. Even more significantly, it means changing our thinking, then how and what we design. Equally, it also requires understanding that the 'dialectic of sustainment' is another basic feature of being human. Whenever we bring something into being we also destroy something – the omelette at the cost of the egg, the table at the cost of the tree, through to fossil fuel generated energy at the cost of the planet's atmosphere.[2]

This relation between creation and destruction is not a problem when a resource is renewable, but it's a disaster when it is not. Currently, the planet's renewable resources are being used up at a rate 25 per cent faster than they can be renewed, and the ecological human footprint (averaged over the global population) has tripled since 1961.[3] Such observations clearly provide a perspective on emissions that are increasing global warming and thus speeding climate change. While the media focus is dominantly on changes of temperatures, weather patterns, the rate at which polar ice shelves are melting and so forth, the actual damage being done to biodiversity, human settlement patterns, agricultural systems, human health and so on go by massively underaddressed. Destructive economic expansionism also puts into historical context the ever increasing rate at which population growth and industrialization outstrip the meek emissions reduction efforts – the now oft-cited indicator of this being that in 2007 China was building two coal-fired power stations per week to meet its energy demand. However, as a 'workshop of a globalized system' wherein much of the industrial production of 'postindustrial' nations occurs, viewing the nation purely in nationalist terms is misplaced.

Thinking the Moment

The 'state of the world' and the state of design need to be brought together.

While the destruction of the planet's natural environments comes from many quarters, it is climate change that has most dramatically and recently

entered public consciousness. Yet there are two major factors associated with this problem that mostly go unrecognized. The first is that even if solutions were to arrive immediately (a very unlikely prospect) the problem is going to be around for a long time as some greenhouse gases have an atmospheric life of well over 200 years. And the second is that there is no real sense of how bad things will get, or where the actual 'tipping point' into climate chaos is – climate chaos combines high levels of unpredictable climatic behaviour with, correspondingly, the end of predictable weather patterns. The nature of the climate moves ever more into the domain of the unknown, rendering historical climate data increasingly redundant. Certainly, rising temperatures are already making life harder for vast numbers of people, especially in Africa. As overall emissions levels continue to rise this situation will worsen in many parts of the world. The rate at which polar ice is melting indicates that sea levels are rising much faster than was initially expected. Even if the levels only rise by half the 7 metres expected by the end of the century, there will still be an enormous amount of suffering. A rise of just 1 metre will have a large impact on many Pacific islands, while a rise of 1–1.5 metres would result in Bangladesh losing 40 per cent of its land mass, displacing between 60 and 80 million people. It is against this backdrop that the World Bank, the International Red Cross and a diverse range of experts are talking about 500–750 million plus environmental refugees by 2100. The figure may be more or less; either way global population redistribution on an unprecedented scale is almost certain. Rather than numbers of people moving as a steady stream over time, the more likely occurrence will be in waves as major climatic events happen.

Undoubtedly, there is a huge gap between urgently needed action and the current and imminent availability of the means to create, globally, the political, social and economic changes that would enable humanity and all it depends upon to be sustained. There are technological challenges, but more significant is the challenge of creating the will and means to mobilize appropriate technologies at the scale needed to make a real difference. Moreover, the problems of climate change and unsustainability more generally, are amplified by other factors. Not least the drift of the world's population toward

the expected peak of between 9 billion and 11 billion and the prospect of escalating conflicts over natural resources – which will inevitably add to already considerable global tensions. The scale of these problems, as will be seen later, is of a magnitude that they cannot be accommodated within the existing global order – which is itself part of the problem.

To name and face the situation as briefly outlined is not 'doomsaying' but realism. Problems cannot be solved unless they are confronted and if they are to be solved it will not be by chance but, as said, by design. We human beings must recognize that we are now on the cusp of one of the most dramatic changes in our mode of earthly habitation. Against this backdrop, 'design futuring' has to confront two tasks: slowing the rate of defuturing (because, as indicated, for us humans the problem adds up to the diminution of the finite time of our collective and total existence) and redirecting us towards far more sustainable modes of planetary habitation.

As change has to be by design rather than chance, design has to be in the front-line of transformative action. But for design to be able to perform this role, the sum of all design practices, including architecture, themselves have to be redesigned. A brief sketch of the 'state of design practice' will make this need for change clear.

First let's consider the deregulated pluralization of design activity – which is currently being called 'design democracy' by some. This is being driven by a growing mass of free or cheap design software, which is increasingly allowing anyone to practise as a designer although often only at a superficial level.[4] It is possible, for example, to acquire software that, after keying in base data (for things like a wine bottle label, a floor plan for an apartment, a book jacket, a fabric pattern or a business card), will run hundreds, thousands or even tens of thousands of variations. Thereafter, the user simply makes their selection. Commercially, this activity takes design decisions away from designers and gives them to design (or even marketing) managers. Another problem here is not simply that more people are 'designing' but that design becomes increasingly trivialized and reduced to appearance and 'style'. This trend is not new. Architecture and product design have drifted in this direction now for many decades. What this trend does is to render invisible more and

more of the designing of the materiality or operability of things, this through the designing of engineers, software designers or materials scientists. So while design actually embraces the totality of what something *is* and *does* it gets *seen* to be purely appearance and performance. Design thus not only gets materially 'gutted' but actually acts to conceal the material nature of objects. Graphic design, interior design and fashion design all, of course, have a much longer history of being held in this grip of style.

Second, and even more significant, is design's complicity in adding to the rapidly increasing impetus of the forces of unsustainability. Certainly, since the 1990s, various forms of 'sustainable design' have arrived in most industrialized economies but for all the rhetoric, organizations, policy and examples advancing 'sustainable design', the actual and enormous changes required to establish the 'sustain-ability' of the artefactual world we create, use and occupy has hardly begun. Currently, the challenges of sustain-ability ever increase. It should be noted that the word 'sustain-ability' is used throughout this book in preference to the term 'sustainability', which is widely used, with various connotations, across a number of disciplines. 'Sustain-ability' aims to suggest a more materially grounded objective and agency.

Once the growing forces of 'design democracy' and unsustainability converge, design, as it has been known to date will be terminal. This view is held to be true by a growing consensus of people occupying a wide range of positions across the design professions, the academy and the corporate sector. In this situation, design either goes on becoming trivialized, technocratic, invisible and elemental to the unsustainable, or it becomes a pathfinding means to sustain action countering the unsustainable while also creating far more viable futures. This possibility for design as a practice and objectified agency is exactly what *Design Futuring* sets out to examine, elaborate and promote. In doing this, the aim is to contribute to building a new design intelligence (which is absolutely nothing to do with 'intelligent design'). Before saying more on this topic, another distinction has to be made, this between 'design democracy' and 'democratic design'.

Democratic design has both a claimed history and imminent potential. Its past goes back to the late nineteenth-century democratic ambitions of

anarchism centred on the writings of Peter Kropotkin, much of whose agenda looks like it was created last week rather than more than 120 years ago.[5] Kropotkin wanted: to restore the quality of the natural environment after the ravages of industrial development; the production of far more durable artefacts; a focus on the development of community; the devolution of government; the overcoming of alienated labour and the development of the practice of apprenticeships. Over time, his ideas have resonated and filtered through various practices, especially architecture, landscape architecture and planning. They influenced the radical geography and 'land for the people' movements; in the 1940s, they are echoed in writings on participatory planning by thinkers like Julian Huxley (who incidentally founded the World Wildlife Fund); they have traces in Ian McHarg's influential *Design with Nature* (1967) as well as with contemporary works like Randolph Hester's *Design for Ecological Democracy* (2006). The basic premise that 'the people' should have much greater power in deciding the form of the environments in which they wish to live, and that this way of life should enhance the environment in general is the connecting thread. But history tells us that the realization of this ideal is problematic.

The Tennessee Valley Authority's (TVA) New Deal project of the 1930s was not just a vast hydroelectric energy generation project but also the largest regional planning project that had ever been. In writing on the project, and addressing the issue of 'planning and the people', Julian Huxley made reference to another federal organization, the Pacific North-West Regional Planning Commission, which aimed to take the TVA token participatory planning activities further.[6] To do this they set up a substantial publication and educational workshop programme. This action recognized a fundamental and still absolutely relevant point about democratic design and democracy in general – good decisions require the people making them to be critically informed.

Democratic design is of immense importance but its potential is obstructed by problems that have to be surmounted. First are those that cluster around democracy itself. Democracy is a plural and contradictory political concept over which, as we shall see in more detail later in the book, critical debate

is increasingly gathering.[7] While mainstream political rhetoric evokes democracy as a coherent political ideology, the reality is that its forms are contested and many of its presented appearances illusory. There can be no simple appeal to democratic process by either the 'managers' of participatory forms of design decision making or by participants themselves. What is actually required is a clearly defined model and means to induce people to function within it. To date, civil society has been taken as a prerequisite for modern democratic process. To date, the freedoms that democratic subjects enjoy have rested on the rule of law that this form of society administers. But now we are moving into an era where maintaining freedom will become indivisible from establishing those delimitations needed to establish sustain-ability. Without sustain-ability neither we nor freedom have a future.

The implication of these observations for democratic design is quite simply that in addition to the form of democracy needing to be specified and operationally structured, design practice itself has to be remade to become an agency of sustain-ability. It follows, for the reasons given, that unreconstructed forms of design and democracy cannot be bonded together to become an effective agent of change. Bringing design and ecology together does not solve the problem either. These views are the obverse of Randy Hester's argument in his *Design for Ecological Democracy*.[8] Hester considers that simply by bringing democracy and ecology to design, it and its agency will be transformed. This is not the case, and not only for the reasons already stated.

The binary relations of politics/democracy – ecology/nature come weighted down with the baggage of modernity, epitomized by the profound influence of Thomas Hobbes on the development of modern political theory. For Hobbes, nature was what politics had to overcome and perpetually hold in check. In this respect, nature was the ever-present ground upon which politics depended. This relation travelled in time. In one sense this can be seen as civil society and civilization in part existing to maintain the divide between civilized human beings and animality; in another sense, it can be seen as the history of politically enabling the continual appropriation of natural resources as an economic and national sovereign right.

The present contradictions of political institutions straddling economic and ecological notions of 'sustainability' (most overtly expressed via 'sustain-able development') are inescapably refracted through this history.

There are two further issues to acknowledge. The first is that design and the ecological have to break free of a biocentric configuration – sustain-ability depends on ecologies of the artificial, mind and image as well as the natural. And second, democratic design as it is currently understood, depends to a large degree, on socio-political orders in which democracy has currency. This means its ability to become adopted outside such regimes is, if not impossible, certainly questionable.

In contrast to trying to work in the domains of democratic design and 'sustainability' while ignoring or just glossing over the problems of a dysfunc-tional binary, there are other options. For instance, Isabella Stengers elegantly elaborates the notion of political ecology 'as a politicization of "positive" knowledge-related issues or practice concerning things'.[9]

This is an abstracted echo of the kind of arguments that this book turns on – which is the remaking of design as a key force of redirection toward sustain-ability in order to move from 'sustainable development' (and all it stands on) to the 'development of the Sustainment'.

On Redirection

The duo that powers this move is design redirected to become a redirective practice. What this actually adds up to is taking back the power of design and reorienting it. It is not consensual, it is participatory, but not in a popularist sense, and it is political, although on the basis of a common cause rather than a political ideology, and it is an alternative to those forms of action that travel under the banner of democratic design. By its very character, redirective practice can never be universal or theoretically generalized – it can only ever be situated and circumstantially reactive.

Almost in a martial arts sense, some forms of redirection need to be viewed as deflective rather than confrontational. In this respect, and at the most

general, it can take the energy from the existing momentum of a particular force and bring it to a means of change. But equally redirection is a process of establishing new signposting systems that first indicate the error of following those existing pathways of thought and action as they serve to defuture all that is vital for viable futures (at both the level of mind or matter). And second, such systems point to new forms of knowledge and action that have sustainability.

Redirection, of course, always has to go to the actor and the acted upon. It certainly cannot simply rest upon those overplayed and vague notions of 'attitudinal change' posited with individuals that are so often evoked by idealist reformers. Such a notion of change implies an inflated faith in the ability of the will of these individuals to alter the nature of cultural, economic and institutional structures. Rather, redirection requires an ontological shift in the mode of being of the actor. The value of what one knows and does may have to be fundamentally altered. So, for instance, a great deal of knowledge that historically has been acquired as the corpus of the discipline underpinning a profession, and the manner of its deployment, could well need to be discarded and replaced in order for any real ability of the 'remade professional' to drive affirmative change. By implication this means that the being of professional identity and conduct is radically and structurally changed.

The issues flowing from these remarks will of course be elaborated as the content of the book unfolds.

On Design Intelligence[10]

Design intelligence (not to be confused with 'intelligent design') is one of those terms bandied about at certain kinds of design events, with the assumption of a common understanding. Not only does this assumption invite contestation, but, importantly, the very notion actually begs elaboration and exposition.

To understand design in its full complexity actually requires recognizing an intelligence, which is neither constituted within the modes of cognition of the sciences nor the liberal arts, this notwithstanding the efforts of design science

or cultural theory. Currently, this intelligence can only be claimed to exist, and be capable of being communicated, in very underdeveloped forms that centre on starting to recognize the act of prefiguration and the independent agency of 'things' in the world that have been prefigured. In this respect, it is an exploration of how things come into being and act beyond their mere function as material or immaterial objects.

Rather than illuminating fundamental questions about design, human beings and the making and unmaking worlds, most design theory has a very narrow, reductive focus. It is dominated by focus upon the act of designing by designers and what they design, thereby folding into how design is currently economically and culturally positioned. But another kind of design theory is needed, one able to deal with human beings making ever greater demands on the environments of their dependence. As damage to the planet's ecological systems – triggered by human actions – continually increases, there is a pressing need for the way we human beings live, act and engage the world around us, to change. Such change is characterized by the notion of the development of an age and process of the Sustainment as the basis of our redirected, but plural, future. Essential for the creation of this possibility is design remade with sustain-ability, but in order for this to happen design intelligence needs to be developed.

The realization of design intelligence would mean that having the ability to read the qualities of the form and content of the designed environment in which one exists, would be a mode of literacy acquired by every educated person. In increasingly more unsustainable worlds, design intelligence would deliver the means to make crucial judgements about actions that could increase or decrease futuring potential. Just as alpha-numeric literacy became an essential requirement for individuals wishing to function in the modern world, so now in the present epoch design intelligence will need to become a life skill. Its potential is the provision of an ecology of mind able to provide a way of reading, knowing and informing actions in the world of unsettlement that unsustainability is sending us. Adapting to coming conditions will be as a much a mental as a physical imperative. Design intelligence could and should inform all education and practice, leading it away from content that

inducts learners into unsustainable ways of thinking and acting. To grasp its importance is to recognize that design intelligence needs to be elemental to education in general. Rather than it being, as with environmental education, a slot in the curriculum, it would need to be structurally integral to almost everything in it. Obviously, this approach would clearly cut across the current way design is thought, not least in relation to practice, production, consumption and environment.

Although directive of every kind of design activity, from informing a sense of what needs to be designed, to the act of designing, the nature of the design object, and then on to consequences of its actions in the world (immediately and over a considerable expanse of time), design intelligence has to occupy a larger frame. It has, in fact, to fold into intelligence per se. What it names is thinking about design-in-action in both the worlds that exist and the worlds that have to be brought into being if we humans are to have more than just a very limited future. Design intelligence would not be created out of a void – besides drawing on the prefigurative disposition that all human beings share by degree, it can build on sediments of knowledge which already exist, as we shall see in a moment. At the same time, its creation is a huge project demanding the efforts of many minds over an expanse of time. *Design Futuring* aspires to be both a contribution and spur to this project.

Registering the Archaeology of the Idea

Proto forms of design intelligence have been implicit in craft practices well before design was constituted as a discourse. This is evident across all cultures. Certainly, in the West, design intelligence was evident from the rise of the first machine age in the eighteenth century. By the early nineteenth century the ability to identify and resolve design problems within a practice had become a highly refined tacit knowledge – the performance and appearance of Henry Maudsley's machine tools are prime examples of this attainment. The emergence of a design literature was all about 'capturing' this intelligence.[11] Yet none of the contributors to this body of knowledge developed a comprehensive theory of

design as a particular sphere of intelligence. Limited horizons equally applied to the arrival of the 'design research and design methods' agenda in the 1960s. The development of architectural science as a specific subdiscipline during this period was also equally circumscribed. By the 1980s, with the increasing profile of artificial intelligence (AI) the actual language and claim of design intelligence gained a particular flavour and impetus – it was characterized as a subset of AI. The modelling of design problems, design solutions, design experience and creativity all became objects for the application of 'intelligent systems' to create and deliver 'design tools' (now found in the space of 'design democracy').

History frequently repeats itself in tragic ways. Just as modern design knowledge/practice was largely a product of the appropriation of what was tacit in pre- and proto-industrial crafts, so now 'advanced' technology is enabling the appropriation of knowledge embedded in contemporary design skills. Examples include: rapid prototyping in industrial design; rendering programs in architecture; photographic retouching programs in graphic design and fashion to the full-blown design 'democratic' software.

Against this backdrop, design intelligence has to be reclaimed as a mind able to speak the power of design disclosed. This means having the ability to break through the contextually delimited ways that prevent the actual agency and world-shaping character of design being seen and understood. In turn, this means displacing the 'design community' tendency to reduce design to the process, product and expression of a professional practice; the media's reduction of it to an aesthetic form; the art-world's comprehension of it via aesthetically inflected perceptions; and the predisposition of science and technology to view design as the specification and expression of organizational or material forms.

The Book

Design Futuring places design in a political frame wherein it is remade in order to become the force for change that it needs to be. Unlike modernist

design utopianism the presented focus of change is upon the processes of redirection rather than of form. What is put forward offers no vision of 'a brave new world' but rather design as a 'redirective practice' able to take the diversity of humanity away from deepening the disaster of unsustainability toward the futuring character of sustain-ability. Central to the task adopted by *Design Futuring* is adding to and mobilizing, design intelligence. It does this in three ways. First in Part I by changing how design practice is understood, developed and deployed. Next, in Part II, strategies to enable change are presented and examined. Finally, in Part III, the context in which redirected design practice and change strategies can be deployed is elaborated. This will especially put forward the idea of the Sustainment as a moment in time that unfolds as a continuous process.

Throughout the book arguments are supplemented by variety of examples and case studies, which aim to ground the ideas put forward and extend the reader's perspective beyond the obvious and the Western.

In exploring the nature of practice and design, and their futuring character, the narrative of the first part of the book creates a conceptual foundation through which to view practice and design as they are brought to the imperative of redirection. All these elements are then united under the auspices of 'redirective practice', which allows common objectives to be pursued by different means. To show this an unusual award-winning urban design project is presented as a case study. Following this, two particular methods of redirective practice are put forward. The practice is then put into a larger frame of consideration by making connections between redirection and futuring, economy and culture.

The second part of the book takes the ideas, issues and politics of practice rehearsed in the previous part and mobilizes them in relation to the creation of affirmative change. It does this in terms of further qualifying design's futuring capability from four perspectives: the self, community, culture and ethics. The next two chapters both give accounts of approaches to the strategic deployment of methods of change. This is followed by an exposition of the proposition that the new can be learned from the past – here, as elsewhere, the account will move across cultures. The concluding chapter of this part of

the book explores what it means to be a 'redirective practitioner'. For many readers who have an existing practice this chapter will deliver a key agenda – one able to be brought to the defuturing qualities of the world around them. In so doing, an initial and developable ground from which to redirect will be established, commencing with the redirection of one's existing knowledge and practices. Crucially, for the ideas in this chapter to realize their agency, they need to be situated within the argument and analysis that precedes them.

The book's final part steps back to review existing ways 'sustainability' is able to be pursued within and beyond the design professions. It then places the entire issue of 'the Sustainment' in a meta-historical, economic and cultural content. From this very large picture it then goes to the other extreme and asks and answers the question of how and where readers of the book can act. Finally, *Design Futuring* places what has been presented in a comparative relation to other ways of thinking and delivering change. In so doing it confronts the issue of the seeming impossibility of redirecting the trajectory of human development away from the defuturing path of unsustainability.

This book aims not only to break with how we understand and discuss design but how design is conducted and by whom. It certainly does not claim to be the last word on design futuring but rather the first. As such it invites all readers, if so motivated and not already doing so, to make a contribution to futuring, large or small, in their daily lives, individually or collectively. If there is 'massive change' it will only have been because we, who refuse to be led to oblivion, have created it.

Unless otherwise stated, the reference to design throughout embraces all design practices, including architecture as well as rethinking practice in the context of the Sustainment.

Part I

Rethinking the Context and Practice of Design

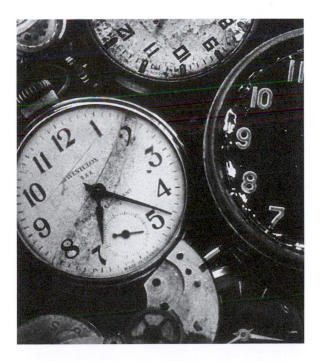

Practice, as the application of knowledge and skill to realize some kind of end, is frequently positioned in the realm of familiar experience and observation. Yet as it becomes second nature it recedes into embodiment and the concealed. The pencil in the hand of the illustrator, the scalpel wielded by the surgeon, the pianist playing piano, the interrogation of an accused in the dock by a prosecutor, the bricklayer laying bricks – once familiar, all these and myriad more practices, at a basic performative level, are enacted unthinkingly. The proficient exercise of any practice actually depends on it becoming an ontology – it has to become part of the being of the person who employs it. In this way they can engage the demands, problems, issues, possibilities and advancements of what they are doing without having to think about the act itself. Often, the greater the skill of the practitioner, the easier and more naturalistic its exercise appears to the observer. Such appearances, of course, deceive.

To acquire the practice takes time and compliance – conformity and limitation go ahead of the freedom of application. Training, repetition, reflection and correction all act to move what is initially an alien activity into the ontological realm of the taken-for-granted. As indicated, it is this condition that provides the ground for the ability to innovate, create, exploit and critically deploy the capability gained. In acquiring a practice, and it becoming part of its owner's being, the practice marks the mind and identity and, in some cases, the practitioner's body. It is both owned by and owns this person. And, in many cases

it actually frames how they are seen – the plumber, butcher, drummer, farmer, jockey, nurse may be seen as functional roles prior to their recognition as persons.

It follows from what has been said that if there is a wish to change the existing practice of a particular profession then it will require a great deal more than information, new knowledge and acts of will. It will actually need the redirection of the habitual, a change in the being of the practitioner. The chapters in this part of the book outline steps toward redirecting the practices of design so they can help redirect the status quo toward viable futures. Doing this means reflecting on what design practice already is and what it is starting to emerge as.

The position taken is not neutral – it is totally biased toward what design needs to bring into being to transcend the unsustainable, sustain all that needs to be sustained, and make viable futures possible.

I

Understanding the Nature of Practice

No matter the practice, its nature cannot be assumed to be transparent – it is never just what it appears to be. So said, the position to be taken rejects the adequacy of the dominant way of addressing practice(s), which is to consider them instrumentally, in terms of how they are organized and what they have been created to do.

Practices are codified in instructional directions and prescribed modes of conduct. As such, they are embedded in many dimensions of socio-cultural, economic, political and military life. We readily associate practices with, for instance, the knowledge, habits and materialized values of ancient and modern craft skills, as well as with the activities of professional occupations. As modern life, at home and work, has become more diverse and complex, practices have proliferated. Design as a cluster of practices ranging from architecture to fashion folds onto this context.

To understand fully what practice is requires seeing it as much more than just the specificity of any particular activity that expresses its existence. This is to say that a practice is something in itself and is never reducible to just its instrumental expression as a form of manual or mental labour.

If, as proposed, we are going to set out arguments aiming successfully to change particular practices and create new ones, then it will be necessary to understand the essential character of both practice and design. We will then be in a position to adequately engage design practice later. We have to know what can and cannot be changed and how change can take place. But before going further, it should be acknowledged that practice and design, as embodied in action, are primordial, whereas the arrival of the terms themselves is very recent. There is also a need to say why design practice has been chosen as our starting point.

Why Design Practice?

In sum, we human beings live a contradiction. In our endeavour to sustain ourselves in the short term we collectively act in destructive ways towards the very things we and all other beings fundamentally depend upon. Such longstanding and still growing 'defuturing' needs halting and countering. To do this effectively means radically changing how we humans think and act in the way we make and occupy *our* world and as we impose it on *the* world in general. 'To be' we have to be another way.

Design can be one of the key movers of this change. But for this to happen the very foundation of design and designing has to be transformed in terms of how designers think about design and designing, how they design and the character and consequence of what is brought into being by design. The key to the instigation of this process of change is the remaking of design practice, for this is what designs the designer's designing.

Design practice is not simply the application of a methodology and it is certainly not the same as the design process. Rather, design practice is what brings designers into being as such and thereafter sustains them. It is what

forms and animates their ontology as designers. It is thus implicit in the essence of what it is to be a designer, the design act and the character of the designed. This is why design practice is the critical starting point of our project. However, to unpack design practice requires that we first unpack the nature of practice itself and then design.

On Practice

Practice is superficially simple but once looked at in any detail it is complex. The French sociologist Pierre Bourdieu argued in his *Outline of a Theory of Practice*, that practices cannot be causally reduced to the material conditions out of which they appear to arrive.[1] Rather, he suggested, they come into being as a result of the structuring of *habitus* (the underpinning condition on which structure itself stands). For Bourdieu, *habitus* names something more fundamental than milieu or environment. His claim is that everything that sets up our disposition towards being materially situated, especially in relation to how we see the potential of these material conditions, is itself already structured (hence the underpinning quality of *habitus*). In saying this, he is identifying strong connections between *habitus*, structures and practices. Effectively Bourdieu is telling us that we 'arrive' in our specific worldly circumstances biologically, culturally and socio-economically already prefigured. This does not mean we are totally over-determined but we are nonetheless delimited by the world we are born into *that we take to be the world itself*. Thus the perceptions we acquire are in fact prefigured by the structuring of structure of the world we see, come to know and act within (the form of family and kinship, climate, the nature and form of the constructed and natural environment, and so on).

What is being described here is the structural operation of *habitus* (as it is constituted by the convergence of natality, sociality, mind and all other material/immaterial designing forces of the world in which one 'arrives'). Predesigning is perhaps an apt way to understand the prefigurative character of this structuring of structure which is *habitus*. This understanding

is actually a way of acknowledging that designing is a quality of the human-created structured world we inhabit. It exposes that designing is an active characteristic of everything we take to be given within the unnatural world we are born into. As such, we come to be what we are not just genetically prefigured but equally prefigured by the particular designing character of the artificially fabricated world into which we arrive. We are *de facto* the product of converging biological, social and artefactual structural forces – to recognize this is to render the binary reduction of 'nature versus nurture' redundant.

Without making any claim of a 'higher power', design viewed as a giving of form can be seen as existing prior to being a practice and at the very centre of how we individually and collectively gain our particular culture and thereafter act within it as designers.

As soon as human beings started to make a world for themselves by incremental (and later, rapid) environmental transformations (by design and violence) the process and the agency of this structuring (*habitus*) obviously started to change. The implication is that while we have always been prefigured (that is designed) as soon as 'we' started to modify our environment and make a world for ourselves via the use of tools, we began to form practices that were to structure what we were to become. Effectively, the designing of design and of our human being emerged out of the use of the most basic of tools. Not only did the use of tools facilitate prefigurative acts of world making and transformation that have brought us to the fabricated and damaged world we now occupy – they also acted back (in the sense of feedback within a cybernetic system) on the tool users – hence these proto-designer/makers themselves became designed. This process, while now infinitely more complex, remains the key to grasping the relation of humans to technology, science and the fabricated world. We are never just users; we are always equally the used.

To comprehend *habitus* so formed and framed by the human coming into being via the practice of self- and world making, is to open ourselves to seeing design in two ways – as structuring both: (1) features of the world in which we dwell; and (2) many of our material and immaterial relation to this world. It is practice, as designed and designing, as manifesting our

active being-in-the-world, which dissolves the binary relation between being structured and structuring. In so doing, the totality of practice strives to regulate, replicate and modify our domain of habitation ('our' world). Yet collectively, we have arrived at a moment wherein all that humanity attempts to regulate is at odds with the world that actually regulates us.[2] It is not just that many contemporary practices harm the world of our dependence but also that so few of them deliver the means to actually know the consequences of their activities beyond a horizon of immediate concern.

On Design and Action

'The designed' has become more discernibly visible and integral to the character of structuring of *habitus* in and of the modern world. In so doing, it has infused every aspect of human conduct at the most basic level. It is not just that we are born into a designed world but that our interaction with this world is also designed – our built environment, forms of work, modes of transport, manufactured products, media, infrastructure systems and myriad other things are all designed in relation to use. In actuality, design is one of the main operative agents of the social, cultural and economic functioning and dysfunctioning of humanity's made world.

Ironically, in an age of hegemonic technology and capitalism, the practice of design has itself become subject to functional direction (pragmatically and symbolically). Increasingly design, as a service, acts on instructions rather than taking action in the original sense (the Greek verb *archein* originally defined acting as commencement, leading and completing). So whenever design action is evoked or implied in this and subsequent chapters, this is done recalling its Greek origin.

Mostly, design action, exercised through a designer responding to the direction of a commercial brief, brings objectified things into being without the designer recognizing that what has been realized is world making or negating. This is to say, that consequences go well beyond the 'environmental impacts' that better informed designers now take into account. The general lack of a

sense of how design makes or breaks worlds is a major aspect of the political amnesia of the design professions. Such a limited horizon of responsibility conforms to a problem that Hannah Arendt characterized as a 'substitution of making for acting'.[3] The slide in agency she identifies occurs in a culture where politics has degenerated into means that have lost sight of ethical ends and the vision which should prefigure a political agenda. Dominantly, the ontologically designing character of contemporary design(ing) and designed 'things' works to obscure those agendas that, beyond the most immediate concerns, would make designers fully accountable for what design brings into being.[4] Optimistically, Arendt asserts that instrumentalization and the degeneration of politics never fully eliminate the possibility of action.[5] Unless one fatalistically abandons oneself and everything to which one is attached, there is no choice but to subscribe to this view. Design action has become diminished. Driven by a deterministic economic imperative, design serves an instrumental mode of making that brings things into being without knowing what the consequences will be.

There are, for example, now well over 700 products on the global market that contain unregulated and unlabelled nanoscale particles – this notwithstanding considerable international concern, including the United Kingdom's Royal Society recommending that the manufacture and release of nanoparticles be prohibited until more is known about their impact.[6] Likewise, Swiss Re, one of the world's largest reinsurance companies, asserted that 'no expense should be spared in assessing the risk' of this technology.[7] What is being let loose are materials that may act in the material world as viruses do in the immaterial world. Synthetic nanobiological technology is, moreover, an even bigger risk.

At the behest of the call for profit, so many industries, with the support of design practices, negate the future as they fabricate the form and economy of the present. This process of negation feeds the ruling global regime of unsustainability as it exists now and as a condition of imminence. To understand this situation is to grasp that design practice cannot simply add 'sustainable practices' onto its flawed foundations. Rather, the nature of design practice has to fundamentally change – it has to be redesigned. These remarks return

us to considering the relations between making and action, but in proximity to an engagement with *praxis*.

The Greeks bonded the idea of *praxis* to action (remembering that action meant *archein*) – thus the concern was with what action created beyond what it instrumentally directed. As such, action can be understood as that which forms humanity as collective, as community, as society, as polis, as particular identities and as difference. Action, as *praxis,* is futural in so far as it secures being. In contrast, making, fabrication (*poiesis*), can never make what is absolutely vital for humanity's continuity (which is why, in the end, 'sustainability' can never be created as a product of technology). However, *poiesis* should not be thought of as completely partitioned from *praxis* in that once 'made things' enter the world of human affairs, a relation is established in which they may be completed as *praxis* (Aristotle actually confirms the ability of *poiesis* to become *praxis* in his *Nicomachean Ethics*).[8]

In our epoch, clear distinctions between making, artefactual things, artificiality, technology and the human become ever more difficult to discern – the synthetic exists around, and increasingly, within us. The implication is that an engagement with *praxis* is becoming critical. It is a key perspective in evaluating: what created 'things' do; the growing breakdown between 'the human' and 'human designed artifice and artefacts;' and questions associated with 'the meanings we give to ourselves'. In this context, and along with the regime of unsustainability, new practices able to engage and transform those structures that structure (*habitus*) with futural potential will become vital. Design, so remade, would be inverted. It would have direction (time and orientation) as its primary objective, with form (objectified function) its secondary consideration.

Design Practice and the Imperative of Knowing

To bring design remade into view within and beyond the design community initially requires the development of new knowledge, interpretative skills, objects of experiential encounter and objects of critical reflection. Central to

all of this activity, as has already been indicated, is recasting how acting and making are observed, understood and engaged as (design) practice bonded to *praxis*.[9]

As has been pointed out, action and/as practice always exists amid our structuring via *habitus*. But in our acts of making, we are also always un-makers. In our desire and need to create, we human beings fell trees, break eggs, kill animals, level mountains and damage ecologies. Such is the blind power of our anthropocentric drive that so many of our practices conceal this omnipresent unmaking. What actually needs to be faced is that while our 'being destructiveness' is unavoidable, how much, and what is destroyed demands to be visualized prior to the act of destruction. This needs to happen so that action can more become a matter of ethical judgement and socio-environmental accountability.

Marx famously observed: 'Men make their own history, but not of their own free will; not under circumstances they themselves have chosen but under the given and inherited circumstances with which they are directly confronted.'[10] Irrespective of one's view of Marx, this statement remains salient. Yet it is equally true if inverted – as comments on design, practice, making and unmaking indicate – 'men are equally made by their historical and material circumstances'.

Designers design, but how they are themselves designed, and what is de-signed by the designing of what they design is rarely recognized or understood. What will be advocated as we proceed is a practice to be embedded in all design practices that exposes design's world-making and unmaking. This practice is effectively a bringing forth of design as appearance (*eidos*), know-ledge and skill (*techne*) and action (*praxis*). Without this practice becoming integral to all design practices, humanity (in its plurality) will lack the ability to give a form to futures able to sustain humans, non-humans and all else that we and they depend upon.

2

Understanding the Directional Nature of Design

The popular view of design, especially when centred on historically celebrated or contemporary designer objects and 'name' designers, tells us little about the fundamental character of design. Most of what is designed, and most designers, are anonymous. Design as such cannot actually be disaggregated from the world around us and presented as a thing-in-itself – contrary to the appearances that the media coverage of design mostly trades on. Rather, design is deeply embedded in our worlds and in us. At home, work and play we are surrounded by things designed to function in ways that go unquestioned and absolutely taken for granted. In its efficacy, design impacts on the viability of our future. Yet for all this, it generally appears in the public sphere as aesthetically elevated iconic objects and structures, as gizmo trivia, as sexy

technology and as the product of a particular breed of creative talents. What certainly does not arrive is its importance.

Design is a directional practice that brings directional objects and objectified things into being. To understand it in this way means realizing that designing not only conceptually and technically prefigures the form, operational and symbolic function of the designed but equally its plural destiny (i.e. its posited short or long functional life as an agent of harm or harmlessness). It is from this perspective that the statement that 'everything designed goes on designing' can be made. Effectively this means that design does not actually create a finalized object or product. Rather all that design brings into being remains in process within a particular kind of ecology of things, organic or inorganic. We need to understand two issues in relation to this observation.

First, all that is matter, and much that is immaterial, including information and images, exists in a perpetual condition of exchange. Everything comes from and goes somewhere. No material objects are eternal. Some break down extremely quickly before our eyes, others take millennia or longer, and appear to us as completely unchanging. In the case of the immaterial, in order to be legible or functional, it has to come from a context that gives it the possibility of being interpretatively engaged symbolically or operationally. Things material and immaterial only gain efficacy by virtue of exchange.

The second issue is that there is more than just one ecology – there is the biophysical realm that we conventionally view as ecological; there is the ecology of the artificial as it exists independently from, and fused with, the natural; and there is also what Gregory Bateson called 'the ecology of mind'.[1] This notion acknowledges that ideas exist relationally – they connect with and feed off each other, and travel in time and cultural space. And then there is an 'ecology of images', which recognizes that we exist in a relationally complex environment of signs that enable our 'seeing' in a meaningful sense via the memory of the seen. All these ecologies interconnect. So, for instance, our disposition toward and conduct within biophysical ecologies are partly determined by how we mentally and visually perceive them as a result of their mediation by ecologies of mind and image. Crucially, how we think about and view 'our world' is indivisible from how we treat it.

Design, Directionality and Relationality

At the most fundamental, design objects always exist in concord or tension with relations within and between varied ecologies – they come from and go to these ecologies passively or actively supporting or negating them.

Relationality, as causal interaction, is at the core of all ecologies. It names the dynamic complexity of interconnected and multidirectional causes as they create major or minor changes in the ecological totality.[2] Transposed into a theory of knowledge, relationality contrasts directly with the linear notion of cause and effect which has been such a dominant feature of Western rationality. In that the ability to sustain depends absolutely on relational interactions its development and deployment as a theory knowledge able to direct design will become increasingly critical.

While linear instrumental thought has underpinned the West's greatest attainments in science and technology, the pervasiveness of unsustainability (as unaccounted for consequences) evidences its perspectival limitation. Paramount among these limitations has been the inability to comprehend that the 'objective' pursuit and application of knowledge was steered by an anthropocentric sensibility which did not take cognizance of immediate and defuturing biophysical impacts. The world was simply seen as a domain ruled by humans existing to give up its resources according to the mobilization of force, the requirement of capital and according to whatsoever technological means could be mustered. In producing the world of culture and artifice we humans ceased viewing ourselves as relationally connected to those categories *we created* to describe 'the natural world'.

We humans cannot fail to be anthropocentric. However, we *can* recognize anthropocentrism as our inescapable condition and henceforth take responsibility for it. The problem, in the main, is that it slips under our radar – our being anthropocentric has barely been recognized in the millennia of Western philosophy, let alone in popular consciousness. Furthermore, this lack of recognition prevents unsustainability being seen as part of our nature; we focus instead on its symptomatic manifestation in the 'natural world', this leading to the erroneous hope that science and technology will 'save the

planet', while allowing humanity to universally realize an ever higher standard of living. The persistence of this view obstructs gaining an understanding of the kinds of directional changes that have the potential to provide a path to viable social, economic and environmental futures.

The Western professionalization of design has been dominantly framed by the general circumstances outlined. It has been linear and decisionist. Until very recently, the consequence of what human centredness took from, or imposed upon, environments and ecologies was just not taken into account – expediency ruled. That ecological impacts are now on the agenda should not make us complacent: understanding of past and present, let alone, future impacts of human planetary conduct is still rudimentary.

Is it possible for design to break free of linear, instrumentalist thinking? Certainly, comparative philosophy has exposed ways of thinking that pose substantial challenges to the way Western reason has been directive of so much design thinking. The value of thinking from a tradition of thought other than one's own is that it provides a perspective of critical reflection. For example, consider the dramatic difference between Chinese correlative acosmotic thought, which does not hold that 'the totality of things constitutes a single-order world'.[3] In contrast to the West's reductive focus upon the originary moment and first principles, correlative thought sees causality in terms of associative relations (initially of 'ten thousand things').[4] This is not just an 'interesting historical comparison': Chinese correlative thought provides a significant path to thinking the causal web that is implicit in the relational ecology of contemporary environments of manufactured commodities.

An Example of the Need for and Lack of Relational Thinking

Globally, the demand for energy is ever rising but, equally, due to global warming, the demand to reduce emissions from burning fossil fuels can but grow. One of the responses by governments in trying to meet these demands is to turn to nuclear energy in its 'clean' and most advanced form. In response,

'environmentalists' mobilize familiar objections based on risks from nuclear waste, accidents, high water use and cost. The riposte of the pro-nuclear lobby is to claim that all the problems have been solved, that today's reactors are extremely safe, can be protected from terrorist attacks and that they stack up economically. Both sides display linear thinking and fail to explore the relational complexity of the issue. Even the briefest of sketches of this relational complexity changes the picture.

We live in a world with a still fast-growing population, with natural resources under considerable pressure and with those that are renewable being used at a rate totally outstripping their regeneration. There is also the structurally present, asymmetrical conflict between the 'West and the rest', plus increasing new tensions between nuclear-armed power blocs. Added to these problems are the unfolding human consequences from the threats posed by climate change, including potential geopolitical destabilization as a result of massive redistribution of human populations. These factors, combined with likely increases in contestation over natural resources (especially water), mean that there is a strong likelihood that an already dangerous world will become even more dangerous. In the face of this scenario, there are two risk-reduction imperatives: putting political and economic structures in place that reduce the chance of conflicts; and protecting those resources and forms of volatile infrastructure that are in some way vulnerable.

Nuclear power stations are high-risk infrastructure. As part of a nation's energy infrastructure, every power station is a potential strategic target in war. Although not sources of weapons-grade plutonium, they nevertheless pose a large danger. Every one of them is potentially a huge 'dirty bomb' if directly hit by a missile, a terrorist suicide plane packed with high explosives, or a laser-guided bunker blaster from an advanced economy adversary. Even if nuclear energy was shown to be completely environmentally sound and economically viable for meeting future energy demands, is building hundreds, or even thousands more nuclear power stations worth the risk? To answer this question, one needs to consider not just the risk at the moment a power station is commissioned, but risk over the design life of the total nuclear energy infrastructure.

The Design Agenda Culturally Contextualized

Design, as a directional force, could become paramount among practices able to enact directional change – this notwithstanding the seemingly insurmountable odds of overcoming a still-globalizing commodity-based defuturing economy and culture. For such change to happen, what is needed is not only a transformation of design and ways of designing, but also the coming into being of another kind of designer.

Designers are not faced with a simple either/or choice between the tradition of design as directional or the adoption of relationality as the basis of a new design method. Designing and the designed cannot cease to be directional. What relationality can do, as a critically reflective way of thinking, is to subject the question of direction to rigorous analysis in ways able to recast design thinking and practice. Crucial to this thinking is asking: 'what will that which has been designed design?' This question brings design within the directional ambit of the designer by presenting the imperative of taking responsibility for what will be brought into being by 'the designed designing' (a definition of design's ontological character). Unambiguously, this responsibility and its challenges, changes not just the designer's role, but the very nature of the practice.

An understanding of ontological design exposes the close and animated relation between humans, material and immaterial things.[5] As the previous chapter indicated, we are all born into a world of structures that structure our *habitus*. Designed things fold into this condition. The designed things of the world into which we are born, learn to understand, occupy and employ, themselves design very many of our capabilities, habits, perceptions, and desires. At the same time, in our being in this world, we act upon it and contribute to its making and unmaking (knowingly or unknowingly, again often by design). Thus our children do not arrive in the same world as us. So while ontological design is a circular process, it never returns to the same point.

Ontological design thinking needs to be distinguished from crude deterministic materialism, environmental conditioning or the determinism of

'economic rationalism'. Although the idea of ontological design does embrace a certain deterministic quality, it also enfolds 'free action'. Our 'free choices' are always circumscribed by conditions of structure and limitation (as the discussion of *habitus* indicated). While an ontological relation between human beings and their made world has existed since the dawn of human time, what becomes critically transformative is developing knowledge of what occurs in this process and then employing it toward futuring ends.

What humanity brings into the material world, via design and its instruments of production, has always been directive of futures. But never more so than now, in this age when the extraordinary power of technology continually increases and becomes integrated with systems that go beyond the control of any individual, corporation or nation to become part of the lifeworld of billions of people. The manner in which the products of human creation act on the material world have actually become decisive of our very existence – 'we' do not just live with technology but by it.

As the geological and biological historical data reveals, the planet has withstood and can withstand massive directional changes (be it with dire consequences for many of the forms of life exposed to these changes). The actual human capacity for adaptation to dramatic and rapid geophysical and biophysical change has yet to be tested (and will be) but within the scale of changes evident in the past, and even with technological support the capability may be very limited. While humanity can do little about its cosmic fate, it still has the potential to make critical decisions about what it brings into being itself. Bringing ontological design to the centre of a remade design practice is one of the significant means by which such a form of human material and immaterial creation can be brought into a regime of responsibility. Realizing such an objective is extremely difficult, very political and absolutely vital in transforming design from its current incarnation.

The impression given in the way ontological design has so far been discussed is perhaps of design engaging individual objects but this is not how things exist, act and need to be understood. Objects actually inhabit complex relational assemblages that constitute particular environments that themselves have designing agency that again evidence a causal determinacy that is contrary to

a linear model. This relational context is not purely spatial but also temporal. It is therefore not just a question of seeing objects in association in space whereby they combine, recombine and act in different assemblies, but equally seeing them as occupying varied modes of being across time. Clearly, this means bringing historical analysis and future projection into the picture of directional design as it sets, or continues, a trajectory. Clearly such thinking challenges the adequacy of forms of analysis that are based on a simple binary object/user relation. The case study below illustrates the relational complexity of the designed designing. In considering it, there is one question to bear in mind: 'what, reasonably, could have been anticipated?'

5 Auto and tractor factory, Coventry, 1950s

Case Study: What the Automobile has Designed

We take the advent of the automobile to be marked by the invention and ap-plication of the internal combustion engine as its motor force. This invention is credited to Karl Benz in Germany in 1885/86. The Daimler/Maybach automobile arrived a few months later in 1886.

Let's assume that like so many other inventor/designers before him, Benz took the realization of his technological objective, the creation of the internal combustion engine, to be a sufficient end in itself. Maybe he imagined how it might develop and what future vehicles might be like and how they might perform, but we can assume with some certainty that, at least at the moment of invention, he would have had very little idea of what his creation would actually cause to come into being over time, and with what designing consequences. To give a sense of the extent of the generative force of what Benz unleashed, consider this far from exhaustive review of the designed designing. Our starting point is with the most obvious.

Every type of car from limousine to beach buggy, all sizes of trucks, motor cycles, tractors, all types of military fighting vehicles, special vehicles from mobile cranes to road rollers – have the one Benz antecedent.

While roads were already in existence prior to the arrival of automobiles, they, and all subsequent road-using vehicles, totally transformed road design, construction, and the complexity of road networks. Equally, the development of road infrastructure transformed and created cities; divided communities; enabled an enormously large and economically powerful goods transport industry; and led to traffic congestion that has dramatically reduced the oper-ability of city life and, by degree, affected public health.

Perhaps the most dramatic measure of the volume of road traffic and growth of road networks world-wide is the number of people killed by traffic accidents (according to the UN World Health Organisation in 2001 it was 1.2 million people).

Motor vehicle road usage has, in turn, led to the proliferation of fixed and electronic road signage; various forms of taxation and insurance; financial products and services; road regulations and laws; specialist policing; accident

investigation; surveillance and traffic-law infringement detection technology; vehicle crash and breakdown recovery equipment and services; crash repair services and the creation of specialist ambulance and trauma medicine services.

The internal combustion engine was responsible for the creation of a massive petroleum industry and its diverse products. This industry itself, via the geopolitics of oil exploration and supply, has had a major impact on international relations. Wars have been fought over oil and won or lost on the basis of its availability/non-availability. Likewise, a century or more of carbon dioxide emissions from petroleum-based engines has significantly contributed to anthropogenic global warming.

The environmental impact of the automobile industry rivals that of the petroleum industry. From the opening of the twentieth century, the creation and operation of an automobile industry became, along with the possession of a large and technically sophisticated army and navy, a major sign of modern nationhood. Moreover, the two assembly systems established by this industry – the 'gang system' devised by General Motors and the more famous 'in-line system' introduced by Henry Ford – became paradigmatic for industrial mass production *per se*. Everything from gas cookers to machine guns was made via the same system of interchangeable component assembly.

In turn, the growth of the auto industry created a plethora of component parts and accessories suppliers. The more sophisticated vehicles have become, the more suppliers have proliferated – pressed steel body parts, cleaning products, computer-based fuel injection, oil filters, sound systems, wheel trims, parking lights, air cleaners and so the list go on. Many of these items feed the shelves of wholesale and retail trade outlets, repair and auto-servicing businesses, as well as the vehicle sales network with its myriad of 'elegant' showrooms. The construction of these showrooms, plus commercial and domestic garages, brings the architectural and building industry onto the scene.

Last but by no means least is the huge socio-economic and cultural dimension of automobiles. The first, most important and ongoing consequence has been simply the creation of freedom of movement over distance at a time that suits the traveller.[6] This has created and is still creating the mass mobility of

settled communities. Individual mobility has completely changed the planning of cities, suburbs, urban design, rural life, retail shopping, tourism, leisure and more. Increasingly, public transport provision has been defined against private transport. Likewise, the freedom of movement enabled by motor transport has had major consequence for labour mobility, the labour market and the selection of locations for workplaces.

The early arrival of motor sports placed the auto-industry in the realm of entertainment. Thereafter, the glamour of speed and danger combined with the design industry's creation of 'car styling' resulted in automobiles becoming highly symbolic objects that spawned subcultures of collectors and customizers. Perhaps the most celebrated piece of writing on this topic is Roland Barthes 1957 essay, 'The New Citroën'.[7] More generally, automobiles have become structurally elemental to family 'modern lifestyle' and to youth culture. Perhaps even more significant, has been the massive and mobilized symbolic power of automobiles to signify wealth, status, virility and taste.

What can we learn from this example, beyond the complexity of even a superficial characterization of relationality and the vast difference between viewing design as product and process? The answer, it is suggested, is what can be learned methodologically from historical reflection when designing from the future to the present. Looking back teaches ways to think about how to project forward. It can be a way to formulate key questions and to create 'critical fictions', enabling the contemplation of what would otherwise not be considered. The result of this activity could radically alter a product, where and by what methods it is produced, how it is characterized, the way its impacts are understood and even if it should be brought into being at all.

Thus, developing an ability to think relationally is not marginal to design and redirective practice but central to it.

━━━━━━━━━━━━━━━

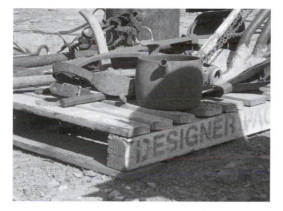

6 A scrap of design

3

The Imperative and Redirection

There can be no viable future for the world of human occupation unless it is able to sustain its interdependent conditions of existence. This statement is easy to make, but what does it really mean? What is it to be sustain-able and what has to be sustained? These questions will travel with us, but for the moment they will be visited in relation to the need to redirect design.

The mainstream and oft-cited definition of 'sustainability' comes from the 1987 World Commission on Environment, Brundtland Report, *Our Common Future*. The report centred on 'sustainable development' defining it as '... those paths of social economic and political progress that meet the needs of the present without compromising the ability of future generations to

meet their own needs.' In this context, 'sustainability' was directly linked to economic growth, managed in such a way, that natural resources are used to ensure the 'quality of life of future generations'.

Although this definition is still continually evoked, it is based on a number of questionable assumptions. It is actually also a significant departure from a good deal of environmental debates that predated it.

The first assumption one encounters is in the report's anthropocentric bias towards future generations. By implication, this means that the interconnected interdependency of all biological life goes unacknowledged. Moreover, to make a blanket appeal to the 'quality of life of future generations' fails to recognize the unevenness of the human condition today. If the socio-economic inequity of current generations is faced, then the issue of establishing a baseline quality of life for several billion people now, has to be confronted, as does the fact that a small percentage of the world's population commands a disproportionately large percentage of its resources. Both poverty and wealth drive unsustainability – the former depletes resources as the truly poor lack any means to renew them; the latter profligately uses and irresponsibly squanders resources. This is not just a simplistic moral judgement: the inequity named here is structural. It is inscribed within the world's financial system, transnational politics, the international labour market, the global system of production and the exchange of raw and manufactured commodities. Clearly, the Brundtland Report's idea of intergenerational equity needs to be subordinated to interspecies and intercultural equity.

The second assumption that invites challenge is just as problematic as the first. It rides on a 'capital logic' proposition that the future is able to be secured via continual economic growth.[1] This kind of thinking reduces change to the rhetorical and cultivates tokenistic forms of actions while in actuality maintaining the status quo. In large part, the Brundtland Report's position was underpinned by a low-level political pragmatic, namely: 'unless capitalism is accommodated, any appeal to environmental protection would just not be taken seriously'.

The Brundtland Report's views were no doubt partly shaped by the emergent environmental thinking of the time. Of particular note, at this moment, was

the economic mainstream's recoil from the publication of the Club of Rome report *Limits to Growth* authored by Donnella Meadows and others in the late 1970s. Of course, after the demise of communism as the sole alternative to capitalism, and the rise of globalization as capitalism rampant, any appeal to restraint looked completely futile. The ability to create the global economic and political conditions that make it possible to sustain the biophysical systems that all living beings depend upon, while at the same time reducing the terrestrial, oceanic and atmospheric impacts of a still-increasing global human population, all suggest the need for major material restraints. The care of environments of dependence is a pressing necessity rather than an option. For this to happen, the fundamental character of the capitalist economy has to radically change. It is now idealistic or plain naive to call for the overthrow of capitalism (to be replaced by what?). Rather, capitalism needs to undergo a paradigmatic shift and, as will be shown later, *design* within the political frame of redirection could play a key role in this transformation.

The Brundtland Report did not provide either a conceptually sound or practically workable definition of 'sustainability'. Likewise, the report's promotion of 'sustainable development' did not provide a foundation upon which to elaborate the 'development of sustainment' – all that was offered was an argument for a mild reform of the existing paradigm of 'economic development'. At the same time, by default, the Report created the impression that 'sustainability' was a realizable objective. Against the backdrop of these critical remarks, let's consider another perspective – that of 'sustain-ability'.

Re-orientation

Sustain-ability, first of all should be understood as 'a means to secure and maintain a qualitative condition of being over time'. It is a process (rather than an endpoint) wherein all that supports and extends being exceeds everything that negates it.

Crudely, being (as an existent process) enables everything in *being* to be futural (future making). Obviously, if there were to be an end of human

being, it would not mean the end of being itself (although it can be said it would be the end of any knowledge of being). Here we have a position that cuts across the confusion carried by the dominant rhetoric of 'sustainability'. This rhetoric poses 'sustainability' as a realizable condition gained through a convergence of environmental, social and economic action. This tripartite objectification (which came to be evoked as 'the triple bottom line') fails to grasp the more fundamental point, which is that human-centredness exists within the 'dialectic of sustainment'. We exist by virtue of being creative and destructive.

The Brundtland Report also fails to acknowledge that the forms of exchange within capitalism and ecological systems are incommensurate – this is the condition underpinning an enormous number of 'environmental problems.' The need to bring the ecological and economic into the same frame of exchange is, of course, one of the main reasons why capitalism has to undergo a paradigmatic shift – as we shall see later; this task is an absolutely enormous challenge that has not even begun under the banner of 'sustainability'.

'Sustain-ability', on the other hand, is an acceptance of anthropocentric desire – it is about 'saving humanity' by saving what we collectively depend upon (thus it refuses the deception of 'saving the planet') and it implies changing the processes by which our lives are sustained. As acting sustain-ably will vary according to time, place and circumstance, it is only possible to have a generalized understanding of what it is. There is nothing that is more important for *us* – without sustain-ability we human beings have no future, have nothing, are lost. At the same time without us, many, if not all, of the environmental problems we deem as examples of the unsustainable would self-correct. *De facto* as soon as we started to 'de-naturalize' and make ourselves a world-in-the-world, some 12,000 years ago, we started to develop our propensity to become unsustainable. In retrospect, the more 'successful' world makers we have become the more unsustainable we are.

As should be becoming apparent, the task of becoming sustain-able is a somewhat larger project than the environmental and political rhetoric of 'sustainability' suggests. It implies nothing less than fundamental directional change in what we do and what we are. Becoming sustain-able is certainly

a lot more that just technologically fixing-up the planetary damage we have done and continue to do. It is not a project of a few years or decades. Rather, it is a project that has to exist as long as we exist – the degree to which we embrace it will actually determine how long we survive as a species. For this reason, we need a way of naming this project, as it rejects and transcends the exhausted, and in many quarters, discredited rhetoric of Brundtland-style 'sustainability'. We mark this difference with the name of 'the Sustainment'.

The Sustainment is not a fixed state; rather the reverse is the case. It is the arrival of a moment of continual material and cultural change to keep what sustains in dominance. Supported by all modes of sustain-ability, as they negate unsustainability in its existing and emergent forms, the Sustainment requires a continual identification of what needs to be destroyed or changed. Thereafter, such identification has to give way to forms of appropriate sustain-able *action* across every dimension of the common and situated differences of our existence (for example, our relations of material and interpersonal exchange; what we make, how we make it and from what; the way we live and organize our ways of life; what we value; how we treat each other collectively at every level from the local to the international). The Sustainment has to be sought, circumstantially, in many different ways, be they in the face of the varied manifestations of environmental and atmospheric damage, conflict and inequity.

Change and Design

The directional change toward the Sustainment will not occur of itself; it can only occur by design. The conceptual space between this general evocation of design and the activity of professionally recognized design practices is, of course, huge. Likewise, the manner in which design is mobilized in language to signify intentional action and a comprehension by the population at large of what design practices can or could do is another great divide.

In order for the kind of changes that the Sustainment requires to come to be, all design practices have to change and break from exclusive service to

the status quo. For this transformation of the economic and cultural role of design to occur, a great deal of design thinking, process and practice has to be significantly redirected toward giving substance to the futuring power of 'sustain-ability'. So framed, sustain-ability can be understood as the ethical and conceptual underpinning of all practices (including design) redirecting and remaking material and intellectual means to advance the moment and process that is the Sustainment.

Implied in the position outlined is that designers place the current needs of the market in second place to the politico-ethical project of gaining sustain-ability. This is not to unrealistically suggest that all commercial considerations are abandoned but rather that they are strategically and economically repositioned under the imperative of working toward gaining sustain-ability. The magnitude of these changes is not going to be instantly embraced, comprehended and implemented. It is going to take time and a cadre of design leaders, strong advocates and progressive educators to deliver tangible results.

Letting Go and Taking Hold: The Question of Redirection

Redirection toward the Sustainment requires a double movement. First is the redirection of all those practices that act to maintain the unsustainable qualities and trajectory of the status quo (in modest and fragmented forms, this activity has commenced). Second is the application of the newly redirected practices to redirect the status quo toward an economy, social structure, culture and political order of the Sustainment (this is the challenge that extends from now to the coming decades). Without question, the project of redirection is a mammoth task equal to, if not exceeding, the making of the modern world. While of a scale beyond its capability alone, design redirected can make a very large and crucial contribution to sustain-ability while also triggering a wider debate on forms of futuring towards the Sustainment. As indicated, redirection is not instant economic dislocation. It does not mean, or aim to create, a total rupture from the status quo. Rather, it means identifying

what needs to be redirected, commencing redirective activity and working to establish the rise and dominance of agents of futuring. So understood, it is more radical than reform but less disruptive than revolution.

Redirection, Practice, Design and the Political

Redirection is a profoundly political proposition. Ultimately, it implies a restructuring of *habitus* by design, this leading to major cultural transformations. And while revolution is refused, the radicality of what is actually proposed, if it is to gain any substantial foothold, requires mobilizing powerful arguments, delivering practical results and overcoming considerable resistance.

Redirection obviously requires the personal, political conversion of many practitioners, not least architects and designers, to become redirective practitioners. The starting point is thus an act of self-redirection based on remaking the ground, and much of the content, of one's own knowledge, combined with acquiring the underpinning, collective, political ontology of the sustain-able activist working in their difference toward the common goal. The pursuit of this end has three major implications for the individual: a willingness to accept responsibility for being anthropocentric; a wish to 'lead against the grain'; a striving to establish conditions of solidarity amongst redirective practitioners and a new practice-centred politics.

The Sustainment redefines and reanimates the importance of 'the common good' – it places the condition beyond the ownership of any particular political ideology, takes it out of the realm of idealism and situates it in the domain of necessity. Sustain-ability extends action for 'the common good' beyond the human. The common good cannot simply be viewed and addressed anthropocentrically, or just in terms of 'the natural'. The commonality has to span the human and non-human, the natural and the artificial, the animate and inanimate *for they are all inter-relationally intertwined*. As a past neglected and futural ethical ground of politics, the sustaining ability of the common good cannot be accommodated into currently existing democratic politics as it functions to uphold the existing economic status quo.

Politically, there are but two current positions occupied by all forms of ruling political regimes: (1) a defuturing politics that refuses or neglects to fundamentally serve the common good and secure the well being of society as a whole – as this would weaken its grip on power; and (2) an expedient politics committed to sustaining the unsustainable (be it in the domains of the biophysical, social or economic) so it may continue to sustain itself. There has to be another way, a politics of sustain-ability wherein the futural and immediate common good becomes the overriding priority. *De facto,* there has to be a dictatorship of Sustainment. Let's be quite clear, this *is not* a statement of ecological fascism, but simply a forceful reiteration of the statement that 'without sustain-ability we have nothing'. It proclaims that it is not a matter of the imperative of sustain-ability being balanced with other political demands but rather that it rules them as sovereign. Without this rule, as with the rule of law, 'we' will have none of those freedoms that substitute for freedom *per se.* Lest the dismissal of democracy is thought to be shocking, there are two things to recall.

First, it should be acknowledged that what mostly travels under the name of democracy is not democratic. As long ago as 1921, Max Weber in 'Politics is a Vocation' (in his seminal book *Economy and Society*) powerfully argued that modern parliamentary democracy and its system of government, is inherently undemocratic.[2] Two years later his former student, Carl Schmitt, published *The Crisis of Parliamentary Democracy*, a radical critique, which returned to the moment of democracy's political birth.[3] Essentially the critique of both Weber and Schmitt centred on the ease with which the system of representative parliamentary democracy slid from representation of the interest of the people to those of powerful interests. Unsurprisingly, the tradition of criticism of democracy has been unbroken, and, in large part, is based on showing the sham that is masked by the name. Jacques Rancière's *Hatred of Democracy*, a polemic against the export of 'democracy' by violence, is a recent case in point.[4]

Second, democracy as we know it cannot deliver sustain-ability. The decisions that need to be taken to correct global structural economic imbalances; the sacrifices that have to be made to secure the common good;

and the speed at which industrial, infrastructural, educational and lifestyle changes have to take place – such things just cannot happen in a system in which the political options put to 'the people' are determined by the dictates of 'consumer sovereignty'. Such politics diminishes freedom to little more than making choices in a market place of competing products (of which 'sustainability' is but one). It follows that because this kind of 'democratic' politics turns on populist marketing, crucial challenges are absolutely avoided. The imperative to change, however, cannot wait for an uncertain moment of distant political enlightenment.

If the dictatorship of Sustainment arrives, it is not going to come out of a blinding flash that illuminates the true way ahead, an awakening of new political spirit within our political leaders, or a cathartic moment in which the existing political edifice is reduced to rubble. Rather its most likely arrival will be from an ever growing number of redirective actions from modest to major acts of practice that fuse into an unstoppable materialized force of change, to which the political regimes will have no choice but to respond. This moment, if it comes, will amount to humanity commencing another chapter of its worldly occupation out of the still unpredictable duration of 'the age of unsettlement'. We can characterize the current era in this way because not only is humanity starting to be physically unsettled by geo-climatic change, with an accompanying, slowly growing and wider psychological destabilization but also because institutional politics is increasingly disengaged from the forces that are shaping futures.

Redirective practitioners will certainly not be of one political shade, travel at the same pace or be equal in capability. The ability to cope with change will vary. Some people will adopt large ambitious projects, others will take small tentative steps, a significant number will resist. What counts is that a sufficient critical mass accumulates and advances towards the realization of the project of sustain-ability. At this point it is important to make two acknowledgements.

The first is that the ambition of redirective practice being voiced here, is no mere wishful thinking, but actually has a material basis. The idea of redirective practice is already in circulation globally. There are already architects and

designers who now think of themselves – and act as – redirective practitioners. There are students who see it as a desirable future career. And there are already redirective projects underway. Certainly, redirective practice has a very long way to go to gain the agency it needs but a start has been made and the idea and the activity can be claimed to now have a life of its own. The second acknowledgement simply wishes to make clear that while taking up the questions raised by the passing remarks made on democracy, these are beyond the scope of the task at hand, and are central to another project in progress.

Lest it be thought that design has slipped out of view, its presence begs re-affirmation. Design can be made a leader of redirection. Not by falling back into offering utopian forms that spark or express a spirit of a new age, a *Zeit-geist* – the error of the modernists – but rather by developing and adopting a diverse cluster of effective and strategically deployable actions within the remit of redirective practices.

Redirection, Ethics and Politics

What actually constitutes design-based redirective practice is going to be given considerable attention in the next two chapters. To establish the context for this, it is worth spending just a little time sketching a brief history of the idea.

The initial idea that underpins redirective practice is Aristotle's ethics and the philosophical tradition it instigated. Within this tradition, ethics is seen as embodied in a 'practical philosophy'. This does not mean a philosophy that completely centres on pragmatic and instrumental ends that ignore the objective of 'the good'. Within this philosophical tradition, ethics is not seen as just being enacted by a particular kind of subject – the individual who acts ethically. Rather, the subject is viewed as both able to direct, but also be directed by, ethics materialized ('the good' as things in action). This understanding allows us to grasp ethics in relation to the performative qualities of objects created and mobilized by individuals striving to transfer 'acting ethically' to

'ethics embodied in the way things of the world act in order to sustain' (which is taken as the baseline of ethics). This thinking enables us to recognize that objects, immaterial things, non-human others and environments can all be given ethical agency. And then equally, individual and collective subjects can be brought under the influence of and directed by the ethical as it is imbued in those material and immaterial things which are engaged by non-human and human, socially and politically formed collectivities. The highest level of expression of the collective, so ethically directed, is registered in the power of 'the constitution'.

The faith Aristotle posited with the constitution, as it unifies sovereignty, rulers and the political order of administration, has travelled to the present (via political theory) to spark new ideas of what a constitution is and can do.[5] This passage of the ancient to the present is graphically illustrated in Bruno Latour's notion of the constitution as 'a gathering of reality defining objects' that, via the mediation of 'the few' can inform the theory, practice and speech of political actors in general.[6] These remarks lead us to the ability to see connections between ethics materialized, redirective practice and ontological designing. This potent trio of forces can be brought to all those objects and things that populate the *habitus* out of which the subject is constituted. So while ethics can be directed by specific agents (like design or a constitution) it can equally be elemental to a milieu wherein individual or collective subjects act by dint of their combined active presence in a particular set of inscribed circumstances of only ethical options.

4

Design as a Redirective Practice

More now needs to be said on why and how design thinking and action need to change and what could trigger such changes. After outlining proposed changes, a case study illustrating some of them will be presented.

Notwithstanding design's intellectual and creative capital becoming increasingly technologically embodied, a lot of people talk about the need for design to change.[1] There is certainly a discernible mainstream drive that spans a range of activities (design management, product/service innovation and globalization), which is increasingly incorporating 'sustainability'. The whole project and rhetoric of corporate sustainability is, however, ambiguous. Sustaining the corporation and advancing 'sustainability' become fused with the result that, in most cases, the unsustainable is sustained (a common example is when the environmental impact of a single unit of production

is reduced while overall volume produced significantly increases, with the consequence that total impact goes on rising). The corporation thus claims its products are 'green', but any advance towards sustain-ability is negated by market growth. Another instance is when a product that humanity and the global environment could well do without, is 'greened' to give it a competitive edge.

Another demand-reactive mechanism of changing designing comes from the notion of user centredness. This can span an ergonomic approach that informs the development of product usability to notions of 'universality' or the 'emotional character' of products but without the fundamental environmental performance of the product improving. A far more intimate set of relations between corporations, design and 'the user' is established by the employment of anthropology (often in its most reductive ethnographic form) to get inside the user's life or head. Users are observed at work or home using products – this to gather information for product development or to assist in identifying situations able to prompt new product possibilities. Likewise, anthropology is also deployed to burrow into everyday life to disclose things like 'brand loyalty' and 'exactly what consumers want' (from products).

The changes just mentioned – corporate sustainability and user-centred design – are partly a reaction to another more longstanding change, which is the intensification of aestheticized design since the late 1980s, manifested throughout the rise of designer products, art typography, fashion as art and postmodern high-style architecture.

Framing Design as a Redirective Practice

Of course, the kinds of changes this book is exploring go well beyond those just noted. They are led by redirective practice, rather than it being the sum of these changes. Redirective practice elevates the seriousness, importance and futuring potential of design. There is a good deal to lose but far more to gain. It takes design beyond a disciplinary model. Currently design and architecture are regarded as disciplinary domains constituted from a number

of subdisciplines (architectural design and architectural science; industrial design and fashion design being representative examples). These disciplines exist within a rationalist model of divisions of knowledge and skills. Having earlier (in Chapter 2) put forward a critique of reason from the perspective of relationality, this now needs to be connected to the question of the adequacy of disciplines as organizational regimes of contained knowledge. Disciplinary thinking, by its very nature, is exclusory, and thus has a limited ability to comprehend and engage the relational complexity of unsustainability and the creation of sustainment. But the suggestion is not that we dispense with disciplines but rather they need bridging by a meta-discipline that facilitates an exchange of knowledge and dialogue based on a common language of engagement, while also amassing collective knowledge in their own right. This thinking is not the same as either the synthesis of 'multi-disciplines' or the dialogue of 'inter-disciplines'. Redirective practice names the meta-discipline. What redirective practice enables is a practical transformation of knowledge in action. In the case of design needing to be redesigned, it is not a matter of somehow abstracting this activity. Rather, it is a matter of having redirective practice in formation and process so that the redesign of design can occur in the course of working on a specific project.

As meta-practices, many practices can converge on, and subscribe to, the redirective agenda. In fact, any discipline with a prefigurative or analytical relation to the form and operation of the material world could find ways to create cooperative working relations with redirective action and redirective practitioners.

Certainly, redirective practice does imply the acquisition of some new knowledge – this to give more sustain-able purchase to a particular practice. Sustain-ability clearly demands new understanding and values as well as new professional and political alignments to neutralize the defuturing content of what one already knows and does. New knowledge gained in the frame of redirective practice can also bring greater authority to the application of one's practice, this not least because of the support gained from other voices speaking similar messages, and other practitioners delivering projects informed by the same imperatives.

Redirective practice has gone beyond merely being promoted as an idea; it is now in a formative stage. There are already people around the world who now think of, and present, themselves as redirective practitioners, and it is also now arriving in design education. It affords many possibilities, including establishing levels of cooperation across previously impossible economic, political and cultural divides. Above all, an agreement on the absolute imperative of sustain-ability provides the basis for a practitioner led creation of 'commonalities in difference'. So said, there is a baseline requiring general agreement on a number of fundamental points, between all who decide to be redirective practitioners. These beg a brief review.

The Redirective Base Line

Redirective practice brought to a design project means that associated activity may not just be confined to design, or that the only disciplines engaged to work on it will be design based or design related. What actually determines the knowledge deemed appropriate to bring to the project is what a relational analysis reveals to be needed.

No matter the designer or design approach, there has to be a willingness to accept responsibility for what is designed as unfinished and thus in continual process – this understanding, based on grasping that everything designed goes on designing, is an essential frame of ethical evaluation.

Understanding that design is political – which is to say that it always serves a particular ideological master (be it serving the political economy that underpins the status quo) – is a prerequisite for anyone wishing to redirect design. Likewise, and unambiguously, to evoke the dictatorship of Sustainment – is to evoke a political ideology that redirective practitioners cannot be equivocal about. Of course, as already implied, a word like 'dictatorship' rings alarm bells, conjuring up images of the actions of some of the most tyrannical figures of human history – this not what is being proposed. What is being suggested is more akin to the way capitalism, in its present hegemonic and all pervasive state, is experienced. It's important to remember here that hegemony (being

a dictatorship of the consensual) refers to imposition that is not perceived as such.[2] This is to say that the rule of capital is taken to be simply how the world works. Yet as measured against the historicity of humanity's earthly presence, capitalism is a very recent phenomenon with an unknown duration. Even when this observation is intellectually understood, it mostly escapes existential recognition.

Such qualifications do not dilute the stark reality of the politics of change towards the Sustainment – it has no moderate or balanced position. It's change or nothing. Sustainment has to dictate; it has to be hegemonic. At the same time, the path to the Sustainment is neither singular, nor straight. Neither is it to be followed under the direction of politically correct dictates. Like 'freedom', 'justice' or 'equity', it is illusive, abstractly known, felt and sensed as the other of its opposite, but nonetheless ranks as an absolute political objective.

The problems that redirective practice confronts are never simply handed-down or handed-over problems. They are certainly never just design problems. Likewise, design is never just 'a problem-solving activity' (the most exhausted cliché of design theory). Rather the first act always has to be to actually identify what the problem is, from the basis of causality rather than by trite definition. This cannot be predicated upon the problem being assumed to be a design problem. To stand any real chance of actually disclosing the causality of a problem, a circumstantial analysis has to be engaged relationally. There are a number of key analytical questions essential to the task of redirection. Fundamental among these is asking and answering the question 'what, in this context, is unsustainable?' Unless this is disclosed, nothing is solved. Thereafter, it becomes possible to determine if and how design can contribute to the delivery of a solution.

No matter the name it ends up travelling under, all architects, designers and their clients will end up with the stark choice of embracing redirective practice or giving way to defuturing – the negation of time. Redirective practice, as expounded here, is akin to a new kind of (design) leadership, underpinned by a combination of creating new (and gathering old) knowledge directed at advancing means of sustain-ability while also politically contesting

the unsustainable status quo. More than this, the directional impetus of redirective practice has the ability, through working in difference toward a common aim, to catalytically constitute a 'change community'.

Designing-in-Time

Designing in space is totally familiar across all three-dimensional design practices, but designing-in-time is not. To design in time is not to claim an ability to see into the future. Rather it involves examining in detail what is likely to, or could, shape future positive or negative possibilities and thereafter deciding what should, or should not, be factored into design activity on a precautionary basis.

Designing-in-time directly challenges architecture and design's failure to realize that we humans have a finite future and that the duration of our existence, notwithstanding a mass catastrophe, is decided by how we act in making a place for ourselves in the material world in which we exist. Historically, a great deal of the unsustainable has arrived by design. We humans constantly defuture our futural being by design and in so doing we sustain the present and sacrifice the future.

Against this backdrop, there is an overwhelming imperative to create a powerful futuring counterforce that embraces the fact that the fundamental change, upon which our very future depends, the change toward sustainment, cannot occur without design.

What now follows is a case study of early redirective practice thinking-in-action. While it only indicates how some of the intellectual tools have been applied to a specific project, it aims to show that they do have transformative agency.

Case Study: Sustainment and Boonah Two

Much of the ability of redirective practice will come from developing the *nous* and skill to redirect a brief from a client. This ability will be one of the key means of enabling redirective practitioners to survive and even flourish in the market place (the conceptual tool to do this is 'the return brief', which will be discussed in a later chapter). With the brief of a design competition, there is often more leeway to be 'creative' and non-compliant. But in both cases, the main point to be made and illustrated centres on taking a brief and redirecting it toward sustainment.

'Boonah Two' was an award-winning submission to an international concept design competition – Building a Sustainable World: Life in the Balance – organized in 2007 by the Royal Institute of British Architects/USA – California Chapter.[3] The submission was a joint one from Gall & Medek (a Brisbane architectural practice) and Team D/E/S (a South-East Queensland-based sustainment consultancy of which the author is a director). The design team was drawn from both organizations. The competition attracted entries worldwide, resulting in twelve finalists from eight countries coming together. The competition brief offered several options, and the one chosen by the joint team, was to design a 'sustainable city' for 50,000 people.[4]

The design team took Boonah, an existing town, as its starting point. Boonah is a small Australian cattle and farming town of a few thousand people in South-East Queensland. It is an hour south-west of Brisbane via a good arterial road. It is on the eastern slopes of the Great Dividing Range, 100 km inland and located in a shire with good soil and a viable catchment. Its location offers protection from the more extreme coastal weather (an important factor in the future) and from the increasingly hot and dry weather of the west. It was selected because it is exactly the kind of place that would be deemed appropriate for 'resettlement' by people abandoning areas exposed to the coming climate of the coast (cyclonic winds and rising sea levels) and the western interior (increased heat in an already hot region, accompanied by less

8 Boonah Panorama

9 Boonah Farmscape

rain). Resettlement in Australia is not a future prospect but a process already underway.

The name Boonah Two was inspired by some lines from B.F. Skinner's book *Walden Two* because of their resonance with the present. In 1976, Skinner, writing on the American way of life, said: 'Not only can we not face the rest of the world while consuming and polluting as we do, we cannot for long face ourselves while acknowledging the violence and chaos in which we live.'[5]

The exercise carried no claim of seeing into the future, although there were some certainties (like the fact that everybody in Australia is already experiencing the increasing consequences of climate change). Of course, the uncertain always remains imminent; however, what the approach asserted was the necessity of a very broadly based and highly informed precautionary design approach. The intent was to put experientially omnipresent forms and structures in place, including 'learning environments' that would dramatically increase the ability of the city to sustain itself and in so doing advance sustainment in general.

10 Boonah store

The Approach

The competition brief required the design of a 'sustainable city'. This was viewed predominantly as a city made self-sufficient by sustainable technologies, especially in terms of water, waste and energy. Boonah Two's approach accepted this requirement, but took it further to conceptualize the city within the frame of Sustainment. This meant addressing not just the built form of the city but also its economy and governance. Likewise, the entire biophysical operation of the city was conceived as a 'metabolic model'. The form and daily life of the city were envisioned to be deeply implicated in the creation and maintenance of ways of working and living in which the objective of sustainment infused social interactions, the form of governance, the nature of education, leisure and pleasure, plus care for people, services, the natural and built environments. The methodological means to bring all the design objectives together turned on designing-in-time. A fifty-year timeline was set, from which to 'design from the future to the present'.

Such designing-in-time generated a substantial research exercise of probabilities, like climate change impacts, social and environmental needs, population redistribution, technological change, and so on. In turn, this research informed the writing of a year-by-year scenario for the fifty years. From this, design tasks were designated to cope with the potential risks and problems identified. Crucially, these tasks were commanded by two imperatives: those things needing and able to be redirected; and, that which needed to be newly introduced.

Theoretically, two ideas underpinned the total approach: (1) designing things that perceptibly ontologically designed (that is: the designing of the structuring of structures of *habitus*), and (2) designing relationally. The initial aim of entering the competition was to learn how to deliver these ideas via redirective practice; as such it was a 'professional development learning exercise'.

I I Boonah main street

Design Elements: A Brief Review
So far in this account the content of Boonah Two has remained rather abstract. To correct this, what follows is a review of some of the key design elements and the thinking that underpinned them. All these elements figured in the 'designing-in-time' fifty-year scenario. Their presentation was a fusion of researched information, creative writing and design.

Designing a Metabolic City
The transition from the existing settlement of Boonah to Boonah Two was conceived of metabolically. This was not restricted to the biological. Besides organic matter, a city inducts and excretes inert materials, goods, services, information, images, cultural forms, people and more.

Designing a metabolic city requires the city to be established and managed as much as possible within the immediate catchment of its settlement. The city has to be directly connected to its region's ecological carrying capacity and natural resources (like water, soil, biodiversity). This also means identifying the number of people that the catchment can support. The form of the city,

the goods and services it employs, the human capital it selects and recruits, the industries and business it attracts or creates, the cultures it forms – all are essential to create and maintain its metabolism. A metabolic city has to have the capability to largely sustain itself and adaptively self-reproduce rather than just grow in size and impacts. It has to spawn another city that functions in the same way but with the ability to adapt to a different catchment and population.

Base-level self-sustainment for a metabolic city means sustaining the food, energy, water, waste infrastructure, common utility materials and cultural needs of its population without defuturing its catchment. The move from Boonah to Boonah Two included retrofitting the catchment to make it largely self-sustaining in terms of food, energy, water and common utility materials. From such comparatively high base level of self-sustainment, all growth would have to equate with improved performance upon this base.

Here is a range of examples of the design strategies to deliver the metabolic base of the city. It should be noted, in considering these examples, that most areas of Australia already have major water shortages, with many large cities being on the highest level of water restriction. Equally, there are small towns where all the water has to be trucked in. During the first decade of the twenty-first century the nation has experienced its worst drought in some areas, it is claimed, for 1,000 years. At the same time, extreme weather events – cyclones, flash floods, hail storms and bush fires – are becoming more severe and frequent.

Feeding and Watering the City

The design imperative to feed the city can be significantly assisted by the development of foodscapes. Central to their creation is making the conservation of agricultural land a major priority within an overall 'geological and topographic good land use management plan.' Such a plan would not only integrate rural and urban food production to maximize local food production and reduce 'food miles' but could also make a major contribution to the growth of local employment. It would take into account protection of crops against extreme weather in relation to planting, construction of wind breaks/shelters,

and the design and construction of fabricated structures, including for hail protection.

The plan would consider water catchment to maximize topographic surface and subsurface water movement advantage, as well as harvesting rainwater from built structures. All stored water would be covered to eliminate evaporation. Experimental means of water conservation, like the use of condensers, would be explored. Likewise, all urban landscaping would be designed for ultra-low water requirements. Commercial and domestic water consumption would be regulated.

Climatic Defensive Architecture

All of the city's architecture would be informed by this mode of design which seeks to (1) protect and adapt existing valued built structures from likely environmental and climatic impacts; (2) protect human life, the natural and artificial means that sustain it and its interdependent life forms; and, (3) protect and conserve vital resources (this includes civic, commercial and domestic dwellings, their ability to harvest water and function within energy and communication networks). Responding to increasing fire risk in Australia (both frequency and intensity of fires), measures would be taken to protect the city against fire. This includes: the encirclement of the city by a fire barrier several hundred metres wide (constructed from a low-grade paving material, like slag) and the design of the water supply to facilitate comprehensive fire fighting.

Construction Methods

The setting up of a local, flexible and sustainable commercial and domestic systems buildings industry was adopted as a key means to: (1) establish the short term core of a nascent local economy as a catalyst for social and econ-omic development; (2) provide the basis of an industry with long term potential to contribute to manufacturing and exporting Rapid Assembly Sustainable Structures (RASS); and, (3) enable a convergence of the efficiencies of industrial production while reducing transportation energy and financial costs of such a materially intensive project.

Combined with the design methodology for the city, the RASS approach and many other elements of the design strategy, aimed to make Boonah Two a nationally and internationally exportable model of a sustain-able city. The design methodology was not based on a specific master plan but rather, on a series of interconnected design principles together with the means of their material realization. Thus exportable cities would be created in similar ways but have varied forms. At the same time, the model is not universal – it would not, for example, be appropriate for cold climates without major modification.

Providing Power

The competition brief required the city to generate all its own power. The Boonah Two submission's approach was two-staged and based on upfront demand reduction. Thus as much infrastructure and as many commercial and domestic buildings as possible would be designed with low energy-load requirement. Phase one would introduce a mixed palette of currently available renewable energy technologies like wind power, biomass and photovoltaics. Boonah has good solar radiation, its wind speeds make wind turbines feasible (especially the bladeless silent spiral type designed by the Finnish Windside company) and there is locally available biomass. The second, overlapping stage would be to phase in solar thermal and geothermal electricity generation. Some of phase one would remain in localized situations, some would be phased out (in 10–15 years) and a network of grid connected solar thermal and geothermal systems would establish the ongoing generation system. These later 'state of the art' technologies – solar thermal and geothermal, being of a larger scale and of greater efficiency would be able to provide the energy load for the city's total population. Moreover, such forms of power generation would deliver an ability to export power (in turn this would offset the embodied energy of materials and goods imported into Boonah Two).

Social Participation in Sustainment and the Celebration of Cultural Innovation

Social ecology (social inter-connectedness and the forms of power that bring vitality) and a 'culture of sustainment' are as much crucial elements of the

sustainable city as material fabric and technologies. This equally requires a great deal of design effort – not to give form but to facilitate it coming into being.

Against this backdrop, social and democratic models of redirective design development were envisaged to place the existing Boonah community and 'newcomers' in positions of power so they would have a design investment in what would need to be sustained. This activity would be an important part of the redirective process of integrating the old town into the new city. Culturally innovative ways of developing a culture of 'care' as the basis of Boonah Two's social ecology would be pursued. These would enfold 'care' – for the self, for other people, for things, the biophysical and the built environment. The actions to realize this would feed the pervasive ethos of a city wherein the 'common good' would be clearly perceptible.

Conclusion

A great deal was learnt by all involved in working on the Boonah Two submission, especially in the identification and management of complexity. Doing well was a big bonus for the design team. Designing how to design a city of sustainment, so that it, itself, becomes a means of design – this was the essence of what the process added up to. While it cannot claim total success, it was a very constructive and productive opening into a different way of designing.

Boonah Two was a large and complex project, so only a fraction of it could be characterized here. In turn, it is part of a larger exercise of 'proving' the power of redirective practice. Interestingly, exactly the same methods were employed by the design team for a later competition – the design of an eco-tourist resort in Western Australia. The result was the same – the submission won an award. The ideas have legs!

Finally, it should be noted that it is very unusual for a submission to an architectural competition to be based on process and text rather than on images. Seductive images and monumental forms almost always win the day, so it quite remarkable when an entry based on process gains an award.

BOONAH 2 - MAJOR ZONES

Supplementary Case Study: Sustainable Urban Housing in Fiji

This short case study is of the winner of the same competition (Building a Sustainable World: Life in the Balance, RIBA/USA, 2007). The entry was submitted by Toby Kyle, a British architect and Chris Cole, an Australian architect

both of whom worked for Kamineli Vuadreu in Fiji. In one sense, as a very practical, modest and immediately realizable project it makes an interesting foil to the complexity of Boonah Two. Yet it also carries another powerful message of redirection.

Among the considerable number of serious problems a Pacific nation like Fiji faces, the project addressed five: (1) housing shortage, especially in terms of affordability; (2) the deteriorating condition of the fabric of the housing stock; (3) shortage and high cost of building materials; (4) frequent and potentially increasing exposure to extreme weather events; and, (5) economic underdevelopment and a lack of employment linked to a small national skill base. Responding to all these problems in a site specific way, Kyle and Cole put forward a concept that linked the design of structures to the development of a micro economy.

Part of their selected site was allocated to grow bamboo. They designed a series of high density medium rise apartments with these structures to be surrounded by the bamboo cropping areas. Large arched open plan buildings, to accommodate individual and collective workspaces, were added as the third element of the project. These working space buildings were interspersed between the apartments and placed on the edge of the cropping areas. The external and internal space planning of the project aimed at meeting both the contemporary economic and traditional cultural needs of the community.

To give the structures the ability to withstand very high wind speeds during extreme weather events they were designed with steel frames (the supply of which they gained from sponsorship from an Australian steel maker). All cladding and infill material was conceived to be supplied from the site grown bamboo. Besides the cost-effectiveness of this strategy, it also meant that any weather-damaged material could be replaced easily. The concept, in relation to structure and materials, was thus based on two seemingly contradictory design principles: permanence and sacrifice. At the same time, the community was seen to be able to be economically sustained by making products from bamboo to sell in and beyond local markets. This could be done sustainably because the manufacture of products could be aligned with the supply of bamboo as it is a rapid regrowth crop. So, in all, the adopted approach can

be seen as a local model of relational thought and solutions able act as an exemplar of redirecting local construction and economic practice in the Pacific Islands and perhaps elsewhere.[6]

======

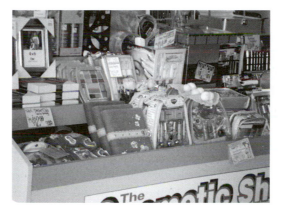

13 Waste in waiting

5

Reviewing Two Key Redirective Practices

Following on from looking at how design can be reframed and connected to redirective practice, we now consider two examples of particular design-based redirective practices: elimination design and recoding. Both of these practices can be appropriated and employed by all design disciplines.

Designing Nothing: Elimination Design

Walk into any 'crazy bargain' superstore in any big city anywhere in the world and there will be aisles stacked with 'stuff', most of which will simply be delayed landfill – products that are badly designed, often badly made, frequently from shoddy material, some for dubious uses and with almost all

having a short life expectancy. Umbrellas that will last to the first gust of wind, toys with two days of play in them, travel bags with zips that burst on the bag's first filling, cheap tools not up to the job – we have all bought such things and dumped them. Tragically there is a whole 'dollar-a-day' segment of humanity making these things or buying them because they cannot afford anything else. Here, then, is a straightforward case for the elimination of a whole swag of manufactured goods that then folds into the more complex issues of quality replacement and alternative forms of employment. The key question thus arises: 'on the basis of a clearly identified overall contribution to extending unsustainability, what exactly should be eliminated?' Answering this question unavoidably means making a judgement between short-term socio-economic gains and longer range impacts. In turn, this task divides into two distinct forms of evaluation: an identification of the absolutely unsustainable; and an identification of the contextually unsustainable that is able to be redeemed in some way.

Design, in the company of many other practices, is dominated by the idea of creation: its practices, in large part, exist to bring something into existence; in so doing what is destroyed often gets overlooked. 'Sustainable design', with its preoccupation with 'green products' and 'green buildings,' is no exception to this productivist disposition. Actually asking whether the thing to be designed is really needed, is just not a question in the forefront of most designers' minds (be they 'green' or not).

There is no doubt that the likes of cluster bombs and land mines, chorine-based paper pulp mills, children's toys made of PVC, the clear felling of forested hillsides, building products containing toxins, and 'big boys toys' like jet skis, should all go. Likewise, chemical technologies that directly damage the genetic structures of plants and animals and harm natural environments; industrial processes that discharge pollutants into the air or water; food manufacturing processes that use additives that harm health – such products and processes, rather than being viewed relativistically and then regulated, should either be made totally benign or eliminated.

Many processes, materials and products could be designed out of existence from within their industries, for example building materials that use urea-based

bonding agents (formaldehyde off-gassing)). Others (like herbicides and pesticides with a long residual soil life) will only disappear if eliminated by legislation. Eradication by public education and strategic media campaigns is also warranted – just as smoking has been 'branded' as anti-social as well as unhealthy, so too could 'CO_2 emissions-excessive' activities like 'gas-guzzler' cars and gratuitous air travel ('jet-setting' around, whimsical pleasure trips, business trips to deal with matters that could easily be dealt with by a telephone or video conference, and so on).

The contextually unsustainable is a different story. Here we are talking about situations where the redirective practitioner can actively engage 'end

14 Mower time

users', markets and producers. The meta-design framing of this activity is often habits of lifestyle or working life. Elimination here encompasses a spectrum from total erasure, cutting out specific elements, cutting down the use of a material or product to maintaining an activity via another means. Mowing lawns provides a simple illustration of such ways of thinking and acting.

Consider a family home in a suburban street with a fenced backyard, a third of which is paved and the rest is grassed. There are also a couple of fruit trees and a modest timber tool shed in a corner of the yard. The small front garden consists of some crazy paving, a bird bath and a couple of flower beds. While no gardening competitions are going to be won, everything is neat. On a regular basis the motor mower is taken out of the shed and whipped around the backyard and the nature strip at the front of the house between the road and the pavement. The job takes no more than three-quarters of an hour and that includes tidying up, brushing off the mower and putting it away.

Elimination option number one is simply to replace the motor mower with a modern lightweight version of an old-style push mower. Certainly, the job takes twice as long, but there are payoffs: the man and woman of the house (they take turns at mowing) have some additional needed exercise and there are no CO_2 emissions.

Elimination option number two is more radical: the motor mower is still exchanged for a manual model to deal with the nature strip; additionally, the grassed area of the yard is dug up, as is the front garden after the paving is removed. Vegetables are then planted and a small rainwater tank is installed on the paved area of the backyard – this for garden watering and toilet flushing. Growing veggies in the front garden, besides increasing productivity, makes a statement to neighbours. It may not sound dramatic, but just imagine the reduced impacts, cost savings and culinary benefits, if such action became 'fashionable' among the suburbs of the 'developed world' (a great deal of the world's poor already know how to produce food on urban land).

Another very different example of elimination-based redirective practice goes to interior designers/architects joining forces with fashion designers to eliminate 'power dressing.' The proposition here is that people working in

offices should dress according to climatic conditions. Having the heating and cooling systems of office buildings set to deliver 22°C all year around so that men in suits will be thermally comfortable is simply energy irresponsible. Temperature settings should be based on people dressing according to the weather.

Staying with the issue of thermal comfort and climate change, consider that as many parts of the world grow hotter a vicious circle will ensue. In brief: the hotter it gets, the more air conditioning will be installed and used, the greater the energy load and emissions from the combustion of fossil fuels. Ideally, renewable energy should be used to break this cycle, but corporations and governments around the world fail to grasp that the cost of not doing this is greater that the cost of doing it – a lost future cannot be bought back! Pragmatically, neither enlightened energy policy nor large scale renewable energy generation is going to arrive quickly, thus another course of action based on 'demand reduction' is needed. Forms of air-conditioning that can, for example, be uncoupled from a building's power circuit and reconnected to a stand-alone renewable energy source; external insulation or shade to lower the temperature of a building's thermal mass (and so its cooling load); changing the building's use pattern – there are many options for both domestic and commercial buildings. The products to make these actions happen are already on the shelf and ready to go!

There are many design-based redirective practice opportunities for industrial designers, architects, building services engineers, interior designers and fashion designers to work on collaboratively. These opportunities link to the enormous number of problems of the unsustainable that can be addressed by low-impact technologies, products, services, modified work practices and transformed lifestyles. Adopting an elimination perspective can be a key to opening up these opportunities. Heat harvesting, wearable technologies, climate adaptive architecture, materials recovery technologies, postindustrial cottage industries, social ecology based organizational redesign – these opportunities can take many forms.

Generalizing the Question of How

Design for elimination cannot be based on a nice, neat checklist. Action is too dependent on the specifics of the analysis of what is to be eliminated, the contextual situation and available resources. So said, there are some general approaches that can be 'keyworded' and reviewed to take the thinking forward, these are: *erasure of 'need' by exposing it as a fabricated want; functional substitution; product multipurposing; dematerialization and rematerialization; symbolic devaluation and the destruction of sign value; and prohibition.*

Erasure of 'Need' by Exposing It as a Fabricated Want

'Needs' are created within the cultural world in which we as individuals come into being – our *habitus*. The power of this structuring can be sufficient to overpower biological urges (for instance, in spite of the instinct of self preservation people die for causes, the incest taboo carries great sexually repressive force and the starving seldom resort to cannibalism). In contrast, 'wants' arrive throughout our lives as the world passes before us in all its natural, televisualized and commodified forms. We fill our minds, homes, leisure time, garages, vacations, social and sexual relations with wants. So many of these wants we take to be needs – the big house, the fast car, the plasma screen TV, fine wines, the pearl necklace, the designer suit – up and down the socio-economic scale, such lists are the stuff of dreams and indebtedness. Sustain-ability has to be a means to make a rift appear between wants and needs. A simple way of life has to be broken free of the mantle of Puritanism – the ethical imperative, the pleasure and virtue of 'living a simple and moderate life' begs being seen as the normative model of all human being toward the future[1] – it is the only way we can continue to be! Social justice has slid from idealism to necessity.

Functional Substitution

This elimination process centres on the displacement of high impact technology by low impact technology, as with the example above of substituting a motor by a push mower. The resurgence of pedal power (be it servo-assisted and applied to load carrying commercial tricycles) is another example. There is great deal of design potential in reconceptualizing existing, past and forgotten technologies. The basic question to bring to this challenge, be it in the workplace, kitchen, laundry, garden, or transport related, is obviously 'what can I, as a user/designer, find or conceive of, that can displace an existing technology by a low impact alternative?'

Product Multipurposing

There are many single function technologies that beg to be perceptually reconceived so they may be materially transformed by design. Consider these simple examples: we grossly under use the heat of space heaters; we do not capture and use waste heat from cooking or from refrigerators; we use potable water for non-potable purposes (like flushing toilets) while wasting kitchen and bathroom grey-water. The point is: the way things are, is not necessarily how they should or could be.

Dematerialization and Rematerialization

Some of our activities invite being dematerialized. The most oft-cited example is the elimination of a great deal of printing paper in the office and home. Computer technology retains the potential to do this, while printer technology negates this potential. But what about dematerializing Christmas and birthdays by saying it in words and music rather than by gifts that many of us do not need or even want? Reducing the household and travel carbon footprint is perhaps a more acceptable option.

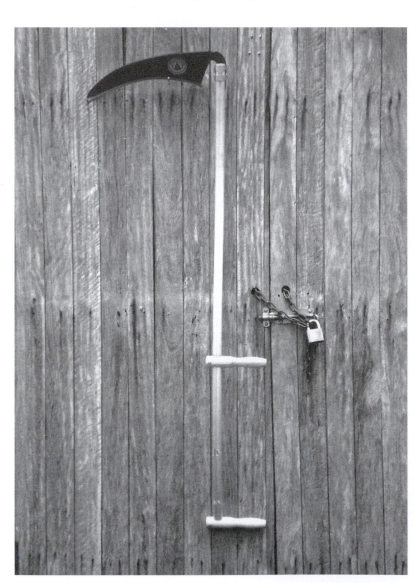

15 The scythe rematerialized

Rematerialization is predominantly the substitution of human labour for machines in a smart way. The scythe is a good example. This was once a well-used farm implement. As other technologies arrived it fell out of use for large-scale harvesting and then for minor grass-cutting tasks. However, the scythe has been reinvented – it is now a lightweight, well- balanced, ergonomically designed object with a finer, high-quality, thin steel blade. Not only can it re-place the two-stoke motor-powered brush-cutter for a significant number of jobs but it actually does a better job!

Symbolic Devaluation and the Destruction of Sign Value

The number and type of commodities based on sign value have dramatically increased in the past few decades. This has been most evident in the rise of designer products, branding and attempts to fuse emotion and brand loyalty. In this market-contaminated culture, the power of the logo decimates utility. While sign-value has been a major motor of capital accumulation and thus of escalating unsustainability, it has a flip-side – it is vulnerable: if the cultural value of the commodity is destroyed, then the desire for the product disappears. Such action (the willing of cultural devaluation – see 'recoding' below) is warranted if the product is unambiguously unsustainable. And it's not hard to find target examples, from soft drinks to tourist packages, from 'sports' vehicles to cosmetics. Having said this, the elimination of the unsustainable by symbolic devaluation should not just be seen in terms of commodities. Such action may be equally directed toward perceptions, values, behaviour and attitudes.

Elimination by the destruction of the symbolic meaning of the *de facto* un-sustainable renders the desirable undesirable and exposes art as artless and the-thought-to-be-wanted as unwanted. Above all, it demonstrates the ability of immaterial action to overpower powerful negative material consequences. As we shall see in a moment, recoding is one of the most powerful means we have available to do this. Conversely, the sign value of much that sustains can be significantly increased.

Prohibition

Although mostly outside the realm of design, elimination by prohibition requires to be acknowledged. There are industries, products and services which should be legislated out of existence. Foundationally, there is no freedom without sustainment. Freedom of market choice is subordinate to this primary condition.

In sum, design for elimination demands working oneself into a way of thinking and questioning that expands redirective practice's design possibilities. This thinking also has two immediate existential implications: first, is the arrival of the realization that elimination is always a political and ethical issue that inescapably centres on acts of judgement; second is the acquisition of a voice that continually whispers in one's ear – 'what can I eliminate?' This question is, of course, inseparable from 'what do I value?'

16 Stamping out

Recoding

As a practice, recoding centres on the transformation of the sign value of objects, images, structures, spaces, services and organizations. As such, it has a relation to, but is more than, the elimination practice of 'symbolic de-valuation and the destruction of sign value' outlined above.

The contemporary idea of recoding emerged out of modernist art practice during of the nineteenth century. This was seen, for instance, in the proto-cubism of Cézanne, the perspective of 'new objectivism' in painting and photography and in the arrival of the collage and photomontage as they mixed media. The intent was to adopt a viewpoint that prompted a different way of 'seeing the world' (as with the panoramic bird's eye view of a Paris boulevard by photographer Adolphe Braun in the late 1860s) or the creation of collisions of meaning that disrupted the representational order. In the early twentieth century these developments were given a political edge by Russian Constructivism, taken to another level by Dada, as is evident in the 'readymades' by Marcel Duchamp (e.g. Fountain – a urinal – 1915). Coming out of Dada, the practice of recoding was made more politically strident by John Heartfield through his anti-fascist photomontages of the 1930s. Subsequently, the practice scattered in various directions, marking the work of the likes of Andy Warhol, and an entire gamut of post 1950s conceptual and political artists – Joseph Beuys, Hans Haacke, Barbara Kruger, Cindy Sherman and many more. Recoding broke out of the art gallery and entered the public domain in three particularly important forms: the billboard (via specific works created for billboards and by the use of well-conceived graffiti to disrupt advertising messages, the latter often undertaken by organized groups like Ad Busters and by individual artists like Barbara Kruger); photo-images projected onto buildings (a practice especially associated with the polish artist Krzysztof Wodicizko) and as a street practice (such as the activities of Situationists in Europe in the late 1950s and 1960s, who set out to fuse art and political protest and in so doing prefigured punk subculture of the 1970s).

Although the actual term 'recoding' strays across a variety discourses, esp-
ecially engineering, genetics, information technology and visual communi-
cation, it was prefigured as a cultural politics to gather a range of contemporary
art practices, by Hal Foster in the title of his 1985 book, *Recodings: Art,
Spectacle, Cultural Politics.*[2]

Despite this diverse history, recoding as a cultural practice never acquired
a clear conceptual project. It has been appropriated pluralistically and by
forms of cultural politics that often folded into hollow gestures. Recoding as a
redirective practice is the obverse of this history. It has two clear objectives:
the exposure of the unsustainable; and the declaration of means of Sustain-
ment. No matter who takes this action, in whatever medium, at whatever
scale and place, adherence to these two objectives unify the *praxis* – the
political intent is clear.

Notwithstanding its long history in art practice, recoding as redirective
practice directed by design has enormous developmental potential. It is de-
ployable in relation to graphics, products, buildings, spaces and fashion. At
the same time, it opens up the possibility of new kinds of collaboration across
culturally based disciplines. To better understand the potential of recoding,
let's look at an example of the kind of 'target' to which the practice could be
directed: the Olympic Games.

The Olympic Games begs global exposure as a major instance of a cascad-
ing unsustainable event and perpetual construction project. No matter that
there are now numerous Olympic venues globally, every day somewhere,
there are contractors building the usual cluster of evermore ambitiously de-
signed Olympic facilities. It is the nearest thing the international construc-
tion industry has to perpetual motion. The emissions associated with the
manufacture of materials, their fabrication and eventual use are huge but
equally so are those from transport, especially air travel. One of the sponsors
of the Sydney 2000 Olympics conducted a lifecycle analysis of all the energy
inputs of the Games and found the largest source of emissions was the air
travel.[3] Relationally, the impacts merge with sponsor activity: the Olympic
Games is the biggest branding show on Earth. Likewise, it is the normative
event for the proliferation of legal and illegal performance-enhancing drugs,
as well as being an iconic security nightmare.[4]

The sporting and entertainment ends simply do not justify the unsustainable means. Now no matter how much time and effort is expended in critiquing the Olympic Games, it is doubtful if it would make the slightest dent in the resolve of the Olympic movement to continue the event. However, the impacts of the Olympics are so monumental that they provide a compelling case to recode its current form as something that is massively destructive rather than being the 'pinnacle of sporting achievement'. Such recoding could additionally go to how the Olympics are organized and conducted – it just might be possible to reconfigure and transform it! Imagine the Olympic Games decentred across a constantly changing number of existing venues. This would eliminate the need to go on endlessly building; dramatically reduce its status as a 'mass-event' terror target and facilitate around-the-clock live-to-air television coverage. Unquestionably this scenario offers numerous positive recoding possibilities that retain the nexus between sport and pleasure but recast the entire event within a frame of responsibility appropriate to the age.

Recoding and Specific Design Practices

While recoding can be adopted by all design practices, it is graphic design that affords it the greatest opportunities. However, this has not been generally recognized within the subdiscipline. In fact, graphic designers have predominantly taken up 'green design' simply at a material level. They have sought to reduce the obvious impacts of print production by specifying recycled papers, dry or water-based print processes, soya-based inks and so on. A major reason for this limited type of action is clearly because recoding, especially in the context of elimination for sustainment, is an action mostly outside the conventional provision of services to a client, unless that client happens to be, for example, an environmental organization. The implication is that graphic design needs a cultural politics extending across print and electronic publication if it is going to take the challenge of the unsustainable seriously. Now, obviously, not many graphic design practices are going to rise immediately to the challenge but the signs are that some will (in fact, some already have).

Significantly, the critical mass of graphic designers needs to firmly lodge recoding in their repertoire of practices. They do have the ability to break ground, as illustrated by the influence of Neville Brody's typography in the 1980s, and his association with the British magazine *The Face*[5] – which is regarded as one, if not the, most influential magazines of the 1980s in terms of design and the number of imitations it spawned. In fact, recoding bonded to 'redirective projects' has the potential to radically change the social relations of graphic design, with commissioned recoding recasting the character of the client, producer and product.

Industrially, design products, material or immaterial, are also signifying objects – they are signs. It follows that that they are equally available to be subjected to recoding. In actuality, recoding is part of the very rise of both industrial design and architecture. Modernist design notions like 'form follows function' and 'truth to materials' were based on the semiotic claims of objects to be able to communicate such expressive assertions (they in fact only did this for people inducted into familiarity with these design codes). More specifically, the rise of industrial design was deeply implicated in the streamlining of products in the United States in the late 1920s, 1930s and beyond. Effectively, what streamlining did, was to give existing technologies new sign values that recoded them as modern and desirable.[6] Office technology, phones, cars, cookers, refrigerators, trains, aircraft and even ships and buildings were all stylistically transformed via this economically directed recoding practice. The enormous success of this enterprise was one of the main triggers of contemporary 'consumer society' – a key driver of the unsustainable.

The challenge now is to invert this history and make products that functionally contribute to sustainment and that have a sign function that corresponds to their performative qualities. This cannot be merely more niche-marketed 'green products'. Rather, the imperative is to create 'products that self-sustain' (themselves and/or via their users) and in so doing, contribute to sustaining ability in general. This objective cannot be reached via individualistic designers expressing themselves through: uniquely styled objects; a stylistic movement or moment (as with streamlining); or through a return to the 'plain

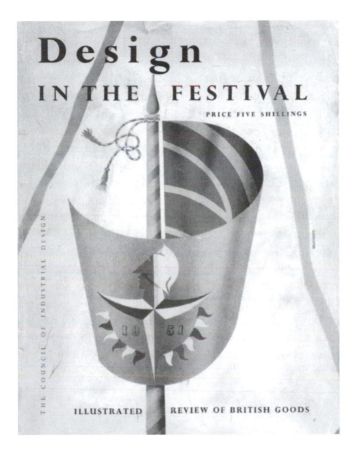

and simple' of the utility goods and furniture of post-Second World War World Europe (the Festival of Britain of 1951 being one of the national 'showcases' of this style). Rather, it requires the creation of product appeal based on the standardized and elegant simplicity of well-made objects that can either have a long life, be economically retrofitted, or easily recycled (without the material always being down-cycled to lower grade uses).

Many of these remarks on industrial design equally apply to architecture. Much architecture begs to be given a very different sign function. The grip of signature stylistics that has dominated recent decades needs breaking. There are, however, two differences that architecture has to take into account: the unfolding of climate change (which will have profound consequences, not least the need to provide much higher levels of climate protection) and the increased criticality of the placement and scale of what is built (because of the way that climate change will induce population redistribution, as many densely populated parts of the world become inhospitable due to increasing heat, diminishing rainfall or inundation from rising sea levels). How buildings are constructed and from what materials; how they are serviced; their size; the amount of energy it takes to build and run them; their design life and designed fate; urban retrofitting – these will all become more important factors.

Fashion offers many possibilities for recoding-for-sustainment. Fashion design has yet to realize the challenge of climate change – the thermal comfort of clothes has got to be given far more attention, and this functionality, of course, has to be given aesthetic expression. As said, power dressing has to be designed into oblivion – the thermal comfort levels of air conditioned office blocks just should not be based on men in suits. Relational thinking quickly indicates the connection between power dressing and building power uptake!

Case Study: The Rematerialization and Recoding of Food

The rematerialization (that is: the 'smart' substitution of human labour for machines) of food production is totally at odds with techno-scientific indus-trialized agriculture. The reasons why this industry often leaves environmental disaster in its wake are many, including: soil erosion associated with broad-acre land clearing; large-scale irrigation reducing river flows; chemically charged runoff from fertigation damaging aquatic ecologies; monoculture farming reducing biodiversity; chemical fertilizer intensive farming resulting

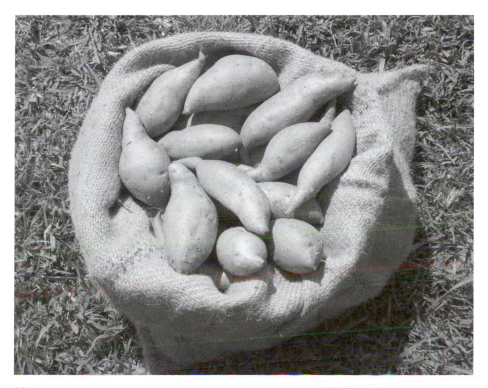

18 Part of the sweet potato crop

in poor soil health; and the still-uncharted long-term dangers of the genetic modification of plants. All these practices and more arrive, with the claim to be a response to the global imperative to 'feed the world', which scientists tell us has to quadruple to meet the needs of a growing global population.

Unambiguously, agriculture that advances sustain-ability requires food production regimes that sustain the very things agriculture depends upon – clearly biophysical factors such as healthy soil, but also, relationally, socio-cultural factors like an equitable food distribution system; a halt to urban expansion taking agricultural land out of production and a reversal of

the depopulation of many of the world's agricultural regions as farming is abandoned for the attractions of the urban.

The production of food, certainly in the city homes of affluent nations, is mostly completely taken for granted. It has actually become dematerialized for urban dwellers. Industrialized agriculture produces fruit and vegetables in which appearance frequently takes precedence over nutritional value. Likewise, foodstuffs like grains, potatoes, tomatoes and milk increasingly have to meet the processing requirements of 'the junk food' industries. Processed foods (frequently cheaper than fresh foods) combined with sedentary lifestyles, have been shown to have a dramatic negative impacts on the health of whole populations. Ironically, nutritional poverty is a feature of the diets of both the overfed underclasses of wealthy nations and the underfed of the world's poor.

In opposition to these developments, food has to be recuperated as a sustaining entity by its producers, those who cook it and its consumers. The growing of food really should be made part of the general experience of everybody; it is one of life's lessons – one we all need to learn! The production of food is actually one of the most direct ways to gain an understanding of sustainability; it is a very direct and powerful way to communicate the connection between the care of the biophysical environment and care of the self; it also delivers an enormous sense of achievement.

The rematerialization of food implies bringing its quality, production and preparation back into a far more important place in people's lives. It means people coming to realize again that the health of the soil and the quality and nutritional value food are indivisible; that the reintroduction of seasonality, localism (which reduces energy expended on food transportation) and freshness all combine to deliver quality and nutritional value. Staples once again need to become the organizational principles of the fresh food industry. The theme that has to drive the marketing of food has to be sustain-ability – profitability has to take second place. There are two powerful final points to make.

- *Point One*: learning to cook is not just a skill attached to the pleasures of culinary consumption but is equally a practice that conserves the nutritional value of produce, which itself is directly connected to the health of the body.

- *Point Two*: the acquisition of practical gardening skills, including the use of hand tools and simple agricultural machinery, does not only provide a rewarding form of experiential learning but can give communities the capability of recovering the vast numbers of pockets of agricultural land within the urban fabric. In so doing, the ability of the city to sustain itself is increased bio-physically and culturally – urban agriculture, as a literal greening of the city, provides habitat, storm water management opportunities, space that can help counter heat absorption by the city's thermal mass (heat islanding), and a means of community development and education. *De facto*, urban agriculture is a form of redirective design.

In conclusion, one asks: has the rematerialization of food and urban agriculture anything to do with design for elimination and recoding? The is answer is unequivocally yes – action that responds to the misuse of agricultural land, changing how food is produced, acting to alter how the city is perceived, and making practical action available to counter the impacts of climate change, are all examples of redirective practice in its most fundamental and available form. Such action also demands and exemplifies design as a democratic cultural politics.

19 Selling the vision

6

Futuring, Redirective Practice, Development and Culture

The need for the Sustainment, futuring and redirective practice are imperatives that extend from the individual to the global. Certainly, they cannot arrive from a Eurocentric imposition, be it via good intentions or by on ongoing Western 'will to power'. The action of futuring, which redirective practice exists to serve, only becomes a global possibility if it is based on establishing conditions of 'commonality in difference'. What all this means is simply that the common goal of creating sustain-ability will only stand a chance of realization if pursued in socio-culturally plural ways.

The Sustainment, like freedom, happiness, justice, ethics and so on can be abstractly defined but experientially it is not reducible to one form of action

or expression. Difference, as in biodiversity, is elemental to sustain-ability, whereas singularity, like monoculture, carries a high risk of extinction. Moreover, difference is a necessity as much in the cultural as the biological sphere. While a great deal of importance is to be attached to cultural difference within and across the world's cultures, it cannot be understood independently of the enormous forces of modernity mobilized against it. What follows are a number of broad cuts into the history of the undercutting of difference.

Totality against Difference

While we should not romanticize precolonial cultures as existing harmoniously in some kind of Garden of Eden, we do need to acknowledge the brutal consequences of European colonialism. The violence of overt genocide enacted by military force and settlers, both intentionally and accidentally by introduced disease, is almost beyond the Western imagination. Colonialism ended the life of countless millions of people; it also did relentless damage to the sustaining ability of cultures across the generations. As victim or transgressor, humanity at large has never really recovered from this moment. The lingering pain of colonial violence continues to shape geo-politics, as is evident in the fragmentation of populations and the artificial construction of nation states that still divide families, tribes and cultures. Likewise, extracting natural resources, clearing land and hunting native animals, in some cases to extinction, did a vast amount of irreparable cultural as well as environmental damage.

Genocide and ecocide have unambiguously been part and parcel of colonialism. Ethnocide, on the other hand has been more diffuse, pervasive and less acknowledged. Ethnocide can be defined as the destruction of a people's culture, as opposed to genocide, which destroys their bodies.[1]

Ethnocide occurs when a more powerful culture imposes its norms and practices on a less powerful one. In the West's colonial expansion, everything encountered that did not conform to Western norms – social structures, cultures and ways of inhabiting the environment – was designated 'uncivilized'.

However 'primitive' or 'savage' others were not always viewed as simply worthless or a hindrance to progress, and thus disposable, but as *redeemable* – they became subjects to be civilized, which added up to the destruction of the legitimacy of the system of belief and social order by rupturing their cultural practices. Ethnocide has been inherent in globalization. The Eurocentric ambition to create a global culture underpinned by capitalism (be it enacted by trade, aid, inequitable conventions, war or cultural strategies) has a history spanning more than 500 years. Rather than just being a consciously pursued objective, this ambition became embedded in 'capital logic'. The dominant thesis carried by this 'logic' being that humanity advances simply by increasing productive and consumptive capacity; entry into the market system; improvement of standards of living and the development of the modern state to uphold these economic conditions. But against the backdrop of the necessity of difference, internationalizing economic, political and cultural conformity via globalization actually negates the possibility of sustain-ability.

Redirective actions that can advance sustain-ability need to come from both non-Western as well as Western cultures. Redress to the situation of imbalance is a matter of action not rhetoric. But actions can neither be simply evoked nor taken up as if ready to hand. In the shadow of a history of colonialism, a process of cultural regeneration needs embracing as a redirective practice. The longstanding and ongoing erasure of difference by the West requires acknowledgement – what this implies is that the integrity of Western culture itself needs to be unsettled and opened to other kinds of knowledge and dialogue. To give these issues more critical bite we need to position them within the discourse of 'development.'

The Nature of World Development

The word 'development' is constantly mobilized with politically loaded ideological assumptions. It has become vacuous; it certainly cannot be taken to name a coherent or neutral process denoting positive or desirable change.[2]

Historically, the development discourse arrived in the period immediately following the Second World War, which saw European decolonization, the rise of modernization theory, the formation of the United Nations and its rapid growth as newly independent nations joined.

The project of UN-promoted global development became inscribed in a geo-spatial and economic classification system that profoundly framed the perceptions of nations and their people. While dominated by the First World (developed) and Third World (underdeveloped), the communist bloc was designated as the Second World, while the absolute poor and dispossessed were named as the Fourth World. While fragments of this system still have a rhetorical afterlife, they are rapidly losing their geo-spatial viability.

The UN arrived in the wake of the environmental and human destruction of two world wars, which themselves were preceded by five centuries of violent destruction of environments, populations and cultures by competing European capitalist powers bent on global expansion. In this respect, the discourse of development is situated within a global theatre of carnage and ecocide, amplified by the technological 'attainments' of the industrial revolution. Imposition takes many forms!

Superficially, 'development' has a positive ring to it. But its arrival in the wake of colonial violence not only so dramatically transformed human lives, futures and geo-politics but, as indicated, deposited some of the world's most intractable political problems and conflicts. More than just reclassifying *un*-developed people as *under*developed (thereby necessitating them becoming developed), development discourse imposed an imported model of the modern that devalued 'tradition' and thus created new divisions within recipient cultures.[3] It is out of the project of global development, idealized as making the entire world modern, that the contemporary condition of poor nation indebtedness was established. At worst, development has been a disaster for hundreds of millions of people. At best, results have been mixed, frequently benefiting elites, as the history of the UN indicates.

Consider that, for example, UN World Health Organization (WHO) programmes have been significant in eradicating diseases and improving public health, yet they have lacked the economic muscle to cope with the spread

and severity of HIV/AIDS or to deliver the most basic level of public health to vast numbers of the world's poor. Likewise, UN action in agriculture (in particular during the 1970s when the 'green revolution' was most aggressively promoted) often ended in a chemical induced agricultural disaster leaving the soil and farmers impoverished. Meanwhile the global population and that section of it with a substantial income has continued to grow thus increasing the demand for agricultural produce. Yet at the same time, as the Washington-based International Food Policy Research Institute has pointed out, supply cannot adequately respond – in 2007 the volume of grain available on the world market was the lowest since 1981, with demand for it and corn to produce bio-fuels continually increasing and forcing up prices.[4] Added to this picture, is the reduction of productivity in many parts of the world from the steadily increasing direct and indirect impacts of climate change. The result, in sum, is a general trend towards higher food prices combined with an unstable and reduced volume of supply. Viewed in the context of a continual global growth in demand for food for many decades to come, informed sources are warning of a coming crisis.

The limitations of the UN point in many direction. Like its attempts to over-come illiteracy, which has been outpaced by world population growth. Then there is the inability of the UN Environmental Programme to halt large-scale environmental destruction around the world, including the loss of vast tracts of rainforests. If we look at the World Bank we find its record to be ambiguous – in spite of a degree of recent liberalization, its role in inducting 'developing country into debt' has created an enormous amount of human suffering. However, it is perhaps the United Nations Security Council's inability to halt genocide, prevent destruction created by international conflicts and keep the peace in numerous wars in which it has been invited to intervene that exposes the greatest weaknesses of the organization. Essentially, on the one hand, the UN has lacked the financial support from member nations, the philosophy, *nous* and political aggression to do what it should have done. On the other, the heavily Western-influenced idealism and humanist aspirations of its founding moment were accompanied by a massive dose of modernization theory that directed its not-so-hidden development agenda, which has simply flowed into the contemporary project of globalization.

Development was not just a political and economic imposition but also a project that deployed culture as a vehicle of modernization (led, in the UN, by UNESCO). This deployment of culture was often tagged as 'cultural imperialism' and as such was indivisible from ethnocide. Actions mobilized against tradition included the displacement of: oral culture by functional literacy, traditional building forms by Western architecture and indigenous cultural practices by modern cultural commodities. In this field of activities, the agendas of trans-national agencies, corporations and non-government organizations often contradicted each other, with cultural conservation and destruction both happening under the auspices of development.

Culture, Dominance and Resistance

The history of development, as it folds into the overarching project of modernity, is clearly more complex than so far characterized. We need to both widen the frame and look at some detail within it.

For the West, the development of a modern world goes back as far the Enlightenment's notion of modernity, which was in fact a diverse project directed toward the creation of the modern state, science, civil society and the modern social subject. In each case, the artificial was mobilized against the domination of natural forces. Retrospectively, the modern world can be seen as a mega-design project of human construction marked by a dramatic escalation in the fabrication of material and immaterial conditions of human existence. As such, it dramatically increased the human propensity to be unsustainable. Unknowingly, forms of 'world making' were initiated that were equally forms of unmaking. This can be seen in examples as diverse as deforestation on a massive scale and the iron and shipbuilding industries of Europe between the sixteenth and late eighteenth centuries.

Of course the Enlightenment was not exclusively a European phenomenon. Certainly the Enlightenment of the Middle East had a different and overlapping vision of the future – the consequences of which flow through to the present conflicts in Islamic culture between 'dogmatic traditionalists and

liberalizing progressives'. In particular, Islamic science was not only well in advance of Western science prior to the Western Enlightenment but Western science itself, in areas like astronomy, optics, mathematics and medicine, took liberally from it.

Likewise, Chinese civilization was in advance of the West in the applied arts and social organization for millennia. As events of the nineteenth century indicate, the conflict between 'development versus tradition' in China was incredibly violent.

The impetus to modernize China came from two sources: humiliation from its conflicts with European powers during the Opium Wars, not least the foreign occupation of Beijing in 1860; and the horrendous internal rebellions of the 1850s and 1860s, the most devastating being the Taiping rebellion conducted by armed peasant groups and secret societies against the Qing regime. The rebellion lasted twenty years and cost between twenty and thirty million lives. Not only did the Taiping rebellion cost more lives than any other civil war before or since but it also tragically coincided with a period of drought and famine in which another thirty million people perished. The Qing government never recovered and was displaced by the rise of the *Han* elite. At its most basic, the rebellion was a conflict over China either returning to values of the past or moving forward towards modernity.

By 1864, the rebellion was spent but the nation, especially the educated classes, had been shaken to their core. The conflict of ideas, together with catastrophic wars, had enormous and tragic consequences for China that went well beyond the numbers of lives lost. China's self-image and modern political history cannot actually be separated from this period of national trauma, nor from Mao Zedong's 'cultural revolution' of the 1960s – which was another massive assault on tradition and the past. In both cases, the view was that the cultural values and practices of the past blocked the way to the future, hence Mao's notion that 'the suppression of the old by the new is a general, eternal and inviolable law of the universe'.[5]

China's rapid economic development over the past few decades and its 'one nation, two systems' policy not only stands on the foundation of these events but retains an objective that connects modern Chinese politics to its

ancient regimes. The objective of every political regime has always been the maintenance of the means to administer such a large, complex, culturally diverse nation and its huge population (many of whom have been locked into a struggle for survival irrespective of whatever regime was in power).

Contemporary Development: Another Face of the Unsustainable

As said, globalization represents a continuation of the totalizing goals of modernity, this notwithstanding the rise of the UN's shift towards the notion of 'human development' during the 1980s as registered by its Human Development Reports. At least since the early 1990s, humanist, 'soft-edge' concepts of development have co-existed with 'hard-edge' market-driven models. Although there are projects that clearly have made a positive difference to the lives of an enormous number of people, the human impacts of conflict, the extent of globally embedded poverty, the underside of rapid urbanization, the ravages of AIDS, and now, the displacement of populations arising from climate change, all add up to an enormous volume of human suffering globally. The situation is graphically illustrated by UNDP *Human Development Report* 2005.

This report gives an account of the rise of a new global middle class (not least in China and India) and the nature of global poverty (again in China and India). It points out that worldwide, 10.7 million children never reach the age of five, that the infant mortality rate among the black community of Washington, DC, is higher than in many Indian cities and that global income inequality is increasing for 80 per cent of the world's population. It goes on to state that almost half a billion of the world's poor are worse off than they were in 1990, 1 billion people live on less than US$1 a day and that 1 billion people lack access to fresh drinking water. It also summarizes the still-rampant scourge of HIV/AIDS, most graphically by noting that life expectancy in Botswana is 31 years of age.

The centre/periphery, First World/Third World model of development that structured perceptions of the world order for so many decades has crumbled. Rather than 'uneven development' being a characteristic of 'developing' nations, it is now part of almost every nation. With the exception of 'dysfunctional nations', which are *de facto* written out of the world order, the global outsourcing of production and services, the dynamics of the international labour market, the abandonment (and often statistical erasure) of under classes within rich and poor nations, the rise of 'affluent cosmopolitan centres', with their accompanying class in large cities across the globe, are all factors that fracture any simple correlation between poverty and geography. The arrival of what Manuel Castells calls the 'informational mode of development' layers onto this picture. Unlike the IT globalizing optimists, Castells does not see this technology as the panacea of world poverty.[6]

Revisiting Sustainable Development

All the remarks made on development flow back into earlier critical comment on sustainable development. At one extreme, such development simply aims to make forms of national and global development less environmentally damaging, and at the other, it supports capital's exploitation of 'the environmental crisis'. Either way, sustainable development is just not sufficient to deal with the multiple faces of defuturing unsustainability.[7] It certainly cannot deal with the central problem that unsustainability is grounded in anthropocentrism, or with capitalism being a source of unequal exchange and thus inequity, or with the causes of conflict. Nor can the modest, slow-moving agenda of sustainable development counter the rapidly worsening climatic situation triggered by global warming with its prospect of vast numbers of environmental refugees instigating major population redistribution.

Obviously, none of us should resign ourselves to the bleakest scenarios; hopefully the problems that arrive will fall short of the worst predictions but this might not be the case. The only responsible action to take in these circumstances is to act from a precautionary perspective. The costs, by any

measure, of little or insufficient action would be unquestionably greater than any overspecification within a precautionary approach.

Reconnecting to Design

The notion of design in support of (world) development has been around for a long time. It was inherent in E. F. Schumacher's applied economic theory as it informed appropriate technical transfer via the formation of the Intermediate Technology Development Group in the 1960s.[8] Likewise, it was a significant part of Victor Papanek's thinking when he wrote *Design for the Real World*.[9] In both cases, the idea was to put 'underdeveloped countries' on an affordable path to industrialization. The mainstream view was that conventional 'technology transfer' would be a key driver of this process. Schumacher and Papanek thus represented a softer approach that favoured 'alternative technologies' that supported local economies and communities rather than sweeping them aside. However, exposure to the commodity world of the West, via tourism and the media, has meant that populations of 'underdeveloped' nations came to want the same products and technologies as the people of advantaged nations – despite the contribution of alternative technologies in areas like water, sanitation and energy.

Both the mainstream and alternative approaches, of course, have their foundation in Western technical rationalism, and both posited a faith in science and technology to solve problems instrumentally or economically. Both underestimated the consequences of the displacement of local economies and the cultures they sustained, including changing the symbolic status of craft skills and the people who possessed them.

Design is never culturally neutral – it always transports socio-cultural values. Equally, what it brings into being always designs beyond mere function. Design is thus a means as well as a product of cultural production, as the history of both architecture and technology confirm.

Design has acted in the service of the culture and economy of modernity and its metropolitan and global extension. It has been deeply implicated in the universalization of modernization and unsustainability.

Design futuring, in contrast to ethnocentrically configured forms of 'sustainable modernization', needs to be circumstantially and critically responsive to the minds, dreams, feelings, material conditions, dispositions, values and beliefs of people within the world they inhabit. At the same time, there are now almost no people on the face of the planet who are not exposed to the products of a globalized economy and its accompanying culture. In this situation, the question of what can provide sustain-ability is vital to explore and to connect with localized remade desires for viable futures. One key option is to mobilize knowledge of the past and present to create culturally and materially situated needs that marginalize or displace imported wants. Such activity directs us to create exciting and exemplary commonality to express redirective forms.

Redirection from Design Otherwise[10]

Design otherwise aims to contribute to breaking the postcolonial double bind (not being able to go back or forward) in which many subordinated cultures find themselves. It proposes a form of design leadership, linked to redirective practice, which strategically joins with cultures working against neocolonialism. The form of this activity would always have to be specific and localized. So said, certain characteristics of 'the development of sustain-ability' against 'sustainable development' can be sketched; the first of these cluster around the formation of a new social ecology.

There are many examples of how, traditionally, labour was expended so that communities could subsist, reproduce their social structures and transfer their material culture to future generations. In many situations, like communal building construction, people worked together as producer communities with established cooperative practices, including forms of ritualized design and construction. When activities interconnect and reinforce each other for the good of the whole they advance the creation of a robust social ecology. Such activity travelled in many directions: the cultivation and production of local renewable resources, the induction of the young into the craft practices that would sustain them and their community; communicating traditional

practical knowledge via the making and content of aesthetic forms. Thus within traditional societies, such everyday practices were means of futuring. In the wake of colonialism, so many of these kinds of activities have been destroyed, abandoned or neglected. Yet, sometimes, an archive remains – in traces of memory, residual skills and artefactual things – and begs rigorous interrogation.

The external world of commodities arrives and so often undermines sustaining characteristics of the present and blocks the recovery of viable sustaining characteristics of the past. Of course, commodities do not arrive as mere objects but as projected desires deemed to be able to convert dreams to reality. They are directed at the young, many of whom have lost respect for a culture they have only experienced in the form of its damaged afterlife. The young want a future but often recoil destructively in anti-social or self-abusing ways when they encounter fragments of what once were sustaining traditions, which have been abandoned by their parent's generation. The nostalgia of elders offers them nothing. In such a setting, the prospect of recovering the past as the future seems neither viable nor attractive. Yet the past *remade* anew as the sustainable has real potential.

This remaking requires intervention by cultural leaders to expose tradition as a product of incremental change, thus opening the possibility of it being available for future innovation (as some indigenous art practices have demonstrated). Across the range of built forms, food production, the making of clothing, craft practices, furniture making, horticulture, music and so on – things that all initially arrived out of responses to particular environments – there is often the possibility of innovation and reinvention taking traditional forms as a starting point. What is being evoked here is nothing to do with the manufacture of commodities for sale in the existing market place but a far more ambitious project: the rematerialization of the culture by making new forms, knowledge and values from the old that, above all, recreate a sustaining social ecology as a foundation of change.

The proposition that developed nations have to confront is that they will not be able to engineer themselves out of the unsustainable and into a futuring condition. Nor will forms of economic determinism, like carbon trading, have

the integrity or power to drive fundamental change. In this situation, lessons from marginalized cultures of various kinds could well become key sources of modes of adaptation and sustain-ability. Against the accumulation of such attainments, the arrogance of reason and Eurocentrism may well have to give way to humility and a totally new admission of difference.

Part II

Strategic Design Thinking

To employ design as a major agent of change within redirective practice is something other than reform or revolution. As has been shown, and will continue to be argued, this requires a major transformation of design practice and the ideas that inform it. To gain efficacy, such action requires strategy, and it is to this that we now turn our attention.

To start with, futuring will be strategically positioned as the consequence of sustain-ability as it acts in process. Design will then be presented, within the frame of redirective practice, as an animatory force of sustain-ability. As such design agency will be shown to span the actions of individuals as well as the collective actions of a culture. We will then more specifically consider a range of methods that demonstrate just how design can be strategically deployed to ethically advance futuring.

A number of notions that have already been touched on, like learning from the past, will also be revisited and developed in a more grounded setting. Finally, the strategic role of the designer as a redirective practitioner will be elaborated.

7

Unpacking Futuring – The Self, Community, Culture and Ethics

Our aim here is to set a scene through which the remaining chapters in Part II can be viewed. As a result, design appears to come into the picture towards the end of the chapter. The immediate concern is with what design and designers have to confront if real progress towards sustain-ability is to be made. Therefore, the thinking presented elevates contexts of design over designers' more usual preoccupation with structures, objects and images.

One would think it obvious that the aim and application of human artifice over the millennia would have been to secure conditions that sustain and improve the human condition. Over the duration of human being, such

pragmatic action, especially over the past 200 years, can be exposed as inherently contradictory. The worldly actions that we have taken *en masse* to sustain ourselves in the short term have increasingly been at the expense of maintaining the long-term sustainment of ourselves and the world around us. The greater our numbers and our technological capacity to misappropriate planet Earth's resources become, the faster we defuture ourselves.

Meeting the material needs of human beings quickly became displaced as the sole function of the operation of the market economy. While the sale of surplus played an important part in the rise of this economy, it rapidly moved beyond supplying goods to meet basic needs to enfold trade in symbolic forms. Once the production of wealth became more important than productive activity to meet biophysical needs, material exchange became disengaged from those fundamental processes of exchange inherent in every ecological process. There is now no correlation between what we human beings need to sustain our wellbeing and our unchecked use of the finite resources of the planet for growing an economy centred on the production of wealth ('enjoyed' in *excess* by only a tiny minority of humanity). This now dominant economy is an expression of the myopic anthropocentrism of the contemporary human condition. Furthermore, the attachment of 'sustainable development' to actions that result in perpetuating this economy is a grave error.

The directional error of human economic development was not an evolutionary inevitability or the consequence of a 'god-given nature'. Rather it was the result of the onward designing of the unwittingly created social, economic and cultural structures that human beings put in place over thousands of years – the history of which forms the substance of a vast literature covered by archaeology, economic anthropology, the history of agriculture and human settlement.

The overriding drive to produce excessive and unevenly distributed wealth has culminated in capital's global hegemony. One of the major means by which its growth was facilitated was by the creation of an ability to manufacture 'wants' within mass markets. These 'wants' being felt and treated as if they were 'needs'. The dichotomy, for instance, between what individuals can be shown to actually *need* and the manufacture and marketing of products

they *want and desire* (not least as a result of the ontological designing of the combined forces of all the 'culture industries') is stark. In this context, poverty is a slippery fish. Abject poverty is unambiguously the lack of the means to basically subsist – not having access to water, food, the fuel to cook it, shelter, clothing and warmth in a cold climate. All other forms of poverty exist as a tension between needs, wants and the significance of lacks. This situation is clearly evident in, for example, the fact that all human beings need a healthy diet, yet rather than the poor existing on a diet based on healthy and affordable staples, they have been made targets in the marketing of junk food. The result, in many parts of the world, is that now obesity has become a sign of poverty.

Just as capital's desire for continual growth knows no limit, so neither do the wants of actual and aspiring 'consumers'. If we were to take a look into almost any wardrobe, garage, kitchen, garden shed, living room, bedroom or bathroom of anyone in employment in any of the world's moderately to very wealthy nations, we would discover, to varying degrees certainly, the same situation – excess. Yet we still want more. The drive of a global economy is to constantly expand. It strives to increase the volume of goods and services purchased by people with disposable income, irrespective of the facts (a) that the material needs of huge numbers of these people have already been met, and (b) that technological innovation, accompanied by the creation of technological obsolescence, is a major and ambiguous driver of global market expansion.[1] Certainly, consumables require replacement, as do some durable goods at the end of their life (although many could be retrofitted or remanufactured). So, while wealth is generated by selling manufactured commodities and services to people who actually need very few of them, there is a very large segment of humanity in abject poverty that have dire, unmet and ignored needs. The cost of this inequity just does not figure in capital logic. Yet the poverty of the world's really poor comes at a very high price, at an individual and collective level. The only commodity they can sell is non-renewable natural resources around them – like, for example, the destruction of the forests of Borneo's Kalimantan region. The annual burn of the region, to rid it of agricultural and forest logging waste and to clear land for palm oil

plantations, is of such volume that it puts Indonesia into third place as the world's greatest emitter of greenhouse gases, while also creating a regional major public health problem from smoke. Here, and elsewhere, the cost of environmental destruction by poverty, in the end, will cost capital far more than investment in damage-preventative social and economic action.

The action of farmers in Kalimantan tracks back to architects, builders and furniture makers around the world designing with timber from this region, either taking no responsibility for what they specify or not caring to find out about the consequence. Rather than allowing such market driven destruction from misplaced need, the farmers should be paid to regenerate and care for the forest on the basis of it being an environmental and economic saving.[2]

More generally, there are not only links between land clearing, the extraction of raw materials, greenhouse gas emissions and the exhaustion of agricultural soils around the world, but equally with the volume and choice of the products in our shops and supermarkets. At the same time, the madness continues of economic growth based on marketing to manufactured wants at the expense of the unmet basic needs of many hundreds of millions of human beings. There is literally no future in humanity continuing in this direction, especially as the global population heads towards 9 billion plus. There is no future in buying into the 'green capitalist' position that claims that 'we can have it all' as long as 'we go green'. This position simply allows the injustice and dangers of existing global inequity to persist and in so doing ignores the consequences of overlooking the plight of the worlds poor! As will be shown, redirective practice and the changes it would aim to usher in, have to be more fundamental – there has to be, and can be, a better life for the planet's poor and dispossessed peoples. Such change is essential to shift humanity towards having a propensity to future.

Futuring: For Whom or What?

Essentially, transformative action has to focus on changing us, especially by transforming the worlds we make for ourselves as they design our modes of

being. Not only is redirective practice a key to this task but it is also a means to bring both the sense and act of futuring within our grasp. This adds up to much more than just marketing green goods, services and buildings. What futuring so framed implies is a counter direction to the existing, industrially inscribed, defuturing grain of the world. Futuring defines a disposition (understood as an inscribed way of being of both human beings *and* of non-human beings and things), a mission and the organizing of principles of practices. Futuring is not the stuff of Future Studies – a quasi-discipline that considers futures non-predicatively.[3] Future Studies has created a range of methods – like forward thinking, foresight, the reading of patterns and trends – that have been taken up, dominantly, as a planning tool by the corporate sector. While Future Studies could serve futuring, as defined here, it currently is more likely to be found in the service of defuturing agents of the current economy.

Futuring, at its most obvious, means giving the self (as the embodied mind acting in the world) a future. This turns in two directions: first, towards the being and care of the self (which implies keeping 'it' nourished and healthy in body, mind and spirit) and second, towards the care of the conditions in which the self is in being. Just as the body and mind defy a dualist division, so also does the division of the self (as a being) and its being-in-the-world. As selves we are, as the philosopher Maurice Merleau-Ponty put it, the 'flesh of the world'. At source, we breathe the same air as all beings, drink the same water, depend on the same sun, draw nutrients form the same soil or oceans – we are not simply beings *in* the world, but beings *of* the world. For the self to sustain anything, it first has to sustain itself.

The world of the self is, of course, a world of others. Our condition of being in the being-of-the-world is social as well as biophysical. Our selves cannot come to be actors in the world without other human beings – in this respect we are of the body of humanity. We have no language, culture, knowledge, skills and humanity without others. We cannot be sustained without them; we have no future without others. This statement takes us to our next agent of futuring: community.

So often, community is a term used in loose ways, totally at odds with its original, authentic meaning and also at odds with how it now needs to

be understood. Jean-Luc Nancy tells us that we bear witness to 'dissolution, dislocation or the conflagration of community' and by his measure it is perhaps of 'the gravest and most painful testimony of the modern world'.[4] Community is an ecology – our ecology. Not only has it been ravaged by the atomization of humanity via the cult of individuality but also by a cluster of other powerful disruptive forces, including: the desocialization of pleasure through the rise of home-based techno-cultural commodities; the national and global mobility of labour; the implosion of many systems of belief (religious and secular) and the economy of manufactured wants obscuring recognition of the fundamental need for social wellbeing. Not surprisingly, the strongest traces of community reside in spaces of the needy where capital is not fully hegemonic, spaces like the vast, sprawling, unplanned cities that grow-up around urban centres of 'newly developing nations' constituting what Mike Davis calls 'The Planet of Slums'.[5]

As climate change will increasingly prompt the need for large-scale adaptive actions, the necessity of community will become an ever more crucial factor of sustain-ability. The destruction of community has not occurred by accident. Rather it has happened because it poses a threat as a body politic in so far as the values of community are at odds with the economic essentialism of hegemonic capitalism as it reduces all value to exchange value. Community can be a collective of what were once called the 'dangerous classes' (which can equally be dangerous cultures) – it can and has to be the voice of that which contests the absolute economic determinism of hegemonic capitalism. Community's destruction is every bit as much a part of the unsustainable as is damage to the planet's climatic system, rainforests or coral reefs. Community is indivisible from all the other conditions of our dependence.

Community is a bond that can accommodate difference, be it of age, gender, personality, cultural origin or intellect. It is what passes through and connects us to others, countering our isolation as individuated subjects. As such, it needs to be seen within the same frame of futuring, for it provides the collective with a sense of continuity that transcends the measure of mortality that existentially inhibits an ability to see beyond a life-time. Moreover, as Nancy points out:

... community is not only intimate communication between its members, but also its organic communion with its own essence. It is constituted not only by a fair distribution of tasks and goods, or by a happy equilibrium of forces and authorities: it is made up principally of the sharing, diffusion, or impregnation of an identity by a plurality wherein each member identifies himself only through the supplementary mediation of his identification with the living body of the community.[6]

Community depends on sharing on many levels but most importantly in relation to belief (theological or mythological). Essentially, belief is what binds people together. Loss of belief effectively means loss of community. What remains thereafter, what is most familiar to us, is the inoperative (functional(ist)) community in which relations are strategic and ephemeral rather than long-term and substantial. Even if authentic community cannot be re-created, futuring requires the building of a form of community with sustaining power. Cast against the unsustainable, the imperative of the Sustainment and the pragmatic need for sustain-ability, the future can be positioned as a figure of belief. As indicated, the revitalization of community is essential in order to cope with the demands of adaptive change, including the provision of social care when state systems fail. Revitalization here has to be deeply and structurally (*habitus*) embedded in a culture – it has to be that which the children of the future are born into. It has to be the culture that carries peoples to the future – and in so doing provides the structure that structures people's lives sustainably.

Futuring has been linked to two very different transformative agents: the self and community. However, while transformation needs to be global and for the common good, it will not occur in a generalized universal condition of commonality – it can only occur unevenly within the structural inequities within and between all nations that mark the contemporary 'world order'.

Strategy and Others

As the previous chapter acknowledged, over the history of modernity, the cultures of colonized peoples were subjected to ethnocidal action. This ranged

from cultural violence against local belief systems by the 'good intentions' of missionaries to colonial governments that banned native languages, overtly suppressed the symbolic forms of precolonial cultures, demeaned, punished and even put to death indigenous cultural leaders. Such destruction has not been confined just to colonial expansionism, 'exotic cultures', or the distant past. Globalization acts ethnocidally both on the cultures of marginal people within the cosmopolitan and the masses of postcolonial nations.

There are of course softer, but still pernicious, forms of ethnocide. These centre on the commodification of cultural forms, reducing them to a matter of mix-and-match choice within a market system. Not withstanding 'ethnic roots' it seems that increasingly people choose 'their' culture from options of what to 'believe' in (or not), what to wear, eat, where to shop, where to live, what music listen to, movies to watch, what friends to hang out with, what politics to be aligned with, what technology to make a sign of the self, or what designer products to purchase. Culture everywhere, is for sale. In this setting, 'indigenous cultures' appear as the beleaguered bastion of culture as it was, as well as just another source of cultural artefacts.

In essence, culture is turning, or already has turned, from the very thing that has provided the means of the futuring of humanity, in its difference, to at best something superficial and transitory – at worse something implicated in defuturing. Certainly as configured though market-manufactured desires, cultures are constantly brought into the service of the unsustainable.

The rupturing of culture and community from place, the mobility of an ever-growing international labour force, the continually increasing labour power of technology and the insatiable appetite of productivist capitalism have all combined against the exercise of environmental care and responsibility – this notwithstanding the contemporary forms of control in mostly privileged nations.[7]

In essence, humanity has shifted from 'being *in* culture' to 'being *and* culture'. This move is massive, be it somewhat concealed by the fragmentation of particular cultures into subcultures and culture being named and offered in the market place, plus its camouflage by innocuous language and imagery. Like identity, culture of the everyday is something that expresses itself in its

moment of lack – when one's culture or identity is secure it simply 'is' and so goes unspoken.

The breakdown of culture is being serviced by design, sometimes, as discussed in Chapter 4, with the assistance of those 'experts on culture', anthropologists. By such means the reach of the commodity is sought to be extended even further into the depths of human being. This indicates that cultural action is not a secondary and soft supplement to the main game of the material advancement of sustainment, but is in fact primary. As we shall see, cultural change toward the making of a culture of sustainment (as a commonality in difference) brings redirective practice, an ethics of things, the political and design reinstitutionalized all into a new and critical relation with each other.

The form in which cultures of the past sustained futuring were not sufficiently robust to withstand the onslaught of modernity and all the 'benefits' it offered. Certainly, even if lost cultures had sustaining capabilities appropriate to the present, their recovery is now impossible. In this situation, and recognizing that sustainment is not possible without a foundational futuring culture, there is but one option: the culture has to be remade as a synthetic construction, a product of artifice. We humans are beyond the point when biological models of socio-cultural organization, which view society as an organism are appropriate to defining what we are and do – in fact we have been technological animals for millennia.

In the light of these remarks, even though the challenge is daunting, the aim of redirective practitioners has to be 'building a form of community with sustaining power' that can be generative of catalysts around which to build new cultures based on developing material forms of the 'common good' appropriate to contemporary circumstances. This takes redirective practice, design and futuring into a critical, concrete engagement with the extant world of material culture. Such activity frames practices of elimination and recoding already introduced, and demands, as we shall see, 'transitional strategies' – all of which requires political direction under what was earlier called the 'dictatorship of sustainment'. This direction, as was said, is not going to arrive out of a blinding flash that illuminates the true way ahead, or from the awakening of new political spirit within our political leaders, or from a

cathartic moment of revolutionary destruction. Rather it will come from 'a critical mass of redirective action letting loose myriad things that end up constituting an unstoppable materialized force of change. This unmanaged, but conceptually coherent, force would largely centre on an ethics of things – a web of relationally directed and linked structures, objects and organizations ordered by the common good under the governance of sustainment made sovereign at every level of judgement. The already cited case study of Boonah Two is a very simple example of this thinking taking shape in practice.

In this context, design is effectively reinstitutionalized by becoming the means whereby ethics (as the character of sustain-ability) becomes embodied in practices and things. Design becomes a means whereby self acquires agency, community is supported and culture is rematerialized. In this respect, 'good design' is futuring. Rather than the still-dominant condition of design – as unfinished, as always being process, but without any clear sense of direction or destination – 'good design' is an opening (into the future). To bring what has been said here into engagement with 'things as they are now' two questions will be posed. Who speaks for design? And, what could or should they say on the future of design?

Voices and Questions

What now follows is a kind of stock take to expose the gap between where design needs to be directed and its current position. Let us start with a re-iteration: the voices that currently speak for design circumscribe it as a service industry. Notwithstanding a still small but growing critical community within design, the overall voice is uncritical and deeply implicated in extending the unsustainable even when addressing 'sustainability'. There can be no directional change in this situation without a significant number of designers and design educators coming to recognize that, fundamentally, design has to serve the creation of futures within which humanity, in its inter-dependent condition of being, has to be redirected toward sustain-ability. Redirection demands design but design rethought and remade.[8] This is not

22 Voice off the street

an option among options, but an imperative to be vigorously engaged for the very condition of making choices to be possible.

Designers

Individually, and collectively via their professional bodies, designers are the constituency that many people would assume to be the authoritative voice on design. But with some notable exceptions, what designers say is mostly uncritical, often inflated and very much within the frame of design as a service and the internal dialogue of the 'profession'. The way that design issues are mostly communicated, especially in the public sphere, are dominantly visual and complicit with the media's reduction of design to aesthetic appearance or function. The focus of attention goes to iconic structures, objects, images and heroic designers. Likewise, this usually reinforces a celebratory relation between design and technology. These ways of presenting design permeate TV coverage, magazines, the press, design award events and professional conferences. While there is a small minority of 'aware' designers who recognize their social and environmental responsibilities, their voices are lost in the corporate-orientated, commercially driven sensibility of the industry.

Question: How do almost all designers manage to become so interpellated (called into compliance) that they are unable to think what design does beyond the functional, economic and restricted understandings of the symbolic – is it that they are dumb, seduced by money, just want to please clients, really think that meeting unsustainable user needs is OK, don't care so long as they are commercially successful, or what?

The Media

The popular media's characterization of design seldom goes beyond style or crass ways of embellishing hyped technology. Notwithstanding the rise of 'designer products', the media reinforce perceptions of a designer as a creative capitalist nerd delivering 'sexy looking things'. Even more significant, the

media never get to the point of realizing that design is a medium though which the made world can be rendered legible and open to critical engagement. Neither does it realize that often the most important design decisions have been made even before the designer comes on the scene (thereby concealing the design and power nexus). Given the highly circumscribed way it covers design, the media contributes to keeping the public ill informed, and so ill equipped to make design decisions in their daily lives. In turn, this means that the public demand for 'good design' (aesthetically, functionally, economically and environmentally) is weak and underdeveloped.

The cultivation of design criticism and knowledge of design is neither on the agenda of most designers nor the media. Designers mostly lack the ability to talk about design in informed critical ways, they mostly articulate what they do in banalities, and above all, have a very limited understanding of the consequences of what they create. Of course, this criticism of them as socio-cultural subjects is more so a criticism of design education (whether tertiary, professional or autodidactically managed) and of the limited amount of critical writing on design available.

Question: We are surrounded by the designed – every element of our built environments and every artefact in them; our urban and rural industries and all they produce; all our institutions, military and civil, and all the systems that enable them to function; all communication media and everything created by the entertainment industry; all forms of representation and all perceptions prefigured by these representations – so why is that we are blind to all almost all of this?

Educators

Design educators, who may equally be designers, design theorists or design promoters, also obviously speak on and for design, most notably to prospective designers. There are undoubtedly a lot of committed and good educators. Unfortunately, there are even more bad or mediocre teachers of design who reduce it to technique. Researchers and authors of Design History, Design

Studies, Theory, Management and Philosophy may also occupy positions in institutions of design education; they also may equally well be practitioners. While such remarks are and can be directed toward design education, they can also be deployed to engage other disciplines and audiences beyond the academy. Non-designer promoters of design, especially marketers of product, interior and fashion design (who are often miscast in the media as 'design critics') can be accused not only of trivialization but also of contributing to the general arrested development of the understanding of design by the public at large.

Question: Would not all design educators say they share the objective of wishing to improve what is designed, no matter what it is, by educating designers to think more carefully and design to an ever higher standard? Yet why have so few of these educators learnt that what they are teaching is an education in error (an education in defuturing, even in the name of sustainability)?

Authors of Design Discourses

There are significant historical and theoretical discourses on design. Design History has delivered valuable insights into the rise of design as a practice, its social and economic history. But rather than broadening the view of its object of study so that design is politically, socially and historically contextualized, such history mostly presents design as historically decontextualized. Thus, design is viewed as a particularist concern, grounded in aesthetic or historicist predilections based on connoisseurship, or it is implicated in a popular cultural celebration of kitsch, style or fetishized objects. The vast bulk of Design History just does not recognize how design has been a significant agent of historical change beyond micro-impacts. It also lacks a sense of how design inflects futures, which by implication means it is history without a theory of history. While Design Studies overlaps with Design History, it operates with a broader, pluralist agenda. While eclectically it throws up interesting material, which examines design in a broader frame of reference, structurally its multidirectional and pluralist character means it is unable to provide any

clear sense of direction or purpose. Design Theory (including Design Research) is predominantly an instrumental discourse, uncritically embracing science. It is totally preoccupied with design process, design methods and empirical studies of design in use. Design Philosophy is the least established and is thus a still inchoate area of design scholarship. However, it has the ability to ask the most critical questions of the nature of the design, its practices and above all, its past and present futuring agency in the world. Likewise, it also has the potential to considerably increase the dialogue with other disciplines, not least on the issues of ethics. More than any other area of the study of the field, design philosophy can ask questions of other ways of understanding, thinking and deploying design without being subordinate to design's institutionalized cultural and economic structures of support. It can thus not only open up discussions of design futures (or design's future) but can interrogate the very notions of both the future and design.

Design Management speaks from and to managerialism. It provides a conduit between design expertise and corporate commercial objectives. In so doing, it has supported corporate avant-gardism pioneered by corporate design strategies, and extended design's ability to be a 'value adding' agency. It has equally promoted the strategic application of design to, for example, user-centred design studies, the creation of customer-centred organizations, the loading of design with 'emotional value' and design as a feature of core corporate philosophy. All these are indicators of design's progressive and instrumental induction into 'corporate capital logic'.

Question: Why is it that while design prefigures so much in our world and how it operates, that not only is it so poorly understood by the population at large but also by those who purport to study it?

An Unavoidable Position

No matter who we are, we either support the status quo or oppose it. There is no fence to sit on. Unless you, the reader, work toward sustaining your

self and the creation of a Culture of Sustainment (no more than a 'solution' in the making) then you are part of the problem of giving legitimacy to the conditions of unsustainability that requires to be surmounted.

8

Methods of Change 1 – Platforming, Return Briefs and New Teams

No matter how good the arguments about change in the face of the unsustainable or how pressing the imperative, unless methods can be developed to deliver this change, the situation will simply go on getting worse. To state this is obvious, even banal, yet the entire history of utopianism and its contemporary afterlife has failed to grasp it. Visions without means are not what are needed. More than this, the two dominant paradigms of action in the face of the unsustainable – the instrumentalist techno-fix (environmental technologies); and environmentalism ('saving the planet' biocentrism) – are just not adequate. The former reductively deals with symptoms but cannot engage causes. The latter does not grasp the now indivisible relation between the natural and the artificial. Both approaches fail to comprehend

anthropocentrism's centrality to the unsustainable; they mostly function in its grip.

This chapter will present three methods of change. Their individual elements already exist; what is new is how they are mobilized and to what end. All these methods recognize a paradigmatic cultural, economic and political change from current circumstances in which defuturing is omnipresent. They are all vital to the opening of an age of sustainment enabled by the futuring capability of redirective practices served by design. Change, so framed, is not a matter of choice but necessity.

Introducing Platforming

Platforming is a strategy that maintains existing economic activity and work culture, while building a new direction and products or services that are based on futuring. The fundamental principle is simply that a change platform is built within an existing organization. This can take several forms, like a new shadow company within the company, or a new kind of research and development arm within it. These entities can be given seed support to initiate two transformative activities: (1) researching, designing and developing new products and services to contribute to a culture of sustainment and an economy based on advancing sustain-ability; and (2) delivering a continuous learning environment for those recruited to work on the platform (which can create knowledge spilling over to the 'parent' organization).

The intent of the platform is to build sufficient critical mass and momentum to gradually displace the parent organization's existing activities. The complexity, speed and radicality of this change would of course vary according to the scale, activities and availability of resources of the particular organization. It effectively means creating a new material base and work culture while retraining all employees. In most cases, it would imply a three- to five-year programme. There are already proto-examples of companies that have embarked on this scale of change.[1]

Platforming is based on a comprehensive programme in which everything and everyone changes to follow a coherently defined direction. This can be contrasted with organizations that, for instance, commission a 'green building' with much fanfare but, once they have moved into it, it facilitates exactly the same economic activities. Such action can be well motivated, although it can also be cynically employed as 'green-washing'. The same goes for organizations making 'green products' in 'non-green' ways (like manufacturing photovoltaic cells or wind turbines using non-renewable energy).

Archaeology of the Idea

The idea of platforming comes out of a history that started with the rationalization of the British aerospace industry in the late 1960s. Lucas Limited had taken over some major companies, including the AEI aircraft group and the aircraft component section of English Electric. By the mid-1970s several thousand workers had been made redundant and a 'Combine Committee' of trade unions was formed to resist the loss of more jobs. In 1976 the Combine Committee presented an 'Alternative Plan', based on using labour slated for redundancy to manufacture 'socially useful products' (as opposed to weapon systems). The plan was put to the then Labour government (it ended up getting little from the national government but a number of local councils were supportive).[2]

This history highlighted the gap between the technology of the missile-making aerospace industry (which we could now designate as a defuturing industry) and the need for technologies to redress social and environmental problems. Specifically, the 'Lucas Plan' (as it came to be known) demonstrated that within the company there existed the design skills, technical knowledge and production capability to potentially redirect what was manufactured. The plan aimed to create products and technologies that were totally different in form and function from the company's 'core business' and were also completely different in social and environmental intent and consequence. Another key element of the project was that the concepts for the products and technologies

24 Illustration (T. Fry) for The Lucas Plan (H. Wainwright and D. Elliot, 1982)

to be put forward (and the additional knowledge to make them) should come from the existing workforce. This idea resulted from a detailed consultative process conducted via a comprehensive 'dialectical' questionnaire, which revealed not just a worker's trade or professional skills and knowledge but a whole raft of useful expertise. This included, for example, what a worker had learnt during his military service, from hobbies, evening classes and so on.

The products that were selected for development were drawn from around 150 proposals. They were divided into six categories: medical equipment, alternative energy, transport systems, braking systems, oceanics and telechiric (remote control) equipment. Looking back on these, we discover many things that are the antecedents of today's 'sustainable technologies'. These included

25 Hybrid engine

a bus that could run on road and rail, a heat pump, fuel cells, wind turbines and a hybrid car.

The hybrid cars of today directly connect to this history. The project started out by investigating the merits of battery driven cars in the context of the energy crisis of the time. Such cars were under consideration for development by Lucas Electrical (another company within the Lucas Empire). The conclusion was that their short range (40 miles (64 km) before needing to be recharged) and heavy weight (due to the number of batteries they carried) made them not viable.[3] In response, the Combine design team started working on the idea of having a small petrol engine on board to keep the batteries

(now reduced in number) continually recharged. Here then was the basic concept of the hybrid car. What was designed was almost silent, had half the fuel consumption of a comparable size car and exhaust emissions reduced by 80 per cent. A prototype was built and tested at Queen Mary College, London, and interest by the car industry was explored.

By 1982, however, Lucas had sacked 2,000 workers and the plan was dead. By this time the Greater London Council and West Midland County Council had taken up the idea of 'socially useful production'.

Other Forms of Prefiguration

A very different strategy that indicates another kind a path to platforming was explored by two commissioned projects conducted by myself and others at the EcoDesign Foundation in Sydney in the mid-1990s.

The first project was the creation of a series of student design competitions for one of Australia's largest office furniture manufacturers. The then owner of the company wanted to stay in the same market sector but was looking for new ideas to lead change rather than just continuing to be a supplier meeting existing need. The appeal of the competitions was that they could flush out creative ideas and new talent.

The first competition was national, focussed on design with recycled materials and was limited in ambition. The second was international and far more adventurous. It was based on a brief that invited industrial design, furniture design, interior design and architectural students to explore the notion of 'the office on the move'. The competition brief recognized that office space downsizing was happening in many of the world's major cities. It was forcing people to work from home (but without the space for a home office) or even from their cars. The competition attracted entries worldwide and included the likes of office as trolley, office as fold-away furniture, office as wearable technology; office as a roll-up sleeping-bag like lounger.

The relevance of the competition to platforming was that it:

1. provided a means to trigger discussion on radical changes in product thinking within the company;
2. delivered this discussion from a space that was removed from the internal social dynamics of the company – it threatened nobody; and
3. illustrated research and development possibilities.

All of these characteristic indicate how and why a platform would be set-up on the 'outside of the inside' of an organization.

The second project was architectural and centred on a new industrial building. An approach was made by a company manufacturing liquid petroleum gas-dispenser pumps. Its management team had decided that the company needed a new factory, but they had a problem – they had concluded that their product, which was exported to many countries, had a limited life.[4] Their requirement was for a factory able to support existing production, but equally able to support the manufacture of a product yet to be identified. Two specific requirements had to be met: (1) whatever was to be made had to be in advance of the existing product in terms of environmental performance and (2) whatever was to be made had to be possible with the existing workforce, be it with some degree of reskilling. Effectively, the time between moving into the new factory, the continuation of existing products and their eventual phase out determined the lifespan of the platform (which was thought to be around a decade). Two processes were commenced: the design of the new factory; and the presentation of skill auditing (based on the Lucas Plan approach) as a way of putting the process of identifying new products options within the remit of the whole workforce. Thus the start of a *de facto* platforming situation was created, but without it being created outside the main company organizational structure.

Generalized Summary of Steps

While the actual number and sequence of steps to set up a change platform will vary according to circumstances and the nature of the organization wishing to change, there are steps that can be generalized:

1. *Knowing why – a common and detailed knowledge of what a platform is and why it is needed is essential for everyone involved.*
2. *Commitment – for success, there has to be commitment from both the leadership and the led.*
3. *Strategic planning – timing, objectives, methods, resources all have to be clearly specified before commencement.*
4. *Recruitment – success depends on picking the right people, and these people then working together as a learning community.*
5. *Redirective practice and design – it is essential to know to what and to where redirective effort has to be orientated (the question of what has to be designed and what it, in turn, will design, is a vital question to ask and have answered).*
6. *Project pacing – getting the stages clearly identified with specific aims is important , but so is setting a very high standard and creating the ability to adapt.*
7. *Team valuing, learning and reassurance – transparency, invitations, mutual support and dialogue should be basis of team relations.*
8. *Product and marketing – vital to develop and market a product in relation to assessed needs over assumed 'wants'.*
9. *Linking – find other organizational change agents inside and outside the platform team.*
10. *Public exposure – not until what the platform is to launch is 'ready-to-go'.*

The Redirective Return Brief

The concept of the return brief has been around in architecture for a long time. Its common form is for the architect to confirm in writing how he or she has understood the client's brief. The return brief is also used to raise issues with the client about matters in the brief that require resolution. The redirective return brief is a more ambitious tool. Its aim is to become a means to take a

conventionally conceived design commission (in any sphere of architecture or design) and turn it into a sustain-able project by structuring a particular kind of engagement with a client.

With the arrival of a new project and client, a return brief is a first move. In this respect, it needs to be judged in two ways: (1) its efficacy in prompting the client to think seriously about sustain-ability and in the long run, the Sustainment; and (2) its efficacy in prompting the client to modify their brief by taking up options presented in the return brief. These two actions may or may not exist in the same time frame. Strategically, a return brief can be presented to a client who has yet to seriously consider bringing sustainment and their activities together – hence it acts as an 'opening into thought', or at the other extreme, it can be the means to shift the balance of the almost-committed into commitment. In such settings, the return brief needs to be seen as both a vehicle to introduce new ideas and an object around which to negotiate.

The essence of a redirective return brief is to say:

> *yes I have understood what you have asked me to do, and I am able to do it in the manner expected. However, I would like to take this opportunity to put some additional suggestions to you. These are based on the universal and particular imperative of sustainment.*

How this is done requires considerable strategic *nous*, skill and finesse. First, an argument has to be put that brings the need for sustain-ability and the client's needs into convergence; and then the options put forward have to be attractive, workable and economic (both in terms of cost and returns) within the context of the client's resources. The entire exercise needs to be well researched; the strategy and the options put forward have to be completely coherent; and the rhetoric and employed needs to be totally appropriate to the client. All of this is a design exercise in its own right, especially in re-lation to the options having presentational appeal supported by deliverable sustaining substance.

Example

The focus of this example, also undertaken by the EcoDesign Foundation was a brief issued by a housing authority for a small town in northern New South Wales, Australia in the recent past. The task this client specified was to undertake a study of a small public housing estate (thirty-six houses) to evaluate: (1) if the estate could be retrofitted/refurbished on ESD (ecologically sustainable development) principles, which it took to mean the likes of renewable energy; improved thermal performance via insulation, cross-ventilation, shade management and glazing; organic waste management and recycling; water harvesting and grey water reuse; or (2) if it would be better to demolish and rebuild the houses to a higher level of environmental performance.

The return brief proposed a site visit and a series of interviews with residents and housing authority officers. It demonstrated a capability to conduct the study in the required terms but also offered an option of a more comprehensive approach (which was accepted). It proposed to undertake re-master planning of the estate with specific reference to issues on the quality of its links to surrounding areas, including the local retail area. The structural condition of all houses was to be considered with the possibility of those in poor condition being demolished and their land sold to provide revenue for a more ambitious 'ESD' retrofit programme.

The study proceeded in the manner outlined. The houses were found to be in varying condition (some very well cared for, a small number in a very poor state, many sound but in need of maintenance). Design concepts were produced and presented in accord with the main recommendations. The most significant of these were: (1) demolition of three houses with land sales to fund a retrofit programme to take all remaining dwellings to a higher level of environmental performance, by introducing, for example, insulation, reglazing, solar water heaters, dual flush toilets, rain water tanks and additional shade where needed; (2) converting some houses into two self-contained flats and enlarging others by infilling between two houses to make one. The latter proposal was based on research findings that showed a

mismatch between house type (three-bedroom family homes) and the needs of the housing authority's client base (large single-parent families and old, mainly single people). The intent was to create a convergence between social and environmental needs.

A Note on Design Teams

Design teams are now a prerequisite for almost all large and complex design projects. Frequently, team members stay very much within their disciplinary comfort zones. Various team-building and bonding methods have been employed to improve team performance – approaches vary. Assembling teams that mix members with broad areas of knowledge and problem-solving capabilities together with others with highly specific 'deep' knowledge and problem-solving skills is one favoured approach. Another is to surround the team's object of engagement with a range of specialists all focussing on the same problem from their different perspectives. Can redirective practice provide an alternative way of creating and operating a team? The quickest and most immediate answer is yes. Redirective practice can provide team members with a shared meta-foundation of knowledge and a common political objective. Team development commences assuming solidarity and a shared theoretical framework (relationality) that itself facilitates the positioning and exchange of knowledge. Most crucially, these characteristics mean that the basis of the team is not merely instrumental.

In contrast to having just a pragmatic investment in team project success, redirective action towards sustain-ability can provide a far more grounded and motivational *cause* for effective collaboration. Rather that constituting a team, what is actually formed is a change community that shares the *belief* that the Sustainment has to be treated as sovereign (a rule to be obeyed). Such a belief is compatible with enabling people to act with 'commonality in difference' – it is not compromised by any particular theological attachment. A team whose members believe in 'the rule the Sustainment', acting as a change community, act with a foundation that subordinates both the project

and their contribution to it – while there are issues of practical negotiation, collaboration is necessitated rather than just desired. The key issue for the members of such teams is commitment.

Commitment to sustainment is not a rhetorically expressed intellectual position, but a matter of ontology. Those existing values, ambitions, dreams and desires vested in the defuturing status quo and held for a lifetime, cannot simply be rationalized away. Commitment to sustainment is thus a work – it is something to be done. This means that changes one makes in one's life – what one buys; the amount of non-renewable energy one uses; the kind of work one chooses to do; how one cares for oneself, one's immediate human and non-human others, one's environment – all become significant means in one's self redirection and re-designing. To understand the self as 'the work' folds back to the comment made in an earlier chapter that the first act of sustainment is sustainment of the self. It also undercuts the common misconception that individual actions count for little when measured against the 'state of the world' – the point of such action is fundamentally not about 'saving the planet' but rather, initiating those ontological changes that establish the self as a change agent committed to sustainment.

The function of a team committed to sustainment is twofold: to provide a working environment that supports the ontological transformation of its members, and thereby their commitment to sustainment; and, to advance sustainment via the work it undertakes.

Working on activities that develop the idea, practices and processes of sustain-ability creates a conceptual language of engagement that can be shared by all team members – this facilitates designers and non-designers working together. The team and its ethos reframe all activity within the regime of time that is defined by futuring – the notion of time as anthropocentrically *finite*. Understanding time as 'being that is defutured by unsustainability', viewing sustain-ability as time-making and as what the Sustainment maintains – all of this becomes foundational team knowledge.

This understanding of time is clearly very different from time as measured by the clock or time as relative to the speed and distance of 'heavenly bodies'.

As we shall see in the next chapter, the actual relation between design and time is central to sustain-ability (now graspable as an act of time-making in the service of futuring).

Everything said here on teams is not opposed to improving the operational performance of teams – although it does qualify the forms of knowledge employed, whether broad or specialized. In fact some forms of 'knowledge' would actually be disabled or even eliminated. Certainly, a team working redirectively would have the potential to take personal and professional development to another level than those motivated by corporate and commercial goals.

Case Study: An Architectural Practice in Transition

This case study reflects on problems and attainments of Gall & Medek, a medium-sized Brisbane architectural practice in transition from producing architecture aiming to be 'sustainable' to becoming a redirective practice.[5]

Currently Gall & Medek have a workforce of ten. The practice has done outstanding and award-winning work in public buildings, urban design and housing (public and private). Their most celebrated project to date is the Lark Quarry Dinosaur Trackway Museum, located in the desert just over 100 km west of the small western Queensland town of Winton. The museum and its viewing platforms are built over the 93 million year-old footprints of a stampeding herd of dinosaurs – an event that the museum interprets.

Jim Gall and Bruce Medek established the practice in 1996, after studying architecture together at Queensland University of Technology. Before this, Jim had gained a Bachelor of Science in Environmental Science at Griffith University, which meant being inducted into a 'holistic' and interdisciplinary approach to knowledge on and beyond 'the ecological'. Jim's knowledge in this field became one of the main drivers of the practice from its inception. For more than a decade now they have established the practice as a local and regional leader in the field. However, as 'green' buildings have become the

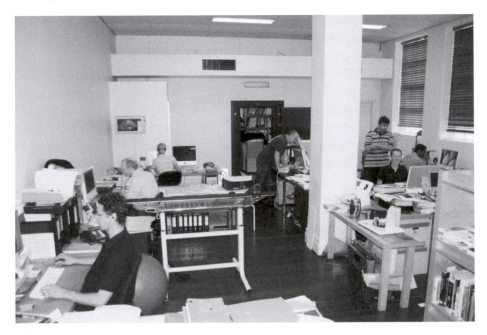

26 Gall and Medek at work

progressive end of mainstream architecture, Gall & Medek's position has become less distinct. There are now many architectural practices in Brisbane and in Australia more generally, claiming expertise in 'sustainable' design. So although Gall & Medek's applied design philosophy is more sophisticated than the predominantly biocentric view espoused by most of their competitors – for instance, their design thinking recognizes 'there is nothing but environment' (which is to say we humans are never on the outside of the multiplicity of forms of place that constitute 'the environment') – it becomes increasingly difficult for the practice to distinguish itself from competitors.

Times They Are A-changing

Influenced by discussions and writing on redirective practice by Team D/E/S, a conversation on the topic began informally in Gall & Medek practice meetings. Effectively, the process of adopting redirective practice as a basis for staff development was initiated, with the lead being taken by Jim Gall. This led to a number of projects, Boonah Two, discussed earlier in Chapter 4, being one of them. There was general recognition that redirective practice was a substantial concept that had the potential to differentiate Gall & Medek from their competition.

The transition is still 'a work in progress'. Generalizing and acknowledging that people move at variable paces, it can be said that interest in, and commitment to, redirective practice is evident in work produced. The intellectual leap to a new kind of thinking is still partial, while the ontological shift to a new sensibility has been slower. The reasons for this are more structural than personal; they connect to problems of organizational change in general and to the professional culture of architecture in particular. The nature of the economics of a service provider is also a factor.

Change within any form of organization, including the home, can generate insecurity among people. This is sometimes spoken, but most often it is silent. This is understandable, for change often equals an abandonment of attachments to the familiar. It can be resisted even when it is unambiguously clear that the advantages of changing outweigh whatever has to be sacrificed. Obviously, when the consequences of change are not altogether evident, insecurity deepens. Architects, like other professionals – perhaps more so – have deep attachments (to their professional identity and the profession's status; to architectural objects and aesthetics; to their own creative and technical processes and more). These attachments are indivisible from the nature of architectural education and architectural journalism, with its focus on heroic architects and iconic buildings. Against this backdrop, to imply, or directly say, that becoming a redirective practitioner requires subordinating architecture is going to generate 'drag', with movement weighted down with baggage that needs dumping.

The resistance can take two forms: (1) a suppressed rejection whereby the rhetoric of redirective practice is strategically embraced within the dynamics of the office, but is not actually felt as a need for change; or (2) minimal engagement and silent subversion within which the status quo is aggressively adhered to. Doubt, producing a reluctance to commit without evidence that the gains are going to exceed the losses, is viewed as appropriate. This is to be expected and should not be confused with resistance.

Based on the experience of critically encountering the education of architects, as a teacher, a visiting speaker and an examination jurist in several countries, it seems to me to remain perpetually problematic. To explore this view at length would stray too far from this case study, but there are some relevant general observations to make.

In many institutions, architectural education becomes an island unto itself wherein what is taught is neither grounded in the actual demands and problems of practice nor in those areas of critical knowledge that give the architect sufficient intellectual capital to adequately understand the context in which architectural forms sit. Anthropology, sociology, economic and social history, and even philosophy are some of these areas. This is not to say the architect has to be some kind of super polymath, but he or she needs to have a sufficiently broad knowledge to grasp something of the past, present and futuring complexity of architecture. It is not that architects should be able to solve all problems encountered, but that they should have the capability of identifying them. The sad fact is that for architecture and many other disciplines, there is a lag between forms of learning that replicate unsustainability as thought and action – what could be called 'education in error' – and the introduction of knowledge in the service of futuring. Any claim that a good deal of education is neutral invites challenge.

Writ large, this means not just an induction into learning how to design the unsustainable but that the unsustainable (as a range of designed forms from large houses to high-end tourist resorts) becomes established as what is regarded as (aesthetically) desirable to design. Here, not only is the unsustainable not named as such, but it can even arrive under the banner of 'sustainable design'. For instance, 'sustainability' can be reduced to purely

instrumental issues of building performance, while the totally unsustainable activity that the building houses is overlooked because this is deemed 'outside the remit of the architect' – an oft-voiced, pragmatic position of service provision that negates the ethical.

Notwithstanding the length of time it often takes to gain an architectural degree, what many experienced architects point out is: that the exposure to the discipline's intellectual and cultural history is now being neglected by many architectural schools; that the young architect's induction into the search for knowledge is slight, resulting in research that is frequently superficial and instrumental (but presented with opinionated conviction) and that the understanding of design gained is very limited and object focussed. One can add that some of the areas of knowledge becoming central to contemporary architecture, like 'sustainable or ecological' design, exist within courses merely as elective subjects.

More specifically, there is the error of conceptualizing complex projects without their complexity ever being adequately identified. An architect acquaintance of mine, for example, was invited to run a project for a group of advanced students on the design of an opera house. His first question to the group was: who has ever been to an opera? Answer: nobody. His second question: who has ever listened to a recording of an opera or watched one on TV? Answer: nobody. The last question: who thinks the absences of experience of opera presents a design problem? Answer: nobody. The unstated assumption (and as the Sydney Opera House has demonstrated): the architecture is what's important, and anyway it's the acoustic engineer's job to get the place to sound OK.[6]

One of the most fundamental problems with architectural education is that it is very successful in inducting proto-architects into a disposition of error that lasts a lifetime – unless intellectually or experientially challenged. This disposition manifests itself in different ways, like reducing design problems to: (1) a series of technical issues to be practically and economically resolved; and (2) the resolution of the aesthetics of a project to the satisfaction of the architect and their peers. Effectively, a great void exists between the poles of the instrumental and the aesthetics (which itself only exists in an impoverished

formalist sense). Vital knowledge on the actual 'being of the building' is absent.

These absences add up to an inappropriate and false sense of what architecture is, and a lack of knowledge of how design acts as a structuring element of not just particular environments, but equally of socio-cultural futures. So, while to a lesser or greater extent, graduates acquire skills, instrumental knowledge and an aesthetically refined sensibility, all of this exists in a limited frame of understanding, imagination and action. At the same time, the culture of architectural education – particularly its duration and forms of pedagogic practice – ensures that a very substantial investment of the self is made in this condition of delimitation (which can mean that a very defensive subject is constituted). Effectively, a particular way of viewing the material world is created that restricts how the world, as a complex interrelation of ecologies and environment is seen. What has this brief critique of architectural education got to do with Gall & Medek? A great deal – it partly explains why change is slow and difficult work.

The problem of making the transition to redirective practice does not arise because staff are especially hostile to the idea – nor is it a problem of specifically reactionary personalities (though the issue of personality is present in every workplace). Rather, as the comments on architectural education suggests, the obstacle is the ontological investment (the *sense of being* an architect) travelling with the afterlife of architectural education. The problem has to be thus engaged at the level of the ontology of subjects inducted into error (a problem we all share). Education for sustain-ability has yet to arrive – which means we are dealing, by degree, with problems of our selves as well as others. Thus there is no error-free position of moral superiority.

As well as the structural (ontological) presence of resistance, neither expressed nor felt as such, redirective practice currently competes with the market forces of a busy practice (the pressure to get jobs out the door). What is remarkable is how much has been achieved in these circumstances, but redirective projects alone are not enough. To go beyond this, to gain serious momentum, to have the ability to recognize and create substantial opportunities, and to been seen to be establishing a position of professional leadership,

something has to change. Time and money have to be invested to establish a change platform that will generate a new ethos, design ontology, internally generated and externally supported projects and market profile.

The change platform has to be established in a way that can be seen and felt to be different from the everyday life of the practice by all involved. It has to be built with care as a space of internal experimentation and affirmative competition between the old and the new. It has to be a space to which people and resources can migrate as momentum gathers. It would require aiming to making all architecture projects redirective while, more ambitiously, developing purely redirective projects. As a *starting place* these activities requires to be given an inviolate time and space. Realistically, for a practice like Gall & Medek, this would need to be of the order of say four hours a week by two rotating facilitators, with all other staff involved between four and eight hours per month.

27 Cuneiform tablet fragment (2600 BC)

9

Methods of Change 2 – Designing in Time

Fundamentally time is a medium, not a measure. Aristotle expressed this when he defined time as 'the event in which things occur'. While, as measure, time is considered to be independent of our being, as event, it is the product of human perception giving meaning to observed change. Human being (from the duration of an individual life to the life of the species) is an event in time – we, as a singularity and as a totality, arrived at a particular moment and as finite entity, we will cease to be at some point. Crucially, the arrival of this ending is partially in our own hands – again as a singularity and a totality. The more sustain-able we become, the greater the chance that we will increase the duration of our being-in-time. What we collectively design and make; our

way of life; and how we treat the world around us – are all decisive. So too is how we think and act in relation to these activities in time. While the inability to project our action in time (as illustrated in Chapter 2 with the example of nuclear power) seems to be a structural limitation of our mode of being, overcoming this condition and acquiring much greater futuring capability, will become an increasingly vital factor for securing our ongoing being.

There are some concepts and analytical tools used by architects and designers that foreground the issue of time in the design process. One, widely used, is the concept of 'design life', which refers to the *specified* (minimum functional) duration of a product, a building, its components or elements. Another is 'life-cycle' assessment, which involves quantification of energy inputs and pollution outputs from the extraction of raw materials, processing and manufacture of a product through to its use life and its disposal, remanufacture or recycling. Despite such concepts, the vast majority of architects and designers work with an extremely underdeveloped sense of time. Predominantly they are preoccupied with matter, form, function/use and space. The past quickly fades into a condition of indistinctness, while the future is a void. What is seldom recognized is that the past, relativistically, can travel with time and exist as an eternal present. For example, in an individual life, events remembered from the trauma of war do not necessarily diminish in intensity with the passage of time; rather their vividness arrives and is lived everyday. The same goes for a culture; so, for instance, the eight Crusades in the Middle East (starting in 1096 and ending in 1291), for contemporary Arab and Moslem cultures, are not completely forgotten. For them, the Crusades are not obscure, movie-framed events as they mostly are in the West, but a living presence, understood as having significantly impacted upon how their cultures have been positioned in the world.

Even more problematic is the way the future is so often thought to be a void, a *tabula rasa* waiting to be filled or written upon. The reality is very different. A great deal of the future is delimited by what we have already thrown into it. The future is filled with the attainments and mistakes of the past, which enable or disable possibilities (our own lives, of course, mirror this situation).

The future, so understood as a fate already partly sealed, travels towards us. This is graphically illustrated by the example of climate change induced by global warming. Because greenhouse gasses can have an atmospheric life of 200 years or more, we live with the past and the coming future of climate change no matter what we do – yet few people, especially policy makers, are even trying to think and plan action in this time frame. The impression they give is that it is a problem to fix and once fixed it will have gone away.

The fact that the future can never be viewed or fully predicted does not negate our responsibility to identify possibilities that beg precautionary action, not least by considering those probabilities that result from what we, through our own actions, bring into being. Redirective practice serves futuring and so aims to secure and extend time in the face of the defuturing momentum of unsustainability; at the same time, it also announces the imperative of 'designing in time' as a crucial methodological aspect of the practice. In the recognition of 'design designing' and the 'future travelling toward the present' learning how to design from 'the future to the present' becomes especially important.

Futuring Scenarios and Design[1]

Futuring scenario building is the key methodological tool of designing from the future to the present, as indicated by the Boonah Two case study presented in Chapter 4. As will become apparent, futuring scenario building not only requires a considerable amount of time and research but skill and practice. The basis of futuring scenarios is not 'what will be' or even 'what might be' but 'what potentialities beg interrogation' – this for possible precautionary design responses. This kind of scenario has to deal with both a moving present and future. A linear evolutionary projection from the present is simply incapable of giving a workable picture of this kind of change. The process actually has to proceed by dialogical steps: starting by establishing a view of what in the present is future determinant; then using this knowledge to elaborate a future. This has two implications: (1) 'impact events' have to be factored into

the notion of a continually modified 'present' and (2) scenario development has to be relational. What this actually means is that a change in any one sphere, for example the biophysical environment has to be traced as it triggers change in the other spheres of human exchange (political, economic, social and cultural). Complexity is not, of course, any guarantee of accuracy, but it moves doubt into a far richer register of consideration.

While the story that is to be enunciated is a fiction, it has to be written from well-researched sources. Moreover, writing such a scenario requires a critical imagination in which creativity cohabits with a sceptical view of sensational predictions and simplistic technocentric solutions to complex problems. The narrative written has to be more than just a credible research tool as measured against the possible (rather than the plausible). It is not a presentational document, but a reference work.

In so far as a specific time in the future is fixed as the narrative's end point, with impact events and transformations elaborated up to that moment, the design task is to design back from that moment. Unless this is done, later events can make earlier decisions redundant or expose them as inappropriate. For example, a conventional projection might tell of events taking place over the course of a century, starting with the idea of building a city, which is subsequently designed and constructed; it flourishes and then is destroyed by a great conflagration. In contrast, designing from the future identifies the environmental and climate risk of a major future fire and this then informs the site selection, design and construction of a fire-proofed city, characterized in its initial concept.

Obviously, the field of action of the scenario can traverse a broad range of geographical, chronological and situational parameters; however, it has to stay within the realm of credible fiction and not stray into impossible fantasy. The voice that speaks the scenario – the narrator – should reflect an appropriate point of view (and thus not be the redirective practitioner). More than one voice can assist in establishing a critical and credible narrative. Thus, different kinds of expertise, cultural backgrounds or politics may significantly and productively change perspectives. Having said this, there are no established rules of format – thus other modes of narration are possible.

The only criterion is that they have to work! Equally, a scenario needs to show a general contextual awareness in relation to the linking of events. For instance, the scenario might move from environmental and economic changes within a nation as climate change starts to bite deep; this is then placed against the backdrop of major global geographic transformations – including land in some parts of the world starting to be abandoned due to both inundation from rising sea levels and higher temperatures making agriculture impossible. Associated with these events is an increasing scarcity of food and fresh water in these regions. These circumstances combine to produce millions of refugees who inflame the already growing global problem of population redistribution prompted by climate change.

The scenario needs to be elaborated in more detail than just linking events. It needs to attach itself to specific circumstances in which the events can be plotted within a narrative that can be tested for its credibility. Thus if we take the events outlined above, one might tell a story of the abandonment of several major world cities over a decade; massive transportation problems in trying to move tens of millions of environmental refugees; regional food crises causing large-scale food riots; and the challenges of trying to physically, economically, socially and culturally absorb hundreds of millions of people into existing nations that are already under environmental stress.

In an inchoate manner, media coverage is bringing actual and potential faces of unsustainability into view. But to be countered, such events have to be visualized and designed against as they exist in their relational complexity. Just try to imagine the coming together of the following:

- EVENT 1 – Japan hit by major earthquake with massive radiation leak from a destroyed nuclear power station.
- EVENT 2 – Economic and social destabilization resulting from 'peak-oil crisis' going critical; the global energy market breaks down and complete turmoil follows.
- EVENT 3 – Dramatic escalations in conflicts over natural resources, especially water, with micro-wars breaking out in southern Europe and across Africa.

The point of this exercise is not to try to spread doom, gloom and fear but to communicate that precautionary design becomes more important by the day and that it has to be able to contemplate large-scale relational complexity.

What even a slight venture into futuring scenarios makes absolutely clear, is that design knowledge and imaginaries beg considerable and rapid development. Many design challenges are already clear, although there is an international resistance to naming and facing them – whatever the dangers (from fear of panic?) ignoring them is unquestionably a greater risk. These challenges include: climate change demanding a new kind of protective architecture along with adapting existing structures to increasingly hostile climates; developing extreme climate protective clothing; decommissioning cities at risk from rising sea levels and relocating their populations to new ones; moving hundreds of thousands, let alone millions, of environmental refugees around the world; meeting national fresh-water crises and conflicts; and dealing with large-scale energy and related economic crises.

Such design challenges demand the formation of numerous teams worldwide; fully elaborated scenarios; the mobilization of an enormous amount of design intelligence; a massive redirective programme; immediate and long-term implementation planning. Can this happen? Only if a sufficient critical mass can be created – which has to be seen as a design challenge in its own right. The claim here is not that designers (and thus design) magically acquire positions of higher order leadership but rather that they learn how to develop and deploy political strategies so as to gain comparable status as setters of direction to those who currently establish future agendas – politicians, policymakers and corporate leaders. The implications are that redirection by design becomes ever a more critical and vital practice; that current leaders are deficient in that prefigurative ability that characterizes design – and designers, within the frame of redirective practice, make the case against merely providing supporting/service roles and embrace leadership.

Using futuring scenarios as a tool in designing from 'the future to the present', at a time of enormous, unprecedented and unnerving challenges, would extend the role of the designer even further beyond the already extended position which has been implied so far in its subordination to redirective

practice. Not only is this challenge evident in terms of the amount of research required, but also in plotting relational questions and finding ways to appropriately respond. Effectively, the current restricted view of design as a professional domain with specific practices addressing delineated objects – structures, products, images and so forth – has to be subsumed within a larger frame.

Design Scenarios (Conventionally Progressive) versus Scenarios of Design (Radical)

As we have argued, the kinds of changes indicated by redirective practice in general, and designing from 'the future to the present' in particular, are not going to occur spontaneously. Most of the design community is not going to immediately transform its commercially grounded practice and embrace radically new ways of thinking about design. The hype and ontology of 'managerialism', ideas of 'new creativity', uncritical views of 'globalization', the 'romance with technology', the vacuous world of fashion – none of these features of the current 'world of design' are going to evaporate. Yet, as we argued, being elemental to the unsustainable they have to fall by the wayside. If the rate of expansion of the unsustainable is to be curbed and surmounted then design conduct and practice has to change.

The pressing question of 'where is the agent of change going to come from?' again reasserts itself. Certainly, it will not come from one source, but from the strategic actions of uncoordinated and convergent fragments – this is another way of saying it will come from the 'commonality in difference' of design within an amassed body of redirective practitioners who while acting independently, and in different ways, are all oriented to the same goal of sustainment. Obviously, this development does not depend on every architect and designer marching in step to the same tune. All that actually matters is that a sufficient number head in the same direction (toward sustainment), using whatever methods come to hand. As soon as links are made between these redirective practitioners, a culture of learning starts to form. The takeup of redirective

practice and debate around futuring scenarios has already started.[2] The debate on the future and scenarios traverses a movement between *design scenarios* (projections of possibilities by design as currently understood) and *scenarios of design* (an exploration of how design could be other than it is). Rather than affording confrontation, this debate opens dialogue on the possibility of objects of common and critical focus.

Design scenarios while not new, and although taking many forms, have been given increased momentum in the past decade by a concern with 'sustainability'. Most notable has been *Sustainable Everyday: Scenarios of Urban Life* – an exhibition with a major book/catalogue publication.[3] The project was led by Ezio Manzini and François Jégou. The exhibition formed part of La Triennale di Milano in 2003 under the patronage of the United Nations Environmental Programme. The content of *Sustainable Everyday* was generated by a series of rolling workshops held in ten developed and developing countries. The approach was framed by the Brundtland notion of Sustainable Development and its social agenda of inter-generational equity – an orientation that we have already criticized – plus the natural resource reduction target of 'factor ten'.

Sustainable Everyday's approach follows the mainstream and dominant 'have your cake and eat it' model of sustainability and sustainable design whereby improvement in 'wellbeing' and the 'quality of life' come via the market place and the extension of capital logic via new developmental modes. The pitch strategically underplays the scale and nature of the problems to overcome (bad news deters!) and plays up sustainability as a 'good news story'. This approach is increasingly common among promoters of sustainable development and it smacks of soft-sell marketing. Without suggesting the project was undertaken with anything but honourable intent, one has to ask if such a strategy is, in reality, inept or actually even ethical. Of course, the fundamental problem with a project that depends on large-scale grant funding is that there are few, if any, major funding sources that will fund projects that are actually progressive, rigorous and radical. Such projects would occupy a counter position which says that unless the extent of the problems of unsustainability are attempted to be squarely faced, put in the public sphere,

and recognized as causally human, then there is little chance that appropriate responsive actions can be taken.

The actual substance of the *Sustainable Everyday: Scenarios of Urban Life* approach is socially pluralist, semi-technocratic and favours conventional sustainability mechanisms: waste reduction and recycling; renewable energy; consumption demand reduction. This delimits the scope of the scenarios that came out of the workshops, like, for instance: a rooftop-based clothes washing and drying service (China); time-share offices workspace (Japan and USA); community networking (Korea); bicycle-centric cities (China); computer call-up bus service (Italy); and a home-made food service for office workers (India).[4] The project presented many more examples and it is clear that for workshop participants it was a rich learning experience, but overall, one has to say, that what was finally presented was not very exciting and not the kind of stuff to spark imaginations or motivate activism. The 'solutions' paled in front of the scale of the problem, even on a 'let a million flowers blossom' model of change and action. There were also three massive absences: productivism and population (the capitalist mantra of growth inscribed in all economic activity amplified by the still rapidly growing global population); the gigantic global explosion of squatter cities and their informal economies that often manifest extraordinarily creative sustaining design solutions and the crucial interface with the rural.

As an object of common focus *Scenarios of Design* can initially facilitate the gathering of conjunctural forces (like, situated crisis, critical actors and transformative knowledge) and people wishing to be change agents (be they architects, designers or others who design by default). In such a context, *Scenarios of Design* have the potential to provide a political frame for learning and an affirmative confrontation with ethical responsibility. Such activity can be posed in relation to forms of local, organizational, single-issue or political party activism that, when well conducted, can engage whatever is deemed in need of change with a scenario able to voice and visualize constructive options to the resisted direction – this as an alternative to traditional forms of political opposition.

Scenarios of Design can also be mobilized by progressive staff and activist students against the kinds of institutional stasis common in architectural and design schools that remain locked into feeding the supply chain of architect/ designer service providers. Likewise, they can also be used as an exploratory instrument by 'platform builders' within organizations who have initiated a change process, or as a vehicle of professional development, or both.

Effectively, *Scenarios of Design* can provide a mechanism for politico-practice in which ideas can be given a concrete form and dialogues or narratives of change can be rehearsed in ways that enable participants to re-educate themselves via critical confrontations with things as they are versus how they could be. For this to happen, scenario creation needs to be prefigured by:

1. *A coherent change agenda – understanding what is desired to be changed from/to with the scenario being a means to articulate this change.*
2. *The structuring of modes of cooperation – the dynamics of the group working on the scenario itself begs design rather than chance.*
3. *The use of a deconstructive methodology able to undercut working from existing unexamined foundations of thought.*
4. *A rigorous understanding of the problems that prompt the scenario (negotiating this activity itself can be socially and conceptually constructive) and an identification of human and non-human (object/things) change agents that the scenario would require for its realization.*

It is from these perspectives that a *Scenario of Design* can expose and examine what design could be as a 'remade and remaking' applied intellectual practice created by forging conceptual and operational connections to redirective thought and practice. Such scenarios could be considered as profoundly anti-utopian means to extend and develop critical facility, intellectual influence and add political muscle to the existing and slowly growing, if fragmented, critical design community. All this is to say that rather than just devising a desired destination (utopian) the scenarios equally focus on how to get there. *Scenarios of Design* could also be employed more widely to generate dynamic

public debate on futures. In so doing they could provide a powerful means to give redirective practice exposure in the public sphere.

More than this, imagine, for example, supplementing the idea and frequency of design conferences and symposia with, on an equal scale, scenario events that, in contrast to exchanging ideas, explore the methods and possibilities of how things can be other than they are on the basis of how they 'need' to be. Clearly, as already implied, this activity would have to be shielded against technological romanticism, wild fantasy and unchecked utopianism by being grounded in imperatives and transformative process rather than 'idealized fictions'.

Revisiting Time

Bluntly, what unsustainability and associated defuturing actions actually tell us is that the amount of time that humanity has to save itself from itself is very limited. Certainly human beings are ingenious, and our fate is not sealed – but only if we learn the vital lessons of sustain-ability and practice them.

We are on the edge of a new epoch – one in which the uncertainty and fragility of our existence will not be able to be suppressed. We are moving into the epoch of unsettlement, and time itself will become unsettled, especially as a psychology of deepening uncertainty about the very possibility of the future itself arrives. Most of us grew up thinking that time was endless. Increasingly more of us are finding out that this is not the case. The future is now something that we have to make together. The more this seeps into our consciousness, the more it will change us.

Modern times ended before the century that announced them was over. Postmodernism was no more than an interregnum. We are now in time's endgame – and subject to our action it could be short or long.

10

Futuring and Learning the New from the Past

Just as design solutions can be found by explorations of non-Western cultures, so they can potentially be found and recovered from the past of all cultures. For this discovery to be possible, not only does a certain kind of archaeology have to be created but a particular imagination needs to be seeded and nurtured. In particular, we need to cultivate the ability to identify and extract design and sustainment principles from historical material and then transpose them into appropriate futuring forms. Doing this is not easy.

Rather than try to discuss this in the abstract, we are going to look at two case study examples – the first considers the contemporary relevance of *Ying Zao Fa Shi*, an ancient Chinese text on architecture; the second looks at the Brazilian re-invention of an earlier, charcoal-based method of iron-making.

Case Study: Book of the Ancient Past and the Unfolding Future

The *Ying Zao Fa Shi* (colloquially referred to as the *Yingzao Fashi*) is an amazing book written in China nearly a thousand years ago. It is remarkable for several reasons – partly because of its very survival, partly because of the dedication it engendered in those people whose care delivered it into the modern world, but, above all, because it still has an unfolding instructive value as a source of knowledge for the future.

The *Yingzao Fashi* was actually a massive tome written by Li Jie, the court architect of the Huizong Emperor. It was published in 1103. As well as being the oldest extant book on architecture amongst ancient Chinese scientific literature, it is also highly valued as a key work in Chinese architectural history. The internationally acclaimed sinologist Lother Ledderose describes it as '… voluminous, detailed, and eminently technical. There is no substitute.'[1]

Formally, the book recorded projects overseen by the Master of Works – the head of a public works department of the imperial government, responsible for the design and construction of palaces, temples, barracks, gardens, bridges and boats. Effectively, it was an instruction manual on standards for building construction. What prompted its creation was the government's desire to reduce the level of corruption of its officials. Builders were skimping on materials during construction and officials were turning a 'blind eye'– so they could later divide up and pocket the money saved. By passing laws that required a completed building to conform to the specification set-out in the *Yingzao Fashi*, corrupt practices were stamped-out.

The book was created and used during the first century of the Northern Sung dynasty (960–1127 AD), a period of enormous urban expansion and building construction in China. At some point the book fell out of use and was placed in a library archive, where it remained gathering dust for hundreds of years. Then, in 1919, it was discovered by Zhu Qiqian, a politician and scholar. He recognized its importance as a source of crucial historical knowledge but

it was not until 1931 that a detailed examination of the text began. This was done by an academic, Professor Liang Si Cheng, who over many years worked to make the text readable. He still had not finished the task when he died in 1951. Alongside the professor's work there was also an enormous search by a team of people to find buildings that had survived, so they could be examined and photographed to illustrate a modern reprint. Again, this was a labour of dedication spanning several decades.[2] The overall project was motivated not just by the significance of the book itself, but also by a wider nationalist desire to recover and develop the nation's cultural history.

By 1963, thirteen of thirty-four sections of the book were ready to go to press – these having been selected as the most interesting and important sections. All of this material had been carefully interpreted and edited, the illustrations had been redrawn, and photo-documentation done. An introduction telling the story of the book had also been written. Unfortunately this was the exact moment when the political climate in China was becoming hostile to people and projects that were in any way about recovering and celebrating the nation's past. By 1966 this political situation had turned very ugly and been named the 'Cultural Revolution'. Intellectuals working to preserve the culture of the past were now deemed as counter-revolutionary enemies of the Maoist state. Many were killed, more were imprisoned, a great deal of their work was destroyed and the lucky ones survived by concealing their activities and values. To save the *Yingzao Fashi* and their research material, the group put everything into hiding. Eventually the political mood changed. The group then recovered all their material and the modern edition was published in 1983 – some sixty-four years after the book's discovery.[3]

The Book's Significance for the Future
The modern version of the book is made up of exact copies redrawn from original line illustrations. These are mostly elevations of buildings, along with details of component elements and construction features. Many of the drawings were supported by photographs taken by those researchers who scoured the Chinese countryside seeking out the few remaining buildings that were

29 Yingzao Fashi/elevation

30 Yingzao Fashi/perspective

31 Yingzao Fashi/bracket detail

constructed in accord with *Yingzao Fashi's* design specifications. Besides captions, the book contains very little text.

Superficially, it could seem that this is a very culturally specific and arcane book but on closer examination it reveals itself to be a rich source of still very useful knowledge. To recognize this requires bringing a contemporary concept to it – 'design for disassembly', one of the concepts employed by 'sustainable architecture'. It is based on the idea of constructing buildings, which at the end of their life can be quickly and economically disassembled so their materials can be recycled. In practical terms, this means that a building with, for example, a steel frame and roof trusses, has all its steel components bolted together rather than welded (thus they can be disassembled). Disassembled components, subject to their condition and interchangeability can either be reused or recycled.[4]

Remarkably, construction design principles in the *Yingzao Fashi* are some ways in advance of those of contemporary 'design for disassembly'. While

32 Yingzao Fashi/part of the 'fen' system

all the buildings are timber and based on a 'post-and-beam' method of con-
struction, as well as stylistically being of their time and place, technically they
are extremely sophisticated examples of modular (as standard unit) design.
They use a system of standardization of parts based on units of measurement,
the basic unit being the *fen*, with fifteen *fen* making a *cai* and twenty-one
fen a *zucai* – the complexity of this system was increased by measurements
being relative rather than absolute (they varied according to the grade of a
building). This system centred on a highly developed geometry of scale and
unit progressions, which was applied to the smallest component through to
the largest structural element (which was the building in its courtyard).[5] As
building types were divided into specific grades of different scales and status
the number of *fen* making up a cai and a zucai were adjusted to accommodate
proportional changes. This system, of course, made interchangeability possible
within the same grade of building but harder outside it.

Absolutely everything in, and to do with the building, was dimensioned
using this system, even the labour time was made part of the system. So, if the
scale of the building was say a grade of 20 per cent larger or smaller than the
standard grade, then the amount of labour time for its construction followed
accordingly.[6] Besides its development of modularity, the *Yingzao Fashi* delivers
a vast amount of very specific technical detail. Especially important was its
attention to the many types of free-moving joints and ways to distribute loads.
The combination of even distribution of the weight of a building together with the
ability to deal with slight movement without being structurally compromised,
has been one of the main reasons why many buildings constructed according to
the *Yingzao Fashi* specifications have survived so long, despite clear evidence of
ground instability (free-moving joints meant the buildings could accommodate
a degree of movement while retaining their structural integrity).

As a design project, the buildings are even more interesting than their tech-
nical features. Looking closely at the illustrations, it is remarkable to discover
that they reveal an architectural language of components that makes it possible
to both compose and recompose different buildings by repositioning existing

component elements, and in some instances, making new components by 'cannibalizing' those elements 'surplus to requirements'. In other words, what was designed were buildings that, once built, could, at some future time be disassembled moved and then reassembled in a new form and with a new use – a temple becomes a hall, a hall a barrack room. Notwithstanding the issue of the problem of movement between grades, and the adjustment of the system of measurement, this kind of thinking is advanced even by contemporary standards. In many ways the *Yingzao Fashi* is conceptually more sophisticated than current sustainable building design, this not least because what it delivers is a 'system of buildings' (via a regime of eclectic limitation) and not just 'system building'.

While the West unceasingly appropriated the knowledge of other cultures, not least the Middle East, India and China, it kept the vast majority of its populations oblivious to the attainments of these non-Christian others. More than this, from the seventeenth century onward these cultures were characterized as backward.[7] Chinese attainments, in areas like metallurgy, hydrology and ceramics, which were, in fact, hundreds, even thousands of years in advance of the West, were mainly ignored or just partially and begrudgingly acknowledged. What the *Yingzao Fashi* illustrates is the need to keep judgements provisional. The book's relevance was never just a matter of what could be deduced from its images and text but rather how the ideas it carried can come to life in new ways in contemporary circumstances. As such it points to methods of reading other historical technical material.

What now follows is a case study that illustrates the recovery of something very tangible – this time a material, rather than a text – that was written off as impractical and of a past age, but which is now being recovered for its futuring value. Yet, as we shall see, there is a wide gap between the potentiality and the actuality. Its significance to design will emerge as the story unfolds.

33 Beehive charcoal ovens northern Brazil

Case Study: The Second Life of Charcoal and the Mini Blast Furnace

We are going to look at a Brazilian project based on a charcoal-fuelled mini blast furnace – charcoal started to be replaced by coal in iron and steel making in England 300 years ago and thereafter in most other nations around the world. Before going further, some historical background is needed.

The Planetary Price of Iron

One could argue that from the moment human beings started using fire, they were contributing to greenhouse gas emissions. However, the impacts were

modest until the birth of the European iron-making industry of the sixteenth century, which was the precursor to the excesses of the modern industrial age.

European iron makers used crude charcoal-fuelled 'bloomery' furnaces, which could not bring the iron to a liquid state. All they produced was a malleable ball of semi-molten iron full of impurities. To make the iron of any use it had to re-heated in a forge and the impurities hammered out. The job was hard, dirty and slow. But so was the task of collecting timber, building an oven, baking the timber to charcoal and then recovering it. Charcoal is fragile – treat it roughly and it can turn to dust. The only available transport was a simple farm cart and the nearest thing to a road was a rough track, so it was easier to bring the iron to the forest than the reverse. This was possible as the furnaces were small, basic and able to be built reasonably quickly.

Making iron in this way, combined with taking timber to build ships for fast-growing navies, decimated the forests of Europe. Such was the scarcity of timber that all British ships trading with North America in the early years of its colonization were legally obliged to return to their home ports carrying a cargo of timber. Likewise, such was the scale of forest destruction that environmental laws were introduced by Elizabeth I prohibiting the felling of trees within fifty miles of the coast. It was not until the early eighteenth century when Abraham Darby discovered how to make iron with coal (a discovery the Chinese had made thousands of years earlier) that charcoal-making started to wane.

Making iron and steel is a thermo-chemical process. The carbon becomes part of the molecular structure of the metal (effectively an alloy) at a certain temperature, having been drawn from combustion of the carbon-based fuel. Both charcoal and coal, once they have been turned into coke, are almost pure carbon.[8] While coal became the dominant source of fuel and carbon in iron and steel making, for a long time the highest quality European steel was made in Sweden using charcoal – but apart from this, the days of charcoal in Europe, and most other continents, could be considered to be over with the birth of the Industrial Revolution. In the past few decades, however, the picture has changed. These changes are set against developments and problems in contemporary steel-making.

Coke-based blast furnaces are very expensive to build and run; they are high emitters of carbon dioxide, especially the older ones with coke ovens that leak gases. Additionally, problems of managing air quality, waste water, chemical, solid and toxic wastes – all framed by issues of global warming – meant that these furnaces became viewed as a 'dinosaur technology'. But more than this, while most small, newly industrializing nations needed a steel industry for practical reasons, they could not afford industrial monster blast furnaces. At the same time, with limited amounts of foreign exchange, they could not afford the high cost of importing iron and steel. Of course, they also wanted a steel industry symbolically, as a sign of their modernity.

The arrival of the electric arc furnace (EAF) provided a partial, but significant, solution. Electric arc furnaces are comparatively cheap, smaller and quicker to bring into use – but they cannot make iron.[9] They are run using scrap steel, but scrap steel is not in large supply in still-industrializing nations. The dilemma for these nations with iron ore deposits was that they were unable to turn the ore into iron to make steel with the available affordable technology. Here is where charcoal-burning mini blast furnaces come into the picture but, as we shall see, the issues cannot be simply reduced to questions of technology.

Our story now shifts to Brazil, one of the few countries with a long history of using charcoal in iron and steel-making, plus having vast iron ore deposits in the north east.

Project Ferro Gusa Carajas, Maraba, Brazil

Ferro Gusa Carajas was a joint venture formed in 2003 between the US steel Nucor and Brazil's Cia. Vale do Rio Doce (CVRD) to produce pig iron – the project being based on the edge of Amazonia in north-eastern Brazil in the industrial city of Maraba, almost 1,200 km due north of Brasilia. The intent of the venture was to construct and operate an environmentally responsible pig iron project to produce around 380,000 metric tons per year. The iron ore for the plant was to come from CVRD's Carajas mine in northern Brazil – the mine, supported with World Bank finance, is claimed to be the largest source of high grade iron ore in the world.

When the mine was set up in the 1980s it was subjected to significant criticism.[10] The environmental safeguards of this World Bank-financed project were both geographically and conceptually limited. They failed to take account of the mine's socio-economic impacts on small producers outside World Bank loan agreements – it was estimated that this affected some 30,000 family-size small producers, mostly smelting pig iron plus large numbers of subcontractors.[11] The agreement was also criticized as it provided no means to enforce compliance and evaporated once loans were repaid.

The pig-iron plant, consisting of two mini blast furnaces, was to be fed by charcoal produced from the company's plantation 198 km east of Maraba – the plantation itself being 82,000 acres within a total forest area of around 200,000 acres. The kilns where the charcoal was made were at the same location. The timber grown for charcoal was a species of eucalyptus able to be harvested at seven years of age when the trees were around 18–20 metres high. Coppicing was used to ensure tree regrowth for future harvesting. The basis of the project was that the plantation would remove more carbon dioxide from the atmosphere than the blast furnaces would emit. Production began in 2005, with the total production going to supply Nucor's steel-making in the United States.

The project was soon revealed to be situated in a sea of controversy. First, as an organization striving to be environmentally responsible, the joint-venture found itself to be the exception in the midst of a large industry producing vast quantities of pig iron from crude charcoal-fired furnaces. This industry has been exposed in the past few years not only for being supplied with charcoal by hundreds of charcoal makers illegally logging but doing so using slave labour. The exposé, by the US business and financial services information service Bloomberg.com, reported in January 2007 that almost one million slaves were working in this industry without pay – officially Brazil abolished slavery in 1888.[12] Moreover, companies like Ford, General Motors, Toyota and Kohler had been buying this pig iron, via brokers and importing it into the United States.

The second issue centres on the fact that the total demand for charcoal was so large that it could not be met by the development of plantations, with the result that charcoal making was driving the destruction of old growth forest.

The third factor is that charcoal can be produced in kilns with low 'scrubbed' emissions (to rid them of particles and particulates) and with a high recovery of by-products, in particular pyrolysis oil and gas. These are fuels in their own right, with pyrolysis oil being the source of other materials like tar and acetic acid. This requires three integrated elements: a modern kiln; a retort and converter able to carbonize biomass.[13] However, the vast majority of the charcoal in the area was made in the crudest way possible, to the detriment of local air quality, the health of the workers and at the price of high emissions.

The picture we end up with is sobering. It exposes that the best of options – a comparatively 'clean-and-green' method of steel-making can be replicated elsewhere. But it also reveals an appalling environmental and industrial situation that, at the very least, codes the exported product with a tainted and undesirable image. In July 2007 *Steel Times International* reported that Nucor had sold its interest in the Ferro Gusa Carajas project to CVRD – obviously the sale could be seen just in economic terms but it is hard to imagine that socio-political factors were not also in play.

Conclusions for Designers

Ironically, to improve the human rights, ecological and emissions situations, some companies in the region are now buying in more costly coke. On the basis of the impacts from how and where the coke is made, and the loss of jobs and income, more questions beg answering. Sadly the progressive alternative – forming the existing small producers into new forms of collective organization to use advanced charcoal-making technology, linked to good forestry stewardship – appears not to be happening. What has been registered here is tragic. The production and use of charcoal has, as we have argued, a great deal of potential if it can be wrested from the ways it has been made in the distant and recent past. Notwithstanding the claims of the Ferro Gusa Carajas project, the manufacture of steel by charcoal-fired blast furnaces in Brazil, combined with the uses the steel was put to, is an overt case of sustaining the unsustainable.

What does this account have to say to designers? The answer is not in the detail, but what, writ large, it symptomatically indicates. It tells us that

we need to make relational assessments of the projects we potentially get involved in. Is the project a progressive contribution towards sustainability? If not, can a strategic contribution be made that could redirect it? Is the form of the project, or its context, fundamentally defuturing and if so can elimination strategies be identified? Notwithstanding the potential hardship that ensues, just pragmatically taking on unsustainable projects for economic ends and uncritically falling into line is no longer defensible. The aim here is not purity and poverty but redirection and efficacy.

34 Chains

Designer as Redirective Practitioner – New Roles beyond Design

An enormous amount of writing on design and the bulk of design education, is based on the proposition that designers and the design professions exist to provide services.[1] *De facto* it means that frequently the most crucial design decisions have been made before the designer comes on the scene – decisions like the nature of what is to be created, its market placement, technology and materials. A poor architectural brief can mean, for instance, that an environmentally aware architect is simultaneously designing a new structure while retrofitting the design concepts imposed by inherent errors in a brief, which are contractually inscribed on issues like site selection, site density, building size or orientation. Likewise, industrial designers may be engaged

to style a product with intrinsic technical and energy inefficiency problems, which they are not in a position to do anything about. Clearly, this kind of design activity will continue but, as has already been argued, it begs to be redirectively transformed, with such forms of transformation moving through various levels.

It is also the case that the 'democratization' of design via software design 'option selection' packages (be they for apartment floor plans, wine bottle labels or sports car wheel trims) is going to reposition the role of many designers. It will move many designers from being creative producers to becoming critics and process managers. At worst it will feed style surfing and Lego-like assemblage; at best it might generate a critical counter-reaction. In particular, it is likely that these kinds of applications will increase the number of uncritical practitioners. The positive and necessary response would be that this 'development' would prompt the rise of a culture of design writers and critics with the intellectual capabilities and political motivation leading them to identify and engage the futuring and defuturing qualities of everyday things and environments across a wide range of media..

It is important that such actions occur but they are just not sufficient. Strategically, the designer as redirective practitioner needs to be a leader, initiating as well as reacting. This means putting dynamic, rigorous and workable alternatives into the public domain. It means approaching the developers and producers of unsustainable things with radical but viable ideas, project proposals and practical solutions that present options for change that equally enable them to stay in business.

It is not being suggested that these activities be simply based around existing products, markets or user environments. Rather they point to the reconceptualization of organizational forms, strategies, projects, user environments, products and modes of communication, together with new kinds of social relations of production and use as well as product after life. Against this backdrop, redirective practitioners become key team leaders, potentially designing and directing programs of change. In another direction, it means the emergence of many more redirective practitioners as designers/producers who entrepreneurially put products and services into the marketplace to

assist in the development of an economy that foundationally shifts from a quantitative to a qualitative basis (more on this later).

Although there are no doubt many new things to create, the overwhelming need is to: (1) eliminate what we do not need, especially those objects/things that actively harm us or our non-human others and all that they depend on and (2) begin retrofitting the made material and immaterial world around us. Obviously this involves a huge amount of adaptation, intervention and remaking. In some instances it means conserving that which already exists, as it functions as a means of sustainment – but undertaking whatever work is needed so it may survive the environmental and climatic changes to which it will be exposed. In other instances it will require far greater modification of built structures to cope with, for instance, a region that is shifting from one climatic zone into another, or to deal with problems of thermal mass contributing to a local, but serious, 'heat islanding' problem.[2] It is also the case that non-renewable energy generation systems and much other infrastructure – including water, sewerage, transport and waste management – will require replacing or converting (so that resources like water, biomass, organic and inorganic materials can be recovered). In the coming decades, retrofitting will equally need to be taken beyond the techno-functional domain. Lifestyle and work cultures are also going have to change.

The clothes that we wear, the food that we eat and at which times of the year, the amount of resources it takes to maintain our way of life, the nature of our gardens and what can be grown in them, our relation to outdoor living, how and how often we travel, the kind of holidays we take and to where – much in our life will change. As for our working lives: the form and hours of our working day; what we make; how we work; the services we provide and the locations of our workplaces – all these elements will, by degree, change.

Redirection in the face of the defuturing propensity of the world of human fabrication is not a matter of choice. Developing a strategic sense of the nature and direction of that change over time is going to be crucial – to simply deal with problems as they arrive would be myopic in the extreme. Creating and employing a universal and coordinated organizational plan for change may be beyond humanity's current ability. However, the formation of forms

of redirective practice which are available globally to be appropriated and adapted in the next few decades, are not. Such a development is in large part enabled by the – in other respects – problematic mobility of labour (which includes the mobility of architects and designers), linked to what will be an ever-increasing global need for sustain-ability.

Looking at a Redirective Practitioner

The creation of redirective practitioners requires understanding in the context of two moments: the initial and the ongoing. The initial moment, the moment that is now, turns on bringing the elaborated idea of redirection to retrofit our own professional knowledge. This stage has two elements.

First is to undertake a reflective interrogation of one's knowledge, to begin to identify what one has formally and informally learnt and what, in hindsight, can be seen as 'an induction into error'. The implication here is that we are taught, and teach ourselves, ways of knowing and acting in our professional and non-professional lives that replicate specific forms of the unsustainable. We are 'educated in error', though of course, without this ever having been the intent – it is merely one of the structural manifestations of unsustainability as it is deeply embedded in our culture. At its most basic, we can expose to ourselves just how much of the performative character of our acquired expertise functions on the basis of unquestioned assumptions. Asking questions like: 'if what I am doing is actually useful or needed, and if so to whom and why? Is what I am doing any harm and, if so, what exactly is it that is harmful and to what or whom?' and 'is the direction my occupation is taking me where I should be going, and where I want others to go in the future?'

The second element goes to broadening one's conceptual reach so as to be able to identify what one's knowledge and practice are already connected to and, perhaps more importantly, to what it potentially could be.

In essence, the individual aim of this re-educative process is initially to strive to identify and eliminate the unsustainable from one's own particular

professional specialism by questioning and devaluing areas of one's think-ing discovered to be in error – this via critical reflection in the company of new or revisited knowledge. This should then provide both a felt sense and consciousness of the need for redirection and the motivation to do it. The re-educative process will hopefully increase the desire to gain greater sustain-ability to advance the cause and substance of the Sustainment. Such individual action can feed the collective aim; it can be a passage of entry into a community of change to become both a contributor and recipient of new knowledge and practice. Thus sustaining the self and expanding a conceptual and organizational frame of effective transformative action become united.

How distant is the prospect of the creation of a critical mass of autodid-actically and formally educated redirective practitioners? There are already educators around the world who have introduced redirective practice into their courses. Likewise, there are already postgraduate courses under way. Equally, as indicated in earlier chapters, it is already forming the basis of practice-based professional development. Realistically, while there are positive signs, a lot more momentum is needed. Yet there is room for some optimism in that ideas often have their moment and there are signs from various parts of the world suggesting that the time of redirective practice is dawning.

Of course, there is more to becoming a redirective practitioner than just the acquisition and mobilization of knowledge with professional competence. In the initial moment, which is currently unfolding, for the established pro-fessional, becoming a redirective practitioner requires gathering emotional resources to deal with the sense of loss and insecurity coming from what one eliminates in one's own professional life. It also requires the courage to become a pathfinder. For the graduate redirective practitioner it means making a career path rather than following one that is already available to pursue. Yet the political importance and adventure of the choice makes the sacrifices for some a non-issue and, for others, worth it.

An imaginary of redirective practice as a career path is not hard to envisage:

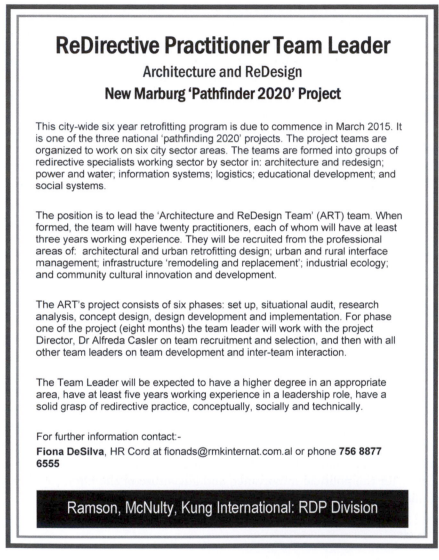

ReDirective Practitioner Team Leader
Architecture and ReDesign
New Marburg 'Pathfinder 2020' Project

This city-wide six year retrofitting program is due to commence in March 2015. It is one of the three national 'pathfinding 2020' projects. The project teams are organized to work on six city sector areas. The teams are formed into groups of redirective specialists working sector by sector in: architecture and redesign; power and water; information systems; logistics; educational development; and social systems.

The position is to lead the 'Architecture and ReDesign Team' (ART) team. When formed, the team will have twenty practitioners, each of whom will have at least three years working experience. They will be recruited from the professional areas of: architectural and urban retrofitting design; urban and rural interface management; infrastructure 'remodeling and replacement'; industrial ecology; and community cultural innovation and development.

The ART's project consists of six phases: set up, situational audit, research analysis, concept design, design development and implementation. For phase one of the project (eight months) the team leader will work with the project Director, Dr Alfreda Casler on team recruitment and selection, and then with all other team leaders on team development and inter-team interaction.

The Team Leader will be expected to have a higher degree in an appropriate area, have at least five years working experience in a leadership role, have a solid grasp of redirective practice, conceptually, socially and technically.

For further information contact:-
Fiona DeSilva, HR Cord at fionads@rmkinternat.com.al or phone **756 8877 6555**

Ramson, McNulty, Kung International: RDP Division

JOB DESCRIPTION

This city-wide six year retrofitting program was created under the Federal governments 'pathfinding 2020' projects programme as a joint venture with the City of New Marburg, the formal agreement being ratified in October 2014. As one of the three national 'pathfinding 2020' projects it is due to commence in March 2015.

These leadership projects are of major national importance. Through what are in effect three case studies, they aim to develop the knowledge, expertise and capability to enable the launch of the 'National Cities Retrofit Decade' during 2020. Using all three case studies, methodological models will be developed to enable every city in the nation to undertake this massive redirective exercise. They will be major drivers in the creation of a transformed culture and economy dedicated to securing viable futures for the nation's population, its biodiversity and the natural and artificial habitat of both human and non-human inter-dependence.

All New Marburg Team Leaders will need to be well qualified, exceptionally talented, have a highly developed understanding of urban metabolism and advanced methods of retrofitting. They will be completely committed to the project and their teams. Having the ability to recruit, select, build and lead a strong team is an absolute prerequisite of the position.

Essential Requirements

1. A higher degree in an appropriate area.
2. At least five years working experience in a leadership role with demonstrable inter-person skills.
3. Experience of work on at least three major retrofit projects.
4. A solid grasp of the redirective practice, conceptually, socially and technically.
5. A good understanding of the technical and socio-cultural aspects of retro-fitting.
6. Evidence of developed trans-cultural information and reporting skills.

Desirable Additional Capabilities

1. Fluency in Arabic, Mandarin or Urdu.
2. Familiarity with the GIS 77 Regal system.
3. Visual communication skills.

Application requirement: a letter addressing interest in the project plus the requirements of the position and a full CV submitted electronically in PDF New Form or Coda 1040.

Application closing date: 11 November 2014 to Fiona DeSilva, HR Cord at fionads@rmkinternat.com.al

Part III

Design, Sustainment and Futures

We cannot, as has already been made clear, solve problems unless we are willing to confront them, no matter how large, daunting or threatening they are. While holding to this view, it has to be acknowledged that this challenge is not quite as straightforward as it might first appear. Problems do not necessarily sit around for us in neatly packaged forms. So often they turn out to be held in the grip of the chimera of language as it, and then we, reduce the plural to the singular. For instance, we've stated anthropocentrism, unsustainability and climate change to be problems. But they are not simply representationally transparent; rather they recede into a monstrous complexity that places us in a position of continual questioning. In relation to anthropocentrism: how can that which is plural (the human) be the basis of centredness? When considering unsustainability: does not entropy reduce everything to the unsustainable? If we think about climate change: is not change the very nature of climate, so how do we distinguish one kind of change from another? The point here is to make the point rather than conduct the argument.

So if complete truth and certainty ever evade us, all we can do is maintain openness to revision and accept that we have to define problems pragmatically and act in relation to them but with rigour in how we define, analyse and seek solutions. Such action is not easy: we simply cannot write or speak with complete indifference or situate everything we say in a web of qualification. Thus, the truths we act on and communicate can but be deemed provisional – the true is true until proved otherwise. Provisionality therefore always

resides under the roof of certainty; thus most of what we say can be subject to correction.

The discussion of design, sustainment and futures in the final section of this book, as framed by these remarks, raises a number of significant challenges, which, if redirection is to become possible, have to be identified and met as best we can. Specifically, it brings us to a consideration of: how we dispose ourselves towards redirective action; what exactly we need to strive to bring into being; how this can be viewed economically; what politics of action to adopt and how we might make a map to guide us through the complexity before us. Acting decisively while being open to correction also means being willing to be pragmatic without becoming an ungrounded pragmatist.

37 Is any of this yours?

12

Futuring against Sustaining
the Unsustainable

Green design, green architecture, environmental design, ecodesign, sustainable design, sustainable products, ecoefficiency and sustainable consumption – all these have claimed to bring design, ecology and environment together over the past two decades. Many of the practices associated with them have a prehistory in the alternative and intermediate technology movements of the 1960s and 1970s (which in turn were prefigured by nineteenth-century techno-utopianism).[1] Such forms of action combine to deposit a variable range of problems and solutions that design futuring has to find ways to respectively engage. To gain a sense of these, it is worth putting a picture together by providing a brief review of five key positions:

1. Technology and technological salvation.
2. Design for sustainability.
3. From products to services.
4. 'Sustainable consumption' and design.
5. Humanitarian design.

This is done with the proviso that distinctions between positions will, at times, blur and overlap because that's how it is. While the focus adopted is weighted critically, it acknowledges past and present positive contributions of the strategic positions cited. It equally recognizes a widespread need for new thinking. The approach will be to characterize and critique each position, then contrast it with a version based on redirection toward sustain-ability.

Technology and Technological Salvation

Predominantly, most 'green/sustainability' design practices are based on the premise that technology can simply be created or modified and used as a corrective to a functionalist and systems-based definition of unsustainability and in so doing deliver 'sustainability'. At its most developed level, this is illustrated by notions of bio-mimicry and the idea of a 'technical metabolism' mirroring the way a biological metabolism cycles nutrients.[2] In other words, the unsustainable exists as a techno-environmental problem to fix. These technocentric models for approaching the delivery of 'environmental sustain-ability' are also associated with the notions of 'economic sustainability' and 'social sustainability.' These three elements (the three 'legs') of 'sustainability' were presented to governments and the corporate sector as constituting the pathways to 'sustainable development' (the 'three-legged stool').

This kind of understanding is theoretically unresolved and relationally disarticulated and it reduces sustainability to an end point, a goal wherein entropy is arrested and stability is established – all to be realized by some kind of administered process. However, the environmental, social and economic, as discourses, let alone the phenomenological conditions themselves, are neither

unidirectional nor structurally interconnected. Thus the crude stool or the more elegant triangular fractal tile (Ecology, Equity, Economy) of McDonough and Braungart are representational illusions with no actual referent.[3] If they were merely heuristics in making an argument from a particular position this would not be so much of a problem. However, they arrive with a realist truth claim (the theory equals a real set of worldly relations). They are not three components of 'sustainability' for *it* does not exist as a composite of the fourth elements drawn from the three (the 'three-legged stool' metaphor falls to the ground just as a stool lacking a structurally sound seat would).

In contrast, 'the Sustainment', as already introduced, names the convergence of an epoch which: (1) is cut loose from developmental capital logic of perpetual growth; (2) recognizes the unavoidability of the dialectic of sustainment (which means it recognizes that entropy/unsustainability/destruction are unavoidable); and (3) registers that our being is finite and that our collective existence is directly related to the sustain-ability of our futuring actions.

In some ways the project of the Sustainment structurally has something in common with the Enlightenment – it is an idea that travels ahead of the material forms it aims to author but without any sense of reaching an idealized end point. Whereas the Enlightenment aspired to bring the free enlightened subject into a fully realized modern world, the Sustainment is neither mono-directional nor a vision. Rather, what it adds up to is maintaining a condition of imminence, with being remaining bonded to becoming (thereby ensuring our being remains with potentialities). Put simply, the Sustainment is a way of thinking about our potential in the light of our continuity. It can be considered a common condition beyond mere survival that human beings can realize in different ways.

The Sustainment is a practical philosophy needing the input of many different kinds of thinkers, designers and makers willing to explore ways in which we human beings can take responsibility for our anthropocentric defuturing selves, while accepting Sustainment as a sovereign rule (one to which we may respond in numerous ways). It tells us that we are at the beginning of a new mode of earthly habitation.

The environmental problems of industrial society have been acknowledged for a long time, certainly long before they were understood scientifically. While problems, like the destruction of forests were evident well before the beginning of the Industrial Revolution, it was not until early in the Second Industrial Revolution (the age of advanced machines that commenced from the early nineteenth century) that a utopian recoil from these problems gained momentum. The response to environmental and social damage by utopians like Charles Fournier, Robert Owen and later Peter Kropotkin, was to propose 'solutions' based on creating a culture and economy of escape – effectively an ideal world within a world of imperfection. Utopianism has been remade in the era of late modernity – this not as a politically idealized vision of a redeemed society and economy but via a faith in technological redemption travelling in the company of technological expansion and carried by the idea of the 'techno-fix'. Such thinking was epitomized by Buckminster Fuller's notion of the planet as a spaceship to steer, manage and repair.[4] It is equally embedded in all forms of 'sustainable technology' and the policy that goes along with it – besides the limited and often questionable value of these technologies, they feed illusions of transformative agency and power: 'if only we had enlightened government we could get the energy, fossil fuel and emissions situation sorted out.' The trouble is, so long as the idea rules that the global energy supply has to go on endlessly growing, problems will proliferate. The most basic, obvious and important action just does not get a look-in – this is the need to eliminate the need for so much energy! The starting point is demand reduction. Turn it off. One of the most graphic pictures that illustrates the point is a composite image made by NASA of the world at night – the brighter the light the richer and more energy intensive/unsustainable the nation; the darker the poorer.

Faith in the redemptive power of technology trades on the illusion that human agency has the ability to direct technology as if it were independent from human being. But as was indicated earlier, at one extreme the toolmaker is equally partly made by the tool (be the tool a hammer or a computer) and at the other extreme, technology, the environment and the human are not totally disconnected from each other – they interpenetrate. Moreover, our limited state of awareness folds into the unsustainable – we are dangerous

beings in our failure to recognize that we are unknowingly throwing problems into the future while failing to deal with problems of the present.

The fact that the 'philosophy of technology' has disclosed much about the character of technology is negated by the reality of it being uncritically embraced by the broader culture. At the same time, voices critical of technology have increasingly been contained within its ever-shrinking academic enclave.[5] Technological progress was once romanticized and celebrated. Now it is completely naturalized. In this respect, all technology is immersive. Certainly there are no visions of futures that are not technologically inflected – the point here is to understand that less technology is not necessarily anti-technology. We are already technological beings. Technology is like food – we cannot survive without it but we equally cannot survive with too much of it. In getting the diet balanced, we need to critically confront what technology is, what it does and how we exist in its shadow.

The challenge before us is how we can induce and maintain sufficient 'alienation' to negotiate new relations with technology that are more sustainable. This does not simply mean more environmental technologies, but rather, the arrival of a level of technological literacy within a regime of 'design intelligence' based on responsibility rather than mastery. Without this literacy, the ability to redirect anything technological would be at best very limited, at worst, non-existent.

Design for Sustainability

So much of what travels under the various headings of 'design for sustainability' focuses on just the designed object itself – the materials from which it is made, the amount of energy embodied in it, its ability to be recycled, and so on. Now, these things are significant, but they do not ensure that a contribution to 'sustaining ability' is being made by the object. This can only happen if the object being designed is overdetermined by the design of the relations in which it is to be situated. The task thus becomes the designing of the 'object of design' so that it, in turn, can design sustaining 'relations and

effects', to which form and function are subordinate. From this position, we can consider, for instance, a 'green building' and an 'eco-designed' product.

There is now a substantial tradition in the design of 'green buildings', accompanied by a plethora of green rating schemes that 'measure' a building's environmental performance. The US LEED (Leadership in Energy and Environmental Design) scheme developed and run by members of the US Green Building Council is perhaps the best known internationally. Now, while buildings that have been designed to take energy and environmental performance into account are unquestionably superior to those that do not, this does not mean they are sustainable. For the ability to sustain turns on three things: the nature of the building itself; how building users use it; and what the building is used for.

While a building can be designed to gain the highest possible green performance rating (in terms of energy efficiency, water conservation technologies, low impact materials and so forth) this does not determine that its users will realize its performative capability. At one extreme, the building may have an electronically controlled building management system that takes away the control of internal environments from the building users. Such systems can produce either passivity or resistance depending on, for instance, the setting of lighting levels or thermal comfort. Being in an office in which it is not possible to turn lights on or off, open the window or alter the temperature does not exactly win people over to 'sustainability'. Likewise, buildings with operable systems to control air flows, light, heat and cooling only 'work' if users understand the system and use it appropriately. As is now being recognized, beyond specialist building services industry research, a building's performance can be as much determined by how it is commissioned as by how it is designed.[6] The key point is that people can make a 'green' building unsustainable and likewise an unsustainable building can contribute to sustainment by the way, and for what, it is used. This last observation takes us to the overwhelming factor in the evaluation of a building's sustaining ability.

The key factor is what a building is used for. If occupied by an organization using it to extend the unsustainable by its productive, institutional or

commercial activities then the sustaining contribution is negated – in this situation the building, despite its environmental performance, sustains the unsustainable. Of course, the reaction by the designer and builder of such a building is that its use is beyond their control – an observation that returns us to relational design, redirective practice and the team.

However inconvenient and complex, if sustainment is the objective, then design problems just have to be addressed relationally. Obviously this means, in the case of buildings, the establishment of structures that bring the commercial interests of developers, building owners, building users, architects, builders, engineers under the umbrella of redirective practice. It means a new design discourse, new kinds of teams and forms of collaboration that transcend base commercial interest. No matter how hard this is, to capitulate to the unsustainable is the only other, and a worse, option. Of course, as we shall see, this kind of activity requires a shift in economic paradigms.

Briefly turning to eco-designed products, let's consider, say a remanufactured photocopier (a photocopier refurbished after 'take-back' by its initial maker to give it a second life) and a boardroom table and chairs custom-made from recycled red-gum flooring after the demolition of a wool store warehouse. Again these objects are unambiguously of environmental value – they reduce the takeup of natural resources and energy, while at the same time providing employment. Yet again they are only able to properly contribute to sustainment if configured within a set of relations that compound toward realizing the same end.

The most 'advanced' model of eco-design is the 'cradle to cradle' approach.[7]

This positions a product in a closed (autopoietic) loop characterized by a material metabolism – it becomes its own boundary for the dynamic circulation of its material elements (cyclical recycling). For example, imagine a vacuum-injected plastic garden chair that, at the end of its life, could be traded in for a new one exactly the same, while the old chair is ground up. Accumulated volumes of this material are returned to the manufacturer who uses it to produce chairs identical with the original. While this model, based on mimicking the cycling of nutrients in organic systems is progressive, in

itself it is no solution. In fact it can even obstruct perceptions of relational connections because it does not question what is produced and what, in turn, the product itself might design. Moreover, the kind of thinking that underpins this approach can again so easily fold into 'sustaining the unsustainable' and support a continual growth capitalist economy. While products may be 'cradle to cradle' this in no way limits the volume of products produced, nor does it deal with the need to make distinctions between short-life products (for which the approach is appropriate) or 'eternal' products (for which it is far less relevant). But above all, it is not framed by the need to decide if a product should or should not be eliminated by design.

In both the case of the building and the product, relational design, managed via redirective practice, inscribes the designed with a futuring agency. While they are designed to meet functional requirements, what they essentially exist to deliver is time.

One understanding of design resonates throughout this book: 'whatever is designed and brought into being goes on designing'. Design, again in all its shades from urban to fashion, from products to software, cannot contribute to the advancement of sustainment without fully comprehending the implications of 'the designing of the designed'.

From Products to Services[8]

Hopes were high over a decade ago with the arrival of the idea of services and sharing (washing machines, cars, power tools, lawn mowers) or imma-terialization (email, e-books) replacing many of the material products of every-day life. The argument for services and sharing displacing products is not over yet but none of it is as easy as expected. Issues of convenience, and the fact that demand is not evenly spread but bunched into particular time zones, are a problem. For example mowing the lawn at the weekend, or needing a car in the school holidays. Likewise computer-based forms of immaterialization proved not to be quite what they seemed once it was exposed just how much energy it took to keep the massive servers that support web-based activities up and running. Questions of taking responsibility for the maintenance of shared

equipment, notwithstanding formal or informal agreements, issues of driving to hire or borrow a tool for a five-minute job, the emotional and fetishistic relation some people develop with their bicycle, horse box, vacuum cleaner, super-deluxe stainless steel mobile gas BBQ and so on, means possessive individualism is no small obstacle to surmount. Certainly, the ethos begs working at, and the implementation is maybe more realistically best viewed as either a micropolitics that requires, at least initially, an interaction between kindred spirits, or highly organized professional services (like a car-at-your-door-on-demand hire service).

'Sustainable Consumption' and Design[9]

As long as there have been designed, manufactured and marketed products, design and consumption have been bonded together. However, it was not until the 1930s that they were addressed and deployed strategically and thereafter considered reflectively. The US recovery from the Depression just prior to the Second World War was claimed as a consumption-led economic recovery. The creation of streamlining as a style by designers retrospectively designated as industrial designers, applied to products as diverse, at one extreme, as ships, planes, cars, trains and buildings and at the other, toasters, ash trays, cigarette lighters, telephones and refrigerators, was credited, along with modes of promotion, with prompting much higher levels of consumer demand than had ever existed before.[10] The dynamic of mass consumption and consumer society was thus 'liberated'.

The more recent link between design and 'sustainable' consumption emerged at the same moment as 'sustainable development', having its high point as a major agenda item of the 2002 World Summit on Sustainable Development. The issue divides into two positions that tend to bleed into each other. One argues for lifestyle and behavioural change based on limits created by politics, policy, programs, education and cultural projects (like voluntary simplicity); the other position folds back into the technocentric approach and favours eco-efficiency, sustainable technologies and a large growth in 'sustainable products'. The entire area is littered with problems.

First, the very notion of consumption itself, as an economic and socio-cultural practice, is mobilized unproblematically. It is the fact that people do not metabolically consume that is at the heart of the problem. Consumption as an economic category is incommensurate with it as an ecological category. No matter the way in which products are acquired and used or whether consumption is thought and theorized as an economic activity, the fact is that all durable products at the end of useful life have not been consumed. The residual materials of land fill, waste dumps, junks yards, plus the content of our attics, cellars, sheds and garages all testify to the truth of this claim.

Second, it is positive to see that sociologists of consumption are starting to become interested in design.[11] But how they view design begs considerable development. For instance, looking at design as predominantly adding value to products and regarding this as part of what is consumed exposes a very limited understanding of what design is and does. The very way design is reduced and presented in relation to bringing goods into being fails to grasp design's ambiguity as an agent of both creation and destruction (this book deals with this relation via the notion of the 'dialectic of sustainment'). This ambiguity applied as much of course to immaterial qualities, like value, as to matter itself – leaving aside the problem of defining the essence of value, what designers do is destroy value at the same time as they create it (a new style product is launched as 'the latest' thus rendering previous versions 'dated'). This means that while it is acknowledged that artefacts can prompt the creation of other objects (such as system elements and accessories) and deliver experiences (for example, pleasure and the use of new skills) what they may equally destroy (knowledge, the use of a service, a craft practice, and so forth) is mostly overlooked.

Third, there is a view now promoted by sociologists of consumption that takes its lead from the work of Bruno Latour on 'actor-networks theory' (the interactive play of formations of human and non-human actors) and 'things'. Essentially it proffers that 'consumers' can develop 'creative relations' with 'designed things' that go beyond the way they have been designed within and beyond the remit of design itself.[12] Such a view has much to commend it, but it is mostly taken up in error when it is based on a restrictive model of design

agency rather than on a wider realization of design designing – its ontological character. Effectively, this view accepts an economist ('mainstream' conventional) understanding of design and casts consumers' action, when non-compliant with the inscribed design(at)ed use of 'a thing', as something other than design (for example, 'creative appropriation'). In actuality, bricolage, adaptive use or reuse and redesign are all recognized design strategies that do not necessarily draw a clear line between professional and non-professional designers and design practice.[13]

In sum, the approach of sustainable consumption theorists travels with an unresolved relation between consumption as an economic category, as a cultural practice and as an ecology of materials. The complexity of the metabolic dimension of consumption and the relation between defuturing and consumerism become overlooked, even when environmental impacts are acknowledged to be linked to the way modern societies organize the social relations of consumption as well as production. This acknowledgement is certainly made by sociologically based ecological modernization theory.[14] What it aims to do is to offset a purely techno-instrumental understanding of 'the environmental crisis' by the introduction of social determinants. Unfortunately this position is both tame and lame. It neither goes to the complexity of natural and artificial ecologies, recognizes the centrality of anthropocentrism to unsustainability, nor realizes the significance of design to both 'the problem' and 'solutions'.

The agency of designed objects (what Martin Heidegger understood as the 'thinging of things' and what François Jullien explored as 'the propensity of things'[15]) is seriously undertheorized by a great deal of the sustainable consumption discourse. Likewise, the non-discreteness of designed artefacts, as they are constitutive of environments of which they themselves are equally experientially constitutive, appear to be underconsidered.

In many respects, the debates on sustainable consumption do not contest the capital logic of perpetual growth – thus the rhetoric of sustainable consumption either knowingly or unknowingly legitimates the unsustainable. Meanwhile and depressingly, the sociology of consumption[16] seems to be imprisoned by the discourse of its adoption and a regressive mode of theorizing that is

less informed and insightful than what predated it by many decades – neither does it appear to have registered recent writing on ontological design.[17]

Humanitarian Design

Over the past few years, the non-profit organization, Architecture for Humanity, has increased its profile in and beyond the architectural profession,[18] especially for promoting architectural projects on post-disaster emergency shelter, refugee housing and health; recruiting architects and forming design activist networks and working on 'live' projects in various parts of the world. Depending on your point of view, the organization can be seen either as inspiring leadership by example, or a moral big stick beating architects around the head. For all the acclaim it has received and notwithstanding the passion and concern displayed by members of the organization (and the lesser ones associated with it), its feel-good, apolitical politics is naive on three counts: (1) its lack of placement of disasters (be they 'natural', human-induced or socio-economic) in the frame of the unsustainable; (2) the inappropriateness of constructing an aid organization model of design action (this *de facto* is a critique – too long and deflective to engage here – of the politics of humanitarianism and humanitarian aid *per se*)[19] and (3) its lack of an adequate cultural understanding of the symbolic agency of especially technologically orientated shelter forms. Providing universal prefabricated emergency housing, as the UK-based Disaster Institute showed in the 1970s, can often undermine the coping mechanisms of a community that it needs, above all, to call on. On this issue, the conclusion the Institute came to was that rather than prefabricated shelters (be they of appropriate materials or style) or structures designed by outsiders (no matter how well received) what was actually needed was infrastructure and local building materials. This approach is, however, not the stuff that attracts architects, provides the basis of design competitions and exhibitions, or is looked on favourably by grant-awarding organizations or corporate sponsors.

Other Ways of Thinking and Acting

As the previous chapter made clear, designers of all shades need to be able to create futures for themselves as independent agents working outside conventional models of service provision; while as 'service providers' they need to work to transform the relationships between designer, client and user. In both cases, as redirective practice makes evident, 'the team' displaces design as individuated action. However, the notion of what a team is begs qualification.

The team as a collective can take many forms. It can be a multidisciplinary group clustered around a single table; a networking group working on the same problem; a gathering of different professionals interested in solving a common problem; a community of interest coming together from different social, political and economic allegiances to more adequately define and engage a problem. In every case, and irrespective of clients and users being inside or outside the team, the common imperative is: the resolution of immediate needs while securing futuring conditions and capability. This position should not be confused with Brundtland's notion of social, economic and political progress meeting 'the needs of the present without compromising the ability of future generations to meet their own needs.'[20]

'Futuring conditions and capability' need to be based on relational interdependencies between all that sustains life as we know it. They neither reduce to just human-centred interests nor to the merely biophysical. We need to remind ourselves here that the first rule of sustainment is sustaining the self – without doing this we can do nothing else.

Sustaining the self is not simply a matter of physical wellbeing, for it is equally an issue of mind. By implication, this means that before designing (be it as professional designers or simply as an act of everyday life) we need to place ourselves in 'the relational picture'. We are always present, implicated and responsible for what we bring into being. We literally need to put ourselves before what we envision and bring our selves to account. Anthropocentrism is turned not by denial but by direct confrontation with oneself and thereafter the collective.[21]

38 The future has a history

13

Sustainment and a New Epoch of Humanity

While there is no assured predetermined arrival of the Sustainment (which, as indicated, is a project that cannot be instrumentally delivered) or for that matter any other sure-footed evolutionary track that will carry humanity to a viable future, one can confidently say that unless the 'challenge' of sustainment is met, we will not survive in ways that we currently recognize as human.

For tens of thousands of years humankind's mode of worldly habitation was nomadic (non-settled). During this period, the total global population stabilized at around 40–50 million people. The world was home, albeit a home with occasional and major climatic upheavals. Then around 12,000 years ago

there was a period of climate change, the response to which changed the destiny of humanity.

Food was scarce; so many people converged on where it was known to exist: the Fertile Crescent of the Middle East, especially Southern Mesopotamia, where there was an abundance of wild einkorn (an early form of wheat). It had become much colder in the west, while the east was experiencing a drought that lasted a thousand years. Slowly the Fertile Crescent became more densely populated and the foundations of human settlement started to become established.[1] In years when the weather was good the people hunted and gathered, but when it was not, they stayed put and harvested a crop. Eventually this practice became dominant and farming, as we know it, started to develop.

Reframing the Human Project

Now, with the arrival of a rapidly changing climate, due in significant part to our unchecked burning of fossil fuels and clearing of vast tracts of land, we humans are on the edge of another epochal change that may be as dramatic as the one that gave birth to civilization as we know it. Many of us will live to see populations of some parts of the world abandon their islands, land, villages, town and cities. While there are predictions of a quarter of a billion environmental refugees by mid-century and well over half a billion by its end, many more people will simply relocate within their own homeland. Clearly the current ways of dealing with refugees will be totally inadequate to cope with an unprecedented massive redistribution of the human population. Although affecting vast numbers of people, this will unsettle everyone. The already tarnished illusion of continuous human development will shatter. Having moved from non-settlement (the nomadic life) to settlement, we may well be heading toward an unknown condition of unsettlement. Having moved from the world as home, to making a home in the world, the prospect is now one of mass homelessness. While this may well be literally true for hundreds of millions of people, homelessness may take on a more fundamental meaning

in a world made inhospitable. While this situation may not yet be inevitable, humanity's future is perilously balanced.

The establishment of the Sustainment is beyond the reach of technology and our technological being. As has been made clear in many ways, sustain-ability is as much a cultural as a technological project. The nature of technology is inherently dialectical – it is both unsustainable and sustaining; it brings what we depend on into being and it takes it away. To have any chance of dealing with this, and our mostly uncritical relationship with technology, there need to be cultures in which it is possible to counter the now overwhelming onto-logical designing of our technological being.

The Sustainment and the Enlightenment

As we have seen, 'sustainability' is mainly presented as a discourse within the realm of technology. As such, it is lodged in an Enlightenment paradigm epitomized by Francis Bacon's *Novun Organum* of 1620 – a work that positioned nature as that 'other' over which humanity, via technology, could increase its power. Overt, direct violence against 'the natural' has diminished. Yet it still continues indirectly as the 'collateral' damage from our very being – the rampant felling of native forests and land clearing still happens on a vast scale; new and seemingly more benign toxic forms of elimination have arrived (indirectly from industrial emissions, industrial and domestic waste, and directly via the deliberate application of chemicals like pesticides); complex chemical compounds not known in nature accumulate invisibly in the fatty tissues of many creatures, with concentrations in the food chain triggering defects and mutations (many still poorly understood). At the same time, technology has been employed to constitute a world of artifice, the scale and complexity of which has fused the natural and the artificial. We humans have not, of course, simply been bystanders watching the events of technological modernity unfold. We have been both active causal agents of technological developments and victims of them. It is, however, a mistake to assume that we have remained the same while technology has continually changed, for in

reality, to reiterate, technology has profoundly changed us in body and mind. We see and understood the world technologically, not least via the 'world-picturing' consequences of the televisual.

The more technology has proliferated, fused with information and structured the activities of everyday life, the more it has evaporated as an object of anxiety (in the 1950s there were still people frightened to use the telephone; 100 years ago there was fear of automobiles running out of control and 150 years ago the fear was of steam trains setting the countryside ablaze). Although technology has become so naturalized, the view persists that it is still under human control. It is still not generally grasped that there is now no longer a clear distinction between technology and us. Moreover, those theoretically informed critical positions that expose the contradictions and psycho-cultural complexity of technology are universally becoming rarer.

Interestingly, the critics of technology of the 1920s, 1930s and 1940s came from both left and right, popular culture and rigorous philosophy. For example, Theodor Adorno and Max Horkheimer cite *The Rockefeller Foundation Review* of 1943 in their seminal collection of essays, *Dialectic of Enlightenment* (which they wrote during the Second World War) – 'The supreme question which confronts our generation today – the question to which all other problems are merely corollaries – is whether technology can be brought under control ... Nobody can be sure of the formula by which this end can be achieved ... We must draw on all the resources to which access can be had...'[2]

The 'supreme question' did not spark a major public debate. The situation in which humanity now finds itself did not arrive accidentally but via the inscription of material forms of the world 'we' ourselves designed and created. The process continues. Education, for instance, has become as much an induction into the operational and metaphysical sphere of technology as it is an induction into a culture of live learning.

We need to remind ourselves that the Sustainment as an opening moment and process is posed against functionalist and ever more linguistically evacuated uses of the concept of sustainability. Increasingly, one sees and hears sustainability evoked as if its meaning was self-evident (the 'triple bottom

line' rhetoric of environmental, social and economic sustainability has clearly added to the gestural use of the term). What and how to identify the unsustainable, and what exactly needs to be sustained, just cannot be addressed by this rhetoric. In the frame of these remarks, the Sustainment is offered as a prefigurative idea demanding realization through design. It demands what needs to be unlearned and learned in order to enable us, individually and collectively, to sustain ourselves. It is not just a question of more knowledge but the erasure of what we have formally and informally learnt in error. It demands a shift away from forms of exchange disengaged from the processes of foundational exchange of interdependent ecologies.

The reality of the current situation is that commodities (materials and artefacts) that are exchanged within an economy have either a benign or negative relation to the 'general economy' – which is the very ground of all that is substance, ecology and environment. Neither the relation of commodities to the general economy nor the actual nature of that economy is adequately understood (for instance, an 'environmental impact' may be identified, but the systemic consequences of that impact may not be understood or even recognized). As the 'dialectic of sustainment' articulates, human action will always be destructive; there is, however, an enormous divide between not knowing and knowing this fact and thereafter making critical decisions in the light of this knowledge. The Sustainment also demands the incredibly challenging abandonment of wealth generated by the current economic model, based as it is, on perpetual growth.

Meeting all these demands does not equate to a single political ideology or an 'orthodoxy of forms'. Such demands can only be realized through a circumstantially directed, paradigmatic shift in the collective condition of humanity as the move from settlement to unsettlement (the age, as was said earlier, that is coming) ruptures a sense of the world remaining the same. With the arrival of the traumatic circumstances of unsettlement, different kinds of situated action, based on the imperative of sustainment would both test 'our' continued 'will to be' and our ability to act in common toward the common good.

It is worth remembering here that the Enlightenment was a prefigurative project driven by a profound dissatisfaction with 'the state of the world' and

the nature of knowledge about it. Its ambition was to establish a mode of thought and inquiry (reason) against the unreason of the mythic that would become widespread and eventually naturalized. In so doing, two modes of inquiry emerged (the Arts and the Science) as divisions of knowledge within philosophy. What the Enlightenment failed to recognize was the value of embedded wisdom carried by many of the traditions and narratives that were labelled as ignorance and superstition. Equally, it overlooked reason itself becoming a mythic article of faith, notwithstanding it becoming the West's naturalized mode of thought, which it globally mobilized with enormous intellectual and instrumental power. It is widely recognized that through the creation of the institutions of reason (science, law, politics and so on) the Enlightenment advanced the goal of delivering the means of human emancipation from superstition and the 'ravages of nature'. But it also became clear that the foundations of thought upon which reason stood were neither totally firm nor faultless (not least in relation to anthropocentrism).[3]

In support of the magnitude of the propositions put forward, it is worth remembering that the Enlightenment existed as a promoted idea prior to becoming a generalized cultural condition of knowledge directing the successes as well as the limitations of the modern world. A key Enlightenment thinker, Immanuel Kant, posed and answered the question 'What is Enlightenment?' within the milieu of a group of German Enlightenment thinkers (the Society of the Friends of Truth – a gathering of kindred spirits who had adopted the motto 'Dare to know' from *Ars Poetica* by the Roman Lyric poet, Horace). For Kant, daring to know became daring to reason, with reason coming to be viewed as a power of human emancipation (freeing a being from the tutelage of the will of others).

An enormous amount has been written on the success and failure of the Enlightenment, not least in relation to idealism and the hollow victory of reason now manifest in the hegemony of technology. Our aim at this point is simply to assert the historical precedent and transformative power of a 'big idea' and to assert the need to go beyond a critique (postmodernism) of those past ideas that drove modernity, with its unsustainable core, to an idea of future worldly habitation – the Sustainment. Yet irrespective of the strength of the idea of

sustainment, it is not sufficient in itself – there also has to be the desire to sustain grounded through *the qualities* of what is designated to be sustained. Rather than a form of utopian dreaming, the desire for Sustainment cannot be for anything other than a work – one requiring a protracted political project, a great deal of labour and much courage. Contrary to the unsustainable being surmounted by the arrival of a solution delivered by a product, a technology or system, the whole notion of redirection is based on recognizing that the task is a continual labour intrinsic to our being – the unsustainable is part of the price of our existence. As stated in various ways, all we can possibly do is to make time.

The Dialectic of Sustainment

The Sustainment speaks to the thinking, designing and making of sustain-abilities in the face of defuturing. This task is extraordinarily difficult to grasp as an overall vision of process, but nonetheless it is vital to embrace. To help do this, let's revisit and further elaborate the concept of 'the dialectic of sustainment'.

To start with, it is not possible to evoke the notion of the dialectic without introducing complexity, controversy and a brief history. As a method of forcing knowledge to reveal itself in a dialogue based on questions and answers, dialectics was demonstrated by Socrates and in the dialogical style of thought of Plato, who asserted in the *Republic* that it delivered supreme knowledge. However, dialectics seems to have been first systematically used in the third century BC by the founder of Stoic philosophy, Zeno, a follower of Parmenides. Aristotle later incorporated dialectics into his method of logic, defining it as reasoning from the basis of probabilities. Out of this history, dialectics became firmly lodged in the rise of Western thought, and as such re-emerged as an object of engagement at various moments in the history of philosophy. For instance, it reappeared in the twelfth century in the writings of Scholastic philosopher Abelard, who employed a mode of argument based on putting a case both for and against his postulated proposition. Equally, a concern

with dialectics was part of Enlightenment thought – Immanuel Kant viewed dialectics as flawed reasoning that led to specious argument. In contrast, Hegel, its greatest champion, claimed it as a specific logic of thought, generally, but inadequately, characterized as a process in which contradiction and then the reconciliation of contradiction occurs by working through thesis, antithesis and finally, synthesis.

Arguments over forms of dialectics continued into the nineteenth and twentieth centuries – the most overt example being Karl Marx who claimed to have turned 'Hegel on his head', dialectical (historical) materialism supposedly usurping its idealist form. Notwithstanding the shadow of Hegel, no consensus on the meaning of dialectics can be given. The very notion goes to the core of the relation between concepts, meaning and language. As Theodor Adorno observed, 'the name of dialectics says no more, to begin with, than most objects do not go into their concepts without leaving a remainder, that then comes to contradict . . .'[4]

By implication, whatever we name, whatever we identify, there is also that which evades, escapes, is other and supplementary. Truth is thus never simply a victory over untruth but a perpetual struggle with its own internal negation. Long before deconstruction arrived and embraced this idea, dialectical thought had acknowledged such a condition. It follows that dialectics itself is not free, and cannot be liberated, from the condition of limitation it speaks.[5]

One cannot think 'the dialectic of sustainment' outside of the implications of such thinking. And one cannot think 'the dialectic of sustainment' scientifically, for in its enfolding of contradiction dialectics is profoundly unscientific. Dialectically, sustainment depends upon the creation of non-scientific thought beyond the limitation and exhaustion of the humanities. Sustainment means nothing without grasping its unbreakable bond to un-sustainment, which is its very ground – this is one reason why so much of the rhetoric of sustainability, with its quietism on (or assumptions about) unsustainability, lacks the possibility of ethical decision.

Recasting the earlier observation on the dialectical character of sustainment, one can say: destruction and creation are indivisibly implicated in each other – the one always coexisting with the other. What is created or

what is destroyed can be comprehended as negation or affirmation. To bring something into existence is to create a force that can, slowly or rapidly, sustain or undermine the very essence of being itself. Likewise, whatever we destroy, can open or close the possibility of affirmative creation. To take this analysis to the project of advancing the Sustainment requires identifying what has to be destroyed as well as what has to be created and thereafter finding the appropriate means to do both.

Brought to the relation between ethics and practice, responsibility is actually enacted by deciding what to materially and symbolically make *and* what to destroy. As settlement becomes unsettlement, such acts of redirective decision are preconditions for establishing the epochal shift that the Sustainment names. Designing directed by the decision of 'what needs to be destroyed and created' should not be viewed as just the means by which immaterial and material things are positively changed but, more fundamentally, as part of the ground of redirective practices which all redirective practitioners need to occupy as they strive to advance sustain-ability though their material and symbolic actions. Grasping the nature and application of the 'dialectic of sustainment' recasts the importance and application of 'design for elimination' as this decision depends upon a very clear understanding of what needs to be created and sustained. In keeping with how the 'dialectic of sustainment' has been characterized, we should understand that the disclosure of negation – although providing a focus for what has to be eliminated, destroyed or unmade – may also bring to light what sustains, or what can be remade as sustainable by a redirective intervention.

On Remaking

Sitting between the task of elimination and creation (of the new) is the huge challenge of remaking what already exists so that it is able to be transformed into an agency of sustain-ability.

Remaking, so framed, embraces not solely material changes, like retrofitting but also the intellectual project of exposing the foundations

of thought to remake thinking (a very different exercise from 'rethinking' with the way we already think) in order to think with sustain-ability. While remaking can mean a literal disassembly and re-creation of some thing, it can equally leave an object-thing totally untouched, but rather transform how it is viewed and used by radically changing its meaning and status (as with recoding). Remaking does not just have to be limited to engaging specific ideas or objects. It can also be characterized in a larger frame as creating a mode of 'our being-in-the-world toward-sustainment' – a way of being in an unsustainable world based on working to remake what is to hand as sustain-able. The 'dialectic of sustainment' here becomes a lived condition of informed action of responsibility to one's own 'anthropocentric self.' In contrast to a 'sustainability professional' or a 'saving-the-planet-environmentalist' the influence of such a person is not based on the limited material attainments of a single individual turned in on itself, but on what Confucius called an 'exemplary person' – a model to be emulated.[6]

Although remaking cannot restore the already destroyed, it is possible to destroy many forces of destruction and recover, recreate and reanimate nu-merous agents of material, immaterial and cultural sustainment. What is being evoked by these remarks is overwhelmingly sobering, extremely confronting, replete with positive opportunities and absolutely vital to confront. Few people have glimpsed this vista, either as a transformation of daily routines or, more dramatically, as a mind-spinning challenge to one's imagination and skills. Certainly, it adds a great deal to the potential of redirective practice and design.

The Sustainment names the only possible way to maintain the most critical freedoms of 'being-in-the-world'. This implies the imposition of control over the still unchecked expansion of defuturing unsustainability that reduces free-dom to market choice.[7] We should recall that a fundamental principle of civil society is that freedom is dependent upon limit and control ('freedom under the law'). This fundamental principle demands being reapplied to the current unstable socio-political world, because societies wishing to be sustained have to impose new limits and controls in the face of the unsustainable. Impos-ition of controls obviously incorporates a good deal of existing environmental

regulation, but more radically, asserts an extensive control of 'the free market'. Obviously, such action puts democracy firmly before a critical gaze, while throwing up some extremely confronting questions, like: 'can the imposition of limit and controls, essential for sustain-ability, arrive democratically'?

14

Picturing Economic and Cultural Futures

This chapter will argue for an economic paradigmatic shift, positioning design as a primary agent of such change. Clearly, this claims a highly political role for design, so to begin, something needs to be said on how to think design politically.

There is a long tradition of design performing a support function to political and social organizations that either uphold or seek to change the status quo. Such servicing includes everything from the design of political posters to public housing. This politically subordinate position simply mirrors the geometry of design's mainstream service role, exposing how designers are

structurally constrained by a combination of their economic role and their constructed ontology (their *being* as designers). On the other hand, design, reframed as redirective practice, is a turning away from the unsustainable towards the Sustainment and, as such, it unambiguously becomes a politics in itself.

40 Turning designers

Design and the Political

Designers (and others) subsuming their practice to redirective practice adopt a prefigurative, rather than reactive, position to the political. They become participants in the creation of a politics rather than serving the needs of politicians, political movements and parties. The nature of this difference needs

to be made clear – we should distinguish between 'design and the political', as opposed to 'design politics' or 'the politics of design'.

'Design and the political' positions design as an agency within the political domain as such, in contrast to those other relations in which the political focus is on design itself. This shift in positioning enables our thinking about the 'designing of the designed' as a particular kind of embodied form of the political (political things). In turn, such thinking has the ability to reveal the political enormity of what design brings into being as a future-creating or negating force. For instance, political parties come and go but what their policies and spending put in place – the form of road networks, prisons, hospital systems and so on, goes on having consequences, often for many decades.

For all that we have said, we can still ask, what shapes the future? One would expect the answer to include: science and technology; human conduct in war and peace as directed by governments and those who oppose them; the changing nature of global and local ecologies and environments. One does not expect design to be nominated as a future-shaping agency of equal significance to these other forces of change, but of course it is, both as an independent force and as a subordinate service. Across a vast range of contexts, forms and scales of importance, every design decision is future decisive. The impacts from the materials we manufacture; our modes of transport; the way we provide heating and cooling; the kinds of cities we build; the products we manufacture; the media of communication we employ – these and myriad other things are environmentally and culturally directive. As already argued, the nature of things we create by design not only transforms 'our' world but also transforms us – such designed things contribute to shaping our bodies, knowledge, habits, practices and emotions. Thus their designing structures that which structures what we become (as was discussed in Chapter 1 in relation to *habitus*). But above all, as has been reiterated, design futures or defutures – it rides the line between bringing things into being that sustain the conditions upon which viable futures depend and taking the possibility of such futures away. Such agency places design centrally within the political and it means that redirective practice does not merely co-opt design, but rather constitutes itself as a politics of designing.

41 Career's ending

Towards an Economics of Sustainment

We live in conditions surrounded by destruction. Our proximity to overt signs of destruction vary (be they the product of poverty, war or industrially created wasteland). The covert signs are omnipresent in the very fabric of the material world in which we are immersed – the reality of the 'dialectic of sustainment' – the reality of the destruction of production – is measured in the total volume of industrial waste and landfill that every society creates and turns its blind eye to. Currently our economy feeds a defuturing disaster, while the general economy that can accommodate the processes of regeneration upon which all living things depend goes under-recognized and under-engaged.

Design is both a means by which things are revealed and concealed. Design, as it is, often has the character of a façade. No matter how attractive the appearances it delivers, it effectively hides the sites and forms of destruction that enabled the object before one's eyes to come into being and in many cases function. Here then is the ground of our misrecognition. Unlike the abject poor, we have the means to replenish, renew and reinvigorate the environments of our dependence – we have the knowledge, technologies and design capability to create an economy in which economic and ecological exchange of the general and the particular connect in ways which significantly reduce, if not eliminate humanity's defuturing propensity. This kind of thinking is not new. As Georges Bataille wrote in the 1960s:

> We can ignore or forget the fact that the ground we live on is little other than a field of multiple destructions. Our ignorance only has this incontestable effect: it causes us to *undergo* what we could *bring about* in our own way, if we understood. It deprives us of the choice of an exudation that might suit us. Above all, it consigns men and their works to catastrophic destructions.[1]

The moment of the Sustainment is the moment of a project of thinking and acting toward the ability to sustain. It lays no claim to realizing this ambition as an end point. Placing the conception of a new economic paradigm in this moment means entertaining a leap of imagination and an overturning of existing economic wisdom, as opposed to simply trying to extend existing economic theory. Essentially, all exchange has to be placed within that general condition of movement, change and transformation, in which we are implicated, that keeps 'being-in-being'.[2] At the same time, that dislocated mode of exchange that Georges Bataille called the 'redistricted economy' (capital) has to be reconfigured so as to be compatible with such change.[3]

Notwithstanding differences of theoretical language, projects, disciplines, geography and time, an understanding of general economy as the fundamental condition of exchange is found amongst a scattering of thinkers who appear to have very little in common. It is firmly lodged within the philosophy of both Georges Bataille and Jacques Derrida (with their critiques of the restrictive economy and engagement with the notion of 'general economy') and in

Gregory Bateson's fusion of biological and economic process (*Steps to an Ecology of Mind*, 1972). It is exemplified in the total system of reciprocity presented as the basis of exchange in Marcel Mauss (*The Gift*, 1925) and it inflects the work of Georg Simmel (*The Philosophy of Money*, 1907).

What unites all these thinkers' philosophical, sociological, anthropological and biological lines of inquiry is their recognition of the material and symbolic 'interconnectedness and entanglement of phenomena' as Siegfried Kracauer, one of Simmel's most insightful students, characterized it.[4] Perceptively, Simmel described exchange as indivisible from the animation of things, sociality and human beings and as '... the purest form and most developed kind of interaction, which shapes human life when it seeks to acquire substance and content'.[5] For Simmel, exchange, as it occurs fundamentally, depends first on a seizing (a taking from the world which is not ours), sacrifice (a giving up to acquire) and then an organizing (of elements, values and symbolic mechanisms). The enormous futuring potential of this thinking was not realized, partly because it remained trapped in unfashionable, inaccessible languages of academic discourse and because of the power and addictive nature of the restrictive economy as vested in specific interests. 'Capital logic' enacted a perverse inversion of meaning that has ended up completely overwhelming almost all other possible understandings. This includes the hypercapitalism of the information economy, wherein commodities, immateriality and meaning all fuse. The colonization of exchange by the existing market-based model not only pervades economic theory and everyday life; it also delimits imaginations. It is therefore unsurprising that design and architecture have become totally subordinate to the 'restrictive economy'. At the same time, for all its apparent success the restrictive economy is very likely a fated failure. In the last instance, all it can serve and sustain is itself as it grows towards its finitudinal limit. In so doing, it has no allegiance to 'human being' (or the-being-of-being itself) as the human servants of its dislocated logic take, on its behalf, more that it gives.

The theorists of the restrictive economy, encased in its 'logic', not only display a limited ability to comprehend finitude but also fail to recognize its restrictiveness. They work within a curtailed mechanism unable to see and

respond to feedback from the unsustainable – this is graphically illustrated by the Brundtland report and those who have adopted its premises of 'sustainability realized without regrets.'

Economic critiques of humanity producing and consuming itself, and much more besides, into unsustainability have been around for a while. The Club of Rome, originators of the *Blueprint for Survival* published in *The Ecologist* and *Limits to Growth* (by Donella Meadows *et al.*) – both of which appeared in 1972 – marked a key moment in how initial debates were framed by the issues of expanding populations, limited global resources and the proposition that, economically, a 'stable state' could be established. Today, we now have a far more complex picture of the nature of human-induced environmental damage, not merely based on sheer numbers, but rather on the multiplicity of impacts attributable to people's differential behaviour as world makers and breakers.

The restrictive economy arrived out of a long historical process that enfolded the demise of feudalism, the hegemony of rationalism (via the Enlightenment), the formation of modern state institutions and civil society, plus, of course, the rise of capitalism and social democracy. Francis Fukayama controversially and erroneously defined the full realization of the restrictive economy and its political underpinning as 'the end of history'.[6]

No matter how difficult the task, how heterodoxical or tentative the explorations, the project of futuring needs to start thinking about another kind of economy – one with a different basis of material and symbolic exchange. This paradigmatic shift is not a matter of choice but necessity. It needs to overcome the considerable institutional momentum of 'sustainable development', which blocks the emergence of different and creative economic thought.

Shifting from Quantity to Quality

The paradigmatic shift that is needed is to think and organize economy in relation to entropy – so as to move from a quantity/fast entropy to a quality/slow entropy economy. This shift would represent a dramatic reduction in

42 Brisbane Powerhouse retrofitted as a cultural venue

materials take-up and production, combined with dramatically increased concern and accepted responsibility for what materials and the made do in and on the world and everything that dwells therein. Rather than this shift diminishing an economy's ability to generate wealth, the very nature of wealth becomes redefined. Currently, wealth is illusory – two absolutely massive costs are excluded from how it is assessed: the cost of destruction (in terms of the 'dialectic of sustainment' one could ask, for instance, what is going to be the real cost of climate change)[7] and the cost of global inequity (the redistributive costs of preventing environmental and other forms of destruction caused by poverty). It has to be remembered here that equity, via 're-distributive justice' is integral to the creation of an ability to sustain.

Now before going further, we obviously need to say exactly what is meant here by 'quality'. Rather than allowing its meaning to free float or to simply adopt a dictionary definition, a contextually appropriate referential ground needs to be established.

Quality, understood within the remit of sustainment, names the performative sustaining characteristic of whatsoever is brought into being in terms of its materiality, function, symbolic meanings and its designing agency in the world over time. For a product, this might include regarding quality in relation to: the nature of its materials; how it is made; its material ecology; the operational and symbolic use it delivers; its meaning and aesthetic as the *qualities* compound to form the degree of its sustaining ability. The same kind of thinking obviously applies to immaterial things, structures, industries, services and institutions.

At its most general, quality, as defined here, names all that adds to everything which is 'good'. As such, quality folds the economic into the ethical; the singular into the collective (the 'common good') as 'things of quality' that help sustain the maker, the made, the user and the world of use.

The Quality Economy

Displacing the fallacy of perpetual growth, illusory wealth and ethnocentric or ethnocidal forms of development by the relation between quality, economy and sustainment, opens a new vista of potential human/worldly engagement. As such, the quality economy can be seen as foundational for a practical philosophy embodied in redirective practices, which could be available to adopt at any level or scale from the most humble maker of craft objects to multinational manufacturing corporations.

The obvious question to ask and answer at this point is 'how much would things of quality cost?' In answering this question it is important to make clear that: (1) the way quality is being presented here has nothing to do with luxury, not least because it is not assigned to the special but to the everyday; and (2) it is not a matter of direct substitution of objects of 'quantity' with

those of 'quality' – as indicated, quality is not simply a qualification of the character of some thing, rather it is a designation of *the agency of a relational condition* (which means it is how something comes to be and what it sustains, as opposed to just 'what it is'). So understood, quality represents a different kind of commodity, a different kind of purchase but, above all, a different being of, and with, things (so understood, quality is what something delivers rather than a designated value of a thing).

In simple terms, objects of quality would cost more but the buyer, or perhaps the lessee, would get more. This might include, for instance, a life-care service of a product involving restyling or retrofitting (so that the same bicycle, computer, printer, cooker, fridge, cordless drill and so on, could have three, four, five remade-as-new lives). As can be seen, reducing the volume of manufacture of new things would be offset by vastly expanding the provision of services. Quality can also be 'turned outward' and developed in other ways – consider the following four examples.

The Making of an Environment of Care

Care is normally taken to be something human beings exercise physically and emotionally – craft workers, racing drivers, surgeons take care; likewise, charity workers, nurses, peace protestors and grief counsellors care. Yet a completely different philosophical understanding of care exists. This posits care as fundamental to our very (ontological) being, and care as vital for being to be.[8] Care, so comprehended, is manifested in our unthinking ability to cross roads, climb ladders, use power tools or cut bread without injury. Against this backdrop, a quality-based economy would need to extend things that increasingly performatively care across every space of everyday life and environments of use.

Transforming the Nature of Things

Quality, as presented here, demands so much more from products and services. Things should be expected to endure by the way they are made, the

materials they are constructed from, how they function, what they look like, the energy invested in them and the financial-material investment in their production technologies. They need either to have an extremely long life or to be easy to remanufacture, fully cycle or be disposed of without environmental costs. Likewise, there may be some products that need to be dematerialized by service substitution (providing these services do actually reduce impacts). More fundamentally, many things need re-conceptualizing as composite objects, like multi-tech roofs designed to generate power, harvest rainwater, provide hail impact protection and provide growing space for light vegetable crops. Extending this thinking invites us to contemplate the relation between the creation of 'quality things' and 'things eliminated'.

Transforming Being with Things

Rematerialization is a concept that brings quality to action and links it to the self. One of the strategies of rematerialization would involve *displacing machines* with existing or improved hand tools and recoding the experience of using them as a means of learning for disclosure (being in *touch* with circumstances and the quality of material things). One can, for instance, displace the motor mower by the mechanical mower, the car by new kinds of servo-assisted pedal power tricycles, the petrol engine powered leaf-blower by a traditional garden broom, the electric food mixer by a hand-powered device and so on. There is the possibility here of gaining a sense of achievement through learning and exercising new skills. Seeding these 'developments' to become a trend means taking back control of one's immediate physical world to reduce invested energy and materials, as well as helping to sustain the self. In a world made unsustainable, in so many ways, 'labour saving' has become 'life threatening'.

Rematerialization is in fact inseparable from remaking. What is to be remade is often modest and mundane but it provides a different path to the world in which 'we' dwell physically, functionally, aesthetically and emotionally. ('We' here has to be understood inclusively – it is we of more than one social class, culture, gender, age group, politics, religion etc – any notion

that sustain-ability is a middle-class and Western concern has to be busted apart.)

Creating Major Changes in Modes of Dwelling

Somehow, and sooner rather than later, how we dwell in our selves (our inner dwelling) and how we dwell in the world with all other beings has to change radically. For this to happen, a culture very different from the current cultures in dominance has to emerge. This culture would recognize: the impossibility of transcending anthropocentrism but the importance of learning how to understand and take responsibility for our being anthropocentric. At the same time, such a culture would accept that how human beings have acted in the past has rendered biophysical ecologies unstable but it would not put absolute faith in science and technology to rectify this situation especially so that today's energy and material-intensive lifestyles are able to continue on 'as normal'. Instead, it would seek, via changed modes of dwelling, to adapt to the different conditions that are beginning to unfold due to the coming of unsettlement. The idea that there are solutions to the kinds of problems that humanity is starting to face is misplaced. Some problems may be solved, many will not and we will have to learn to live with them adaptively.

Fundamentally, while science (and technology) should be appropriately mobilized to deal with some of the symptoms of our unsustainability, the causes, in the most general sense, require that we change how we dwell. Such change can only be created by cultural means that modify how one sees and acts in (and on) 'the world' in which one finds oneself. These changes are essential and become part of the crucial political, ethical and economic transformations that can feed the rise of a culture of sustainment.

A Last Remark

It behoves all concerned, responsible and critical thinkers and actual, or potential redirective practitioners to elaborate, refine, review and extend debate

on the 'quality economy' concept. The investment in quality and the cost and return from those 'things that could be' beg to be grasped as ways of creating and distributing considerable wealth from a dramatically smaller material footprint. The promotion and development of the idea of a 'quality economy' could equally counter the un-freedom carried by the unsustainability of the status quo. The quality economy, as it has been elaborated here, also exposes the inability of current political and economic structures to impose the limits that sustainment will demand (to secure the freedom that is being). Here then is the nexus of design, the political and new economic thought. What has been presented here does not pretend to be an adequately developed theory of a quality economy. It is merely indicative of an idea that begs a major project of plural contributions in its own right.

15

Sustainment by Design – 'Dig Where You Stand'

In contrast to the scale of the task of working to bring about the shift from a quantitative to a qualitative economy, this chapter argues that no matter who or where we are, it is possible for us to redirectively advance sustainment by design, by finding possibilities for affirmative action, no matter our status or circumstances.

What will be proposed in this chapter makes little distinction between readers who are design professionals and those who are not – reaffirming that the ability to prefigure (to design) is one of the distinguishing characteristics of our being human. As Karl Marx famously wrote in *Capital*, Volume 1, 'A spider conducts operations that resemble those of a weaver, and a bee puts to shame

many an architect in the construction of her cells. But what distinguishes the worst architect from the best of bees is this, that the architect raises his structure in his imagination before he erects it in reality.'[1] Designing is not just a practice supplementary to our everyday life, it is deeply implicated in it. Our aim here is to make this relation to design more explicit and dynamic. The aim is to show how redirection can include collective as well individual engagements with the unsustainable – and that although uncoordinated all such actions can travel in the same destination.

Everyone can make a contribution to redirection if they so wish. To say this implies something substantial – it does not mean more 'living sustainably' tips – like replacing the household's incandescent lamps with compact fluorescents, composting kitchen scraps, establishing an office recycling system, buying a hybrid car, or installing a solar water heater, and so on. While such things are worth doing they are not sufficiently redirective of the status quo.

Enabling Redirective Action: Starting with the Self

During one of the legendary 'History Workshops' in Britain in the late 1970s, a Swedish social activist who had just given a paper on the uses of oral history research in the labour movement in his country was asked 'where do you take political action?' His answer cited a Swedish saying – 'I dig where I stand'. This precisely identifies to us all where to start being an active agent of redirection – wherever we are, that's where we start.

Designing redirectively does not commence with the mobilization of a 'design process' – but from the position of the redirective limitations and capabilities of the designing subject. Here the corollary of the dictum 'if you cannot sustain yourself you cannot sustain anything else' is 'if you cannot redirect yourself you are unlikely to be redirective'.

Our starting point is to pose and answer three questions, the first being: 'in the circumstances in which I find myself and have chosen to act, what in relation to myself can I identify to be unsustainable?' The next question is 'what are my sustaining abilities?' And the third is, 'what can I identify

to sustain?' To answer these questions we need to work our way through a methodological process. This starts by undertaking a relational mapping exercise to deal with the first question. Question two requires developing a self-auditing capability. The last question centres on acquiring and applying reflective judgement. Answering these indicative questions requires spending time modifying and fleshing out the three processes that are merely starting points.

We start with a relational mapping exercise that asks: what is unsustainable about 'me' (in terms of my self sustaining)? Then, what, affirmatively, am I sustaining? And finally, what redirective opportunities do I have? The point here is: first, it is to adopt a perspective that acknowledges that as a designer,

My Footprint (individual/household)

IMPACT ACTIONS (annual)	Actual	Reduction target
Total energy uptake		
Total fresh water usage		
Total distance self-driven		
Total distance flown		
Total expenditure on consumables		
Total expenditure on durables		
Other impacts?		
IMPACT REDUCTION ACTIONS	When	% level
Renewable energy generation		
Solar water heating		
Goods repaired or retrofitted		
Self or locally grown food		
Water conservation (where geographically appropriate)		
Other measures?		

architect or other type of actual or proto-professional, we confront issues in common with others and, second, that in viewing ourselves, we come to realize that we display qualities that are part of the problem and the solution (recognizing ourselves as complex rather than just fractured subjects, as with: 'consumer', 'householder', 'voter', 'motorist' 'rate-payer' and so on).

'Looking At Me' – Personalizing the Relational Nature of My Being Unsustainable

Here is a series of questions to use, change or add to, which invite being read in conjunction with Figure 44. In the past, responsible environmental action has had a moralizing tag attached to it and has sometimes been associated with smugness. Such connotations need to be busted. Acting to advance sustain-ability needs to be coded as 'good sense', enlightened self-interest and leadership by example.

It should be remembered that, by degree, we are all unsustainable. In recognizing this, to be in a position to act is to be in a position of privilege. Appropriate action is not making isolated gestures toward being more sustainable but is setting out to make structural changes in one's life that (1) significantly reduce one's overall 'footprint' and (2) provide an example to others, not so much by what is 'sacrificed' but by what is qualitatively gained. We will come to a way of thinking about such changes in a moment.

The starting point of action is self-reflective and requires confronting the difference between how one sees one's needs and wants, while considering the question of quality in terms of an existing or changed way of life. Keeping these observations in mind, we can ask questions like:

- *How appropriate is my home (for example, its scale, physical condition, energy demand and garden) in relation to myself and the immediate others in my life?*
- *Does my home deliver the way I/we actually want to live? Am I expending my non-work time in the way I really want to?*

- *What are the unsustaining qualities of my job?*
- *What do I spend my money on and why?*
- *Can I motivate myself to either reduce the amount I travel by road and air or take action to more than offset the emissions associated with this travel?*
- *What kind of condition am I in physically and mentally and what action do I need to take to better sustain myself?*
- *How do I feel about the values I hold in terms of global equity, war and the needs of others?*
- *And, have I got an argument that privileges justice over charity?*

Self-auditing matrix

What climate adaptive actions have you planned to take? How are your design skills? Do you or can you grow some of your own food? Are you keeping physically and mentally fit? How is your D.Y.I. capability? Have you got I.T. skills? Are you acting to reduce your travel impacts? What energy demand reduction actions are you taking? Got more questions?	
Existing Skills	
New skills needed	
Existing forms of knowledge	
New knowledge needed	

These are all indicative questions. They are not offered as prescriptions but rather illustrate the kind of critical inquiry of the fundamentals of our life, that we all should embrace. So rather than using quantification to prompt responsible action (the function, for instance, of 'eco-calculators') such formatted questioning provides a pointer to complementary qualitative activity (prompting critical reflection on action prior to enacting it).

'Looking at What I Can Do' – Statements for Elaboration

Here we need to identify the areas of our action and knowledge that have sustaining ability (what we know can be divided into: error; knowledge that can be remade; and knowledge that can serve in some way the ability to

Reflection and Redirection: matrix

Major or minor actions? Act today or tomorrow?	
Existing career path	Redirective options
Redirected career choice	Actions needed & when?
Existing lifestyle	Redirective options
Redirected lifestyle choice	Actions needed & when?

sustain). This requires that we acknowledge and document the likes of: 'these are my skills; this is how I sustain myself physically, mentally, culturally and economically; these are the life experience I am able to draw on; and these are the people who sustain me'.

'Looking Back to Look Forward' – Being Redirective

The final part of the process brings the kind of thinking outlined in relation to 'designing-in-time' to individual issues of self-redirection whereby one asks:

- 'Where in my life can I identify redirective opportunities?
- What do I need to bring from my resources to realize these opportunities?
- What do I need to call on from others?
- What is my first course of action?
- What is my time-frame?

To support the somewhat abstracted process just outlined, here is a short scenario to suggest the kind of situation it could prompt.

An Explanatory Scenario

Joanne and Jack are the principals of an architectural practice. They employ eight staff who all live in various parts of the city. Most of the practice's work is in domestic housing, including the design of several 'eco-homes'. Joanne and Jack are committed to living and working to advance sustain-ability. This ambition has had a big impact on their lifestyle, the way they manage the office, the kind of clients they look for and attract, and how they deal with them. But they want to go further. Having spent several weekends creating a clear picture of their own 'self-ecology', assessing their utilized and underutilized sustainment capabilities and conducting individual interviews with each staff member, they created a plan of redirection with six elements:

1. Relocating the practice to a part of the city within waking distance of the railway station (this will mean that five members of staff who currently drive to work will be able to travel by train) and using only one car (on a roster basis) to pick up everyone else.
2. Establishing a small demonstration urban farm (on land made available by a local authority on a ten-year lease at peppercorn rent) – four members of the practice with gardens are to initiate this and all past, present and future clients will be invited to join (Jack worked at his uncle's market garden for several years during school holidays and while he was at university – the idea came from him identifying this as knowledge he had that would become increasingly important in the future).
3. Extending redirective practice to peers – Joanne, who teaches one day a week at a local architectural school, decided to create a rolling programme of redirective practice workshops for staff and senior students, one weekend every eight weeks. She will lead the first one, and thereafter each member of staff will lead a workshop in turn.
4. Changing the trading name of the practice from J&J Architects to J&J Redirective Architects and makeing a large sign featuring this new name when the practice moves. And more importantly, working towards an exhibition on redirective architecture to show at the local architectural institute gallery within the next eighteen months. The content of this exhibition will be then transferred to their website.
5. Twinning with an architectural practice in Argentina to develop a mutual knowledge transfer programme. (Argentina was selected because one of the young architects working for the practice, Paulo, was born and educated there. He also has an uncle who is an architect in the city of Rosario.)
6. Producing a redirective architecture information booklet for clients.

Dialogue and Experiential Learning

Locally based design forms of redirective practice are starting to generate dialogue in various parts of the world. Communicating with other practitioners, sharing knowledge and making project information available is obviously an

important aspect of disseminating and developing the redirective concept and practice. While this is already happening informally, work has started on web-based facilitation structures.[2]

47 Street collector, São Paulo

Case Study: Design and the Coopamare

The Coopamare is a recycling cooperative created and run by homeless people in Brazil. 'Collectors' pulling high-sided hand carts, the size small car trailers, scour the streets of São Paulo, collecting mostly cardboard, aluminium cans and glass bottles. In the absence of a formal urban recycling system in the city, they perform a public service, yet rather being rewarded for doing this they are harassed by property owners and the local authority. There is actually a widespread view of these people as being as undesirable as 'rubbish' they collect. So rather than their recycling activities being seen as a contribution toward the common good, they are vilified and exposed to considerable

hostility. One reason for this was because the collectors were using the void spaces beneath the flyovers of the urban road system to deposit, sort and store material for on-sale; local home-owners regarded this as making the area less desirable, devaluing their properties. In the recent past, this issue has been so emotive that besides pressuring local politicians to have the collectors' facilities removed, relocated or abolished, gangs of thugs have been hired (it is suspected by homeowners) to physically remove or deter the collectors. As a result, a significant number of them have been killed. While it would be simple for a non-controversial inner-city site for Coopamare to be provided by the local authority, to date this has been constantly refused. Despite various kinds of community support, formal and informal, pressure on the organization has been relentless. Notwithstanding all that militates against them, the collector

48 Waste picked recycled products (Jakarta)

community not only has a certain kind of vitality but displays a solidarity that puts many more privileged communities to shame. They also have much to teach these communities and, more specifically, much to teach designers, researchers and students. It should be added that what has been described is a global phenomenon and part of the informal economy supporting hundreds of millions of people. For example, the XSProject in Indonesia buys plastic post-consumer waste from Jakarta trash pickers (of whom there are 350,000–450,000). Using local craft workers it turns this material into sewn products (like shoulder bags, shopping bags, pencil cases) thus generating income for the trash pickers and creating local employment.

Lessons from the Abyss
Many of the people who now survive through the activities of the Coopamare have known what it is to descend into the deepest depths of human misery. Yet they have discovered, in common with other collectives of homeless people around the world, that when you think, and appear to have nothing, you have two things: what can be found on the streets and an innate ability (via design) to use this to make a micro-world to inhabit. Looking into this world reveals extraordinary levels of material innovation and delivers confrontations with products and socio-economic relations that present significant challenges to the way the more fortunate think. Some of these revelations are very pertinent to design and are worth drawing out.

At its most basic design is power – to absolutely lack an ability to design (which is the ability to prefigure in some way the world in which one finds oneself) is to be absolutely powerless. That the homeless act to make some kind of home, be it of cardboard and plastic, is an expression of the saving power of design.

Dominantly, design is understood as a means to bring material and imma-terial objects into being. In contrast, what the homeless do in their endeavour to survive beyond the most basic level is to design with whatever has already been designed. In so doing, they give a qualitative and humanizing dimension to 'things' in the act of survival. Maria Cecilia Loschiavo dos Santos calls this form of design 'spontaneous'.[3] Effectively it means that appropriation precedes

prefiguration (thus 'finding and taking' goes ahead of 'imagining what the found object can become'). 'Spontaneous' is more than just pragmatic for it is also a reaction against being dehumanized and it triggers an act of making a world of individuated human being. Although this action becomes designated as a form of resistance, this underplays the actual character of the dynamic. The act of resisting involves a double movement: the self resists allowing itself to become dehumanized and then the victory of the self with itself becomes a prerequisite for resisting being dehumanized by others and circumstances. It follows (echoing the notion that the first act of sustainment is to sustain one's self) that the political act of resisting conditions of oppression is enabled by a subjective overcoming of the negation of oneself.

In giving found objects new meaning, the homeless bring meaning to them-selves – material and psychological survival become unified and a condition of dwelling is created (dwelling here indicates a mode of being-in-the-world rather than just living in some kind of fabricated structure). Thus such objects become both a means to make a place in the world and an identity to inhabit. Loschiavo dos Santos' descriptions of some of the living environments that the homeless create in left-over urban spaces with cardboard and plastic powerfully illustrate forms of living that transcend mere survival. We read of pride in gleaming pots and pans, symbolic complexity in montages of magazines used to decorate the walls of a cardboard home and of the ingenuity of turning discarded cans into coffee pots, tea pots, cups and the like.[4]

Although the economy of the homeless centres on the recovery of waste and thus supports a recycling industry, there is a more complex relation to everyday materiality evident in the transformation of found objects for the self or community. Much of the profligacy of affluent society is brought into stark relief – by revealing the quantities of products with remaining material or cultural use value that enter the waste stream and which can actually materially support an entire community of the underclass (by their direct use, their redesigned use or being on-sold as recovered materials). The current most enlightened model is 'cradle to cradle' in which the product's materials stay in a closed loop ensuring total materials reuse. The homeless provide another option – 'cradle to re-animation from the grave'. This places a product

in another kind of economy of use and expenditure wherein design is always designing with the already designed.

The material practices of the homeless expose the wastefulness of the 'waste' of the privileged. Where need drives the homeless to fully expend the use of the world of objects they inhabit, the privileged live in a world of accumulating underexpenditure – drawers, cupboards, wardrobes, garages, kitchens, bedrooms, bathrooms, living rooms are full of 'it'!

The urban homeless collectors who have been discussed here are, of course, part of a much larger picture of the poverty in the informal economy, exemplified by the dramatically growing populations of shanty towns across

49 Homeless dwellers, Tokyo

the globe. As Mike Davis has made so clear, not only does a third of the world's population live in slums but slums are the fastest growing type of housing on the planet.[5] These often huge, unregulated and unserviced developments are another kind of spontaneous design from which lessons are being learnt – both the urban homeless and shanty town dwellers evidence how solidarity and community can form out of collective, pragmatic efforts of survival. In both cases, the utilization of 'waste' is a key factor. The absolute poor – the poor who rather than improving the metabolic function of cities by 'consuming' under-expended goods and materials – are those in rural and remote environments where all they can afford to do is to 'consume' the very environment they depend upon (one of the main ways this happens is by stripping the environment of anything that will burn to cook with, be it animal waste or wood).[6]

Conclusion

The homeless beg our attention. Increasingly, they will become the advanced guard of the culture of unsettlement that is travelling toward us as the effects of climate change ever increase. In confronting a problem where hundreds of millions of people will lose their homes and will be unable to be accommodated by the planet's housing stock, there is a great deal to learn about neonomadic life and the transportable structures, designed and created by the homeless. Is it possible for this ever growing section of humanity to live in a state of dependence on the under-expenditure of materials and goods of the more fortunate? The city of Cairo suggests it might be – this city is the *de facto* recycling capital of the world with its huge informal 'community' (making up almost 75 per cent of the total population of Cairo) living largely off 'waste'.

Against this backdrop, how the homeless and abject poor find social and economic ways to survive, the expertise they develop and their ability to 'design with the designed' must all be treated as a repository of futuring knowledge. Certainly, it is clear that there are major design challenges that go beyond how we think, let alone deal with, the tide of homeless refugees that will sweep the planet. What is very apparent is that all nations are currently

totally ill-equipped to deal with the scale of the problem coming their way. As yet, the problem has not been adequately identified, thus what has to be planned and designed has not been contemplated. In defining and responding to 'ultra-homelessness', learning from organizations like the Coopamare will become vital. Certainly 'design with the designed' (as a singular act of 'remaking otherwise' or as a plural one of bricolage) has to be considered as a developable method and addition to the redirective design practices like elimination, recoding and retrofitting. Maybe the place to start is by devising R&D (architectural and design student) projects?

16

Challenges of Sustainment and Futuring – A Review of Change Agents

Whether it is employed by self-designated designers or simply by those who use design skills and knowledge – not recognized as such – within other practices, design is all about creativity at its most fundamental. It is about bringing the to-be-created into being by an act of prefiguration (or at least that is how it has been viewed prior to bringing 'design for elimination' – prefiguring an act of 'creative destruction' – into the picture).

The magnitudes of the challenges facing the entirety of humanity are unprecedented since the move from nomadic life to settlement 12,000 years ago. And as has been argued, the current level of unsustainable human activity – including the increasing problems of climate change, impacts from the ongoing globalization of 'consumerism' and a world population still heading

toward a peak of 9 billion to 11 billion – are daunting. Design, as framed by redirective practice, is poised before all of this, facing creative challenges like humanity has never known before.

Even with a critical mass of redirective designers, the challenges are mind-bogglingly huge. In a vast numbers of cases it is not a matter of trying to deliver solutions – while some problems can be solved in the short or long time, many cannot. For instance, an ice-shelf cannot be refrozen, a recently extinct animal cannot be brought back to life, a logged and soil-eroded mountain-side cannot be replanted, the victims of war cannot be raised from the dead and cultures ethnocidally devastated cannot be restored. In many cases, the challenges to be faced are a matter of finding ways to adapt to changed circum-stances. There is an interesting example of this currently in Australia where there is a slow move away from the idea that the severe drought that has held the nation in its grip for many years is not going to end; rather it is 'normality' – it's the new climate. As previously indicated, forms of 'design for sustainability' can, and in many cases try, to give the impression that once they dominate the mainstream it can be 'business as usual.' This is not the case. There are clearly progressive innovations that can lighten our collective planetary footprint and make a contribution to futuring but there are also others that are counterproductive and simply sustain the unsustainable.

Assessing the Efficacy of Change Agents

Having considered the nature of a new practice, given some thought to how it can be strategically mobilized and examined some of the contexts in which design remade is able to function, we now need to consider how the affirm-ative idea of futuring and the moment and culture of sustainment can be communicated. Is it merely a question of finding an existing medium to hitch a ride on or is it a matter of creating new change agents? To answer this question let's start by a rapid assessment of the currently available, or claimed global change agents.

Notwithstanding growing concern by many governments, citizens and corporations, the scale of the problem of escalating unsustainability is in no way matched by the global response. As seen with climate change, the dominant view (by degree) is that action should not be at the 'expense' of the economic status quo. The assessment that follows is based upon personal experience and a particular political perspective, which means that it speaks from a position of bias rather than claiming objectivity.

There is a caveat to make: the overview presented can only give a very general impression, which means that exceptions exist both in terms of the actions of particular individuals, groups and programmes within particular change agents as well as how some actors manage to appropriate and redirect the change agent's intent. And there is one unambiguous ground rule: a problem cannot be responded to unless it is faced. This must not be confused with either doomsaying or pessimism. No matter how bad the problem, there can be no grounds for optimism unless it is directly confronted. All other positions are idealistically deceptive and, notwithstanding good intent, must be viewed accordingly. We will use this position as a means of briefly assessing the options.

Table I Evaluation of Change Agents/Instruments

Change Agents / Instruments	Discussion and Evaluation	Rated Effect*
Government (policy and institutions) – Environmental Protection Authorities, environmental legislation, Land and Environment Courts	At their best, these instruments do contribute to the protection of the natural environment, not least by regulating polluters and forms of pollution, but they equally partition 'the environment' from other policy areas, especially the economic. Thus they function with restrictive understandings of both environment and 'sustainability'. Such instruments are part of the status quo rather than agents of its transformation.	Moderate to low

Table I Evaluation of Change Agents/Instruments *(continued)*

Change Agents / Instruments	Discussion and Evaluation	Rated Effect*
International conventions	The Kyoto Protocol is undoubtedly the best known of these – it has been outstandingly ineffectual in reducing global greenhouse gas emissions, or even making clear that its targets were moderate starting points towards the major reductions (80%+) that are actually needed. Other conventions aimed at protecting, e.g whales, ocean fish stock and rainforests have been no more effective. Likewise, action against arms reduction has been weak and the containment of nuclear arms proliferation is on the verge of collapse.	Low
Environmental globalism – UNEP, The Earth Charter, UN Millennium goals	Getting the world to march in step to reduce the ongoing impacts of unsustainability, with currently available instruments of change is proving to be exceptionally hard. Problem definition is poor, focusing on symptoms rather causes. Likewise, levels of international solidarity are low, with national economic and ideological interests overriding the common good. Available instruments mostly span the aims of sustainable development and humanitarianism. United Nations Environmental Programmes are diverse and have a strong technocentric bias. While programmes that bring infrastructure, like potable water and renewable energy to communities of need, do improve the quality of people's lives they also suffers from the general gesturalism, lack of vision and bureaucratic stasis that marks the work of so many UN agencies. The Earth Charter is the motherhood of all motherhood statements, and while there is little to disagree with, its actual leverage on change is negligible. The UN Millennium goals, aimed at improving the conditions of life for the disadvantaged people of the world continually fall short of their ambition and material needs.	Moderate to low

Change Agents / Instruments	Discussion and Evaluation	Rated Effect*
Environmental economics, carbon trading and ethical investment	All these instruments go to the greening of capitalism. At best, they can have positive impact reduction results. At worst, they simply become a means of money-makers finding a way to maintain 'business as usual'. Environmental economics does not deliver a fundamental paradigmatic break, and carbon trading is still a fragmented activity of moderate to bad programmes. Its ability to become global and effective is questionable and seemingly many years away. Ethical investment is a good idea that lacks a material ground – ethical corporations to invest in (as a result, its investment base is low and in many corporate cases, questionable).	Low to moderate
Natural capitalism and corporate sustainability	'Natural Capitalism' is a biocentric path to perpetual growth with a mix of good and weak ideas. Corporate sustainability when taken seriously can reduce the negative impacts of a company's activities, but so easily can simply be 'green-washing'.	Moderate
Environmental ethics	As a backwater of philosophy, this sub-discipline is weak and biocentric and has almost no agency or influence. Emerging out of concerns of the early environmental movement, it needs a radical conceptual makeover to break out of its condition of limitation.	Low
Environmental education	This is a very broad area of educational activity from primary school to postgraduate. It is an amazingly mixed bag, spanning the worst of fuzzy thinking about 'nature' to the best and most insightful methods of engaging how humanity currently dwells in the world and needs to do so in other ways. It is extremely important for it to transcend its original naturalistic terms of reference to embrace the 'naturalized artificial'.	Moderate but potentially high

Table I Evaluation of Change Agents/Instruments *(continued)*

Change Agents / Instruments	Discussion and Evaluation	Rated Effect*
The environmental movement	The environment movement, spanning single issue activist groups through to broader ranging non-government organizations and 'green' political parties, contains many dedicated people often taking valued practical action. At the same time, as environmental gesturalism has become part of the mainstream, it has in large part, to coin the phrase President Eisenhower directed at Britain after the Second World War lost an empire without finding a role. Thus it either changes, not least by gaining an informed cultural and design agenda, or dies.	Low
Consumer action	Household recycling, 'environmentally friendly products', environmental labelling, etc. Such action makes a contribution but this is minor in relation to: (1) the overall impacts of households and (2) the nature, volume, global growth and dependence of existing economies upon 'consumption'.	Low
'Sustainable Design'	Substantial comment on the strengths and weaknesses of the shades of 'green and sustainable design' has been made in this text. This indicated it to be a mixed bag of positives and negatives, the main weakness being that it puts nearly all eggs in the 'green technologies' basket.	Moderate
The spark of a moment of crisis	While not an agency in any institutional sense, there is widespread belief that the radical changes that sustainability demands are not going to arrive until a really dramatic environmental crisis occurs. This position is dangerous and limited. It falls in behind positions that defer action that needs to take place now. It is limited by the fact that the crisis is already,	N/A

Change Agents / Instruments	Discussion and Evaluation	Rated Effect*
	here but time measured from the perspective of a human lifetime fails to see this. Moreover, the tendency is for people who are not directly affected by a crisis to go on living 'normally'.	
The great conference in the sky	Conferences can obviously be useful ways to share ideas and make contacts. Certainly they give scholars an important forum in which to be tested. At the same time, there are many large 'talkfests' that are high in rhetoric and political posturing and low in actually leading to practical action or the advancement of thought and understanding. The most negative aspect of such five-star-hotel-flown-in-from-four-corners-of-the-globe events is they are treated as substitutes for doing anything about the issues they are meant to engage: climate change; HIV AIDS, urban development, whaling, being a few examples.	Low
Fun, fun, fun	Here we are dealing with a strategy rather than an agency, but as it (in various forms) is common, it invites comment. The notion is that whatever the form of communication – a conference, book, TV documentary, course, and so on – it has to be entertaining to attract and hold an audience. While this may work for some, the reality is that once the going gets tough the fun seekers get going – out the door! Unfashionable, it may be, but it is crucial to be serious about serious problems.	Low

What follows in Table 2 are some of the forms of action that earlier chapters have put forward. Some have a proven track record, other not, because they are still nascent and have yet to develop institutions and modes of organization. Here rating effectiveness is left for the reader.

*These ratings are the author's.

Table 2 Evaluation of Projected Change Agents/Instruments*

Change Agents / Instruments	Discussion and Evaluation
Leadership in practice	The frame of redirective practice as a common idea having the possibility of permeating different practices, allowing uncoordinated activity to travel in different ways to the same goal.
Design redesigned with rigour and risk	This is what is implied in all the ways design has been talked about. It means inside and outside service relations, architects and designers become more active and effective change agents for sustainment.
A new sovereignty	Our current freedoms exist by dint of 'freedom under the law', our future freedom will, it has been argued, only exist by dint of 'freedom under the rule of sustainment.'
Designing in other ways	No matter if it is designing with the already designed, designing for elimination, design for a changing climate, designing in time – design has to change.

*Unrated.

From this brief review it is fair to say that most of the available 'change agents' remain institutionally hide-bound, functioning with perceptions and practices grounded in the past rather than being orientated toward the future. Given this situation, this book has argued that there is an enormous task to develop and communicate the critical importance of a redefined and clearly elaborated role for design within the frame of redirective practice. It is thus critical that the potential of redirective practice be grasped as a futuring form of action that can be very mobile, and that can move between and link formalized and informal spaces.

On the Hinge: Turning towards Change

Knowing is never enough. In so many ways, in so many contexts, we, as the members of the more privileged classes of our planet (the assumption here is that to be in a position to read this book is to be privileged) already know what to do, but we fail to do it. Certainly, there are political, economic and institutional obstacles in our path, but equally there are intellectual and emotional obstructions. We tend to focus on the superstructural features of our life (our careers, homes, social relations, education, interests and pleasures) and neglect the foundations upon which all these things stand. We neither feel nor really understand our connectedness to all that allows us to be, our being 'flesh of the world'. We do not feel our unsustainability beyond occasional touches of guilt as we fill-up our car's fuel tank, look at the contents of our supermarket trolley or check-in at the airport for a flight that we really can't justify. Certainly, few of us feel the tyranny of our human centredness. But we have to – being unsustainable has to hurt. This pain has very little to do with feeling guilty because we are 'consumers'. Rather it is about facing the fact that we are part of an age that's killing the future. It's the pain of knowing this, thinking we are helpless and making the best of our lives in these circumstances. To move forward we have to come to terms with the discovery of what we have become in our homelessness and isolation – in making a world we have almost lost *the world*, in becoming individuals we have lost common *unity*. Everything that has been said in the foregoing chapters is a rejection of helplessness. The claim is not that design redirected *will* provide the means to get us from where we collectively are to where we need to be, but rather, that is *what we need to make it do*. We are at a moment unique in our being, we stand on the hinge. In one direction it folds toward struggle, but a future nevertheless; the other direction folds towards our suffering the fate of our own defuturing. To choose requires we know what choice we are making.

Example: A History of 'The Impossible'

The aim here is to expose the nature of the relation between language and perception. This task is akin to demonstrating Ludwig Wittgenstein's famous dictum – *'the limits of my language* mean the limits of my world'.[1] For all of us who attempt to grasp the scale, complexity and seriousness of the problems the human race currently faces, it can seem that overcoming them is actually impossible. Yet we need to ask if we actually can, in fact, distinguish between what, at any given moment, is empirically impossible from what our limited perceptual reach tells us is impossible. For instance, for almost the entirety of human history, saying that a human being will walk on the moon would have been regarded as stating the impossible, yet we know it has happened.

We can all think of examples of people, individually or collectively, who have attained the impossible. In many respects, the history of the impossible is the history of humanity. As purveyors of the 'dialectic of sustainment', we, in all our difference, have created worlds and things and have gained destructive capabilities beyond the imagination of people even a hundred years ago. Clearly, the complexity, scope and ambition of the project of the Sustainment that has been put forward by this book, is both essential and utterly reasonable, but at the same time many people will regard it as absolutely impossible. Notwithstanding a bleak analysis and the total inadequacy of current action against the forces of defuturing unleashed by human action as they travel towards us from the past, loom in the present and threaten us from the future, *it has to be affirmed that the history of humanity is a history of the realization of the impossible.* The vast majority view large challenges in a condition of perceptual limitation – this was true in the past, and is so in the present.

For humanity to have a significant and active possibility of making a future there are essentially three challenges that require to be met: (1) resolving as many as possible of those environmental problems that we, in whole or part, have been responsible for causing; (2) adapting to those environmental conditions and problems that we are helpless to resolve, at least in the foreseeable future; and (3) hardest of all, transforming *how we act if* not *what we are* so

we can cease generating the level of destruction, conflict and inequity that threatens our continuity.

Such a transformation means transforming all that brings us into being beyond our biological determinants. It means creating a culture centred on Sustainment, countering our being designed into 'the inhuman' by the technologies of our invention and remaking our worldly conduct by remaking our own world and our mode of dwelling as a condition of care. We are unable to will ourselves to be other than we are *en masse*. In this situation, there are only two alternatives: highly socio-culturally directive political regimes (which history tells us are neither attractive nor effective); or, to bring another world into being by design.

Underpinning so much of what has been said is the proposition that for design to usher in less destructive modes of worldly habitation, it has to be far more overtly ontologically directive/redirective. Notwithstanding earlier qualifications made on determinism, any objection that this is unacceptably deterministic would be ill-founded. To be human is to be determined; and to be a late-modern globalized human being is to be a victim of instrumental and economic determinism. The issue then is: 'what is to be determined by the designing of the designed so that we *act* more responsibly in and on the world in which we find our self'? This question acknowledges that we are, and need to be, plural in the formation of the differences that constitute a culture of sustainment.

The Final Word

For humanity to continue to have a future as a species, the impossible has to be attained. To do this, an as yet unquantified critical mass of us has to overcome the existing limits of mind, imagination and action. The question here is not where to start, because the start has been made but how to increase our ability, numbers and efficacy. What appears here, in this book, has aspired to make a contribution to opening and advancing this omnicritical project. The measure of its success rests with its readers. At this final point in striving to

help bring the enormous redirective power of design into being and then 'out of the shadows' there are a series of comments made in the book's preface that beg replaying, be it with a little tinkering:

1. All human beings are designers (the ability to prefigure being *de facto* one of the characteristics that defines the nature of being human)
2. Some human beings develop their ability to design, make it elemental to their identity and in many cases earn their living so doing.
3. The objective of the entire book has been to expand how design is understood, practised and what it is mobilized for and against.
4. The appeals made to the reader as a designer, which has been the dominant characterization of the reader, have been based on the notion of the reader as equally
 - the designer (the 'I' that calls itself a designer) and
 - anyone for whom design is an intrinsic part of their practice, conceptually or practically.

Notes

Introduction

1. Existential time (time as that in which events occur, as Aristotle put it), measured time (intervals of marked duration) and relative time (the relational time of astrophysics) do not combine into a singularity. Time is thus plural – no particular discourse can claim it.
2. This relation of creation and destruction has been theorized and will later be elaborated as the 'dialectic of sustainment'. See also 'The Sustainment and its Dialectic', in Anne-Marie Willis (ed.), *Design Philosophy Papers Collection One*, Ravensbourne, Queensland, Australia: Team D/E/S Publications, 2004, pp. 57–62.
3. WWF Report, *Living Planet*, 2006 as reported in 'Earth's Ecosystem faces Large-scale Collapse' in *The Australian*, 25 October 2006.
4. The debate around 'design democracy' is currently gathering momentum. One instance of this centred on the article 'Are Designers The Enemy Of Design?' by *Business Week*'s design writer, Bruce Nussbaum, based on a talk he gave to Parsons School of Design, New York in March 2007, which he subsequently posted on his blog. Many publications picked up on Nussbaum's article, including the New York design e-publication, *NextD*, which invited and published fifty responses, positive and negative, from design writers around the world.
5. Peter Kropotkin, *Fields, Factories and Workshops Tomorrow* (1899), London: George Allen & Unwin, 1974.

6. Julian Huxley, *TVA Adventure in Planning*, London: Architectural Press, 1943, p. 131.

7. For example, see the extensive list of authors who contributed to the 1,000 pages plus collection by Bruno Latour and Peter Weibel (eds), *Making Things Public: Atmospheres of Democracy*, Cambridge, MA: MIT Press, 2005.

8. Randolph Hester, *Design for Ecological Democracy*, Cambridge, MA: MIT Press, 2006.

9. Isabelle Stengers, 'The Cosmopolitical Proposal' in Latour and Weibel, *Making Things Public*, pp. 994–1003.

10. For a full account of 'design intelligence' see *Design Philosophy Papers* No. 4, 2004, www.desphilosophy.com .

11. Modern pathfinders who strove to advance design intelligence, like Buckminster Fuller, Bruce Archer, Herbert Simon, Reyner Banham, Christopher Alexander, J. Christopher Jones and Manfredo Tafuri – occupied various socio-cultural perspectives and political ideologies, while adopting diverse objects of focus. Although they all, by degree, made contributions to how design problems, objects, methods and practices are understood, they did so without an adequate engagement with the question of intelligence itself.

12. The kind of content to be embracing would be the likes of: the relational interplay between design and mind; design as artefact and artifice; design's agency in the world; design, economy, ecology and exchange; design interpretation and criticism; design as ethics materialized and ethical accountability; design, cultural authorship and change.

Chapter 1 Understanding the Nature of Practice

1. Pierre Bourdieu, *Outline of a Theory of Practice*, Cambridge: Cambridge University Press, 1977.

2. Ibid., p. 85.

3. Hannah Arendt, *The Human Condition*, Chicago: Chicago University Press, 1958/1989, p. 229.

4. Ontological design can be basically understood as – 'the things of the world (including things that designers design) as they themselves contribute to the designing of modes of being in that world, and thus to the changing character of worlds

themselves'. These are relations in flux; they are dynamic, circular and excessive. See Anne-Marie Willis, 'Ontological Design – Laying the Ground', *Design Philosophy Papers Collection Three* (ed. Anne-Marie Willis), Ravensbourne, Queensland, Australia: Team D/E/S Publications, 2007, pp. 80–98.

5. Arendt, *The Human Condition*, p. 230.
6. Hope Shand and Kathy J. Wetter, 'Shrinking Science: An Introduction to Nanotechnology' in *World Watch Institute State of the World Report 2006*, New York: W. W. Norton, 2006, p. 83.
7. Ibid., pp. 78–95.
8. William McNeill, *The Glance of the Eye*, New York: SUNY Press, 1999, pp. 65–71. The knowledge gained from this kind of observation is not simply delivered via the optics of sight – what is observed calls upon all senses and the resources of mind. It also begs to acknowledge that everything being considered will always be aesthetically refracted, and may well arrive before us by virtue of mediation and interpretation. As well, whatever the means of revelation, it can equally be a means of concealment (the true nature of a thing as itself and as viewed by us are never convergent).
9. Ibid.
10. Karl Marx, 'The Eighteenth Brumaire of Louis Bonaparte' (2nd edn, 1869), in David Fernbach (ed.), *Surveys from Exile: Political Writings*, Harmondsworth: Penguin/New Left Review, 1973, p. 146.

Chapter 2 Understanding the Directional Nature of Design

1. Gregory Bateson, *Steps to an Ecology of Mind*, London: Paladin, 1973.
2. Relationality, as a concept, has a contradictory status within Western rationalist thought. It is ignored, refused, embraced and differentially understood. Ever since Aristotle's address to substance in the *Categories* and his radical reworking of it in book *Zeta* of *The Metaphysics*, relationality has been posed against substantialism. Yet, as Aristotle knew full well, the fundamental substances of the things upon which everything depends turns on the properties of their relations. As we read in book *Delta* of *The Metaphysics,* all things with '. . . relational account, whether numerical or potential, are relations by dint of the fact that the account of something else is involved in what they are, not that what they are is involved in the

account of something else.' Although named in various ways, relationality figures in the work of thinkers as diverse as, for example, David Hume, John Dewey, Ludwig Wittgenstein and Martin Heidegger. Relationality is also found at the core of Alfred North Whitehead's 'philosophy of organism' in which 'All relatedness has its foundation in the relatedness of actualities; as such relatedness is wholly concerned with the appropriation of the dead by the living.' (Alfred North Whitehead, preface to *Process and Reality*, 1st edn, New York: Macmillan, 1929.)

3. David L. Hall and Roger T. Ames, *Anticipating China*, New York: State University of New York Press, 1995, pp. 11–12. Hall and Ames point out the significance of the interplay between 'Ten Thousand Things' (as a key to understanding the complexity of change and correlative thought, as developed during the Han Dynasty in the third century BC).
4. Ibid.
5. On ontological design, see Anne-Marie Willis, 'Ontological Designing – Laying the Ground', *Design Philosophy Papers Collection Three*, in Anne-Marie Willis, Ravensbourne, Queensland, Australia: Team D/E/S Publications, 2007, pp. 80–98.
6. Since the late 1920s a considerable literature on automobiles, movement, freedom and the reorganization of space has amassed. Much of this is focussed on the United States and one of the most interesting reviews of it has been Joseph Interrante 'You Can't Go to Town in a Bathtub: Automobile Movement and the Reorganization of Rural American Space 1900–1930', *Radical History Review*, 21, 1980, pp. 151–68.
7. 'The New Citroën' in translation in Roland Barthes, *Mythologies*, London: Paladin, 1973, pp. 88–90. Ironically, Barthes was run over and killed on a street in Paris (by a laundry truck).

Chapter 3 The Imperative and Redirection

1. The idea that economies always have to continually grow is *de facto* a proposition in accord with the impossibility of perpetual motion.
2. Max Weber, *Economy and Society*, in Guenther Roth and Claus Wiltich (eds and trans.), New York: Bedminster Press, 1968 – the book was originally published in 1914.
3. Carl Schmitt, *The Crisis of Parliamentary Democracy* (trans. Ellen Kennedy), Cambridge, MA: MIT Press, 1998.

4. Jacques Ranciere, *Hatred of Democracy*, London: Verso, 2006.

5. Aristotle's turn to politics as the means by which the ethical could be advanced, while influenced by Plato's understanding of the political being the realm of all human conduct (rather than just that between the individual and the state), undercut the proposition of the ethical state (this critique, of course, prefigured Hegel's conception of the ethical nature of the 'end state'). Specifically, what Aristotle did was to suggest that the discussion of how to advance ethics should focus on legislation and the study of the constitution in order to discover what laws and customs best serve it. This focus, he believed, was the means by which to complete a 'philosophy of human nature' (*The Nicomachean Ethics:* 1181b20). Aristotle's conclusion to his writing on ethics was, of course, the opening into the project that became *The Politics*.

6. Bruno Latour, *Politics of Nature* (trans. Catherine Porter), Cambridge, MA: Harvard University Press, 2004, pp. 10–18.

Chapter 4 Design as a Redirective Practice

1. Design as embodied technology comes in the form of software able to generate vast numbers of variations on the same theme – project home floor plans, wine bottle labels, mobile phone cases, fabric patterns and so on.

2. On hegemony see Antonio Gramsci, 'The Modern Prince', in *Prison Notebooks* (trans. Quintin Hoare and Geoffrey Nowell Smith), London: Lawrence & Wishart, 1971, pp. 123–205.

3. The competition had support from the American Institute of Architects, the Los Angeles Museum of Art and Architecture and a number of distinguished architects.

4. The submission presentation was made in Los Angeles by Jim Gall and Tony Fry in June 2007; it was awarded second place.

5. B. F. Skinner's book *Walden Two*, published in 1948, was itself inspired by Thoreau's *Walden: Life in the Woods* (1854). The words quoted come from the Preface of the 1976 edition, published in New York by Macmillan.

6. The project is also perhaps a modest illustration of an ecology of mind (how ideas travel). Prior to working in Fiji, Chris Cole worked for Lonergan and Cracknell, a Sydney-based architectural practice. Not only are Peter Lonergan and Julie

Cracknell friends of the author but they also did several courses on sustainable architecture that he ran while director of the EcoDesign Foundation, worked on a project with him, as well as Peter Lonergan becoming a board member of the organization. Thus their practice and the people who worked for it were knowingly or unknowingly exposed to, and influenced by, relational design theory and practice very early.

Chapter 5 Reviewing Two Key Redirective Practices

1. 'Living an exemplary life' was one of the cornerstones of Confusion thought.
2. Hal Foster, *Recodings: Art, Spectacle, Cultural Politics*, Seattle, WA: Bay Press, 1985.
3. It was shown that just a one-way flight of a Boeing 747-200 used more energy than was required to build a small factory.
4. Mexico City, Munich, Atlanta – the history of violence associated with the Games is writ large. As global terrorism has escalated, the security risk of the Olympics ever increases.
5. On Neville Brody and *The Face* see 'The Bottom Line on Planet One', in Dick Hebdige, *Hiding in Light*, London: Routledge, 1988, pp. 155–76.
6. On streamlining see Chapter 3 of Tony Fry, *A New Design Philosophy: An Introduction to Defuturing*, Sydney: University of New South Wales Press, 1999.

Chapter 6 Futuring, Redirective Practice, Development and Culture

1. On the violence of genocide and ethnocide see Pierre Clastres, *Archaeology of Violence* (trans. Jeanine Herman), New York: Semiotext(e), 1994.
2. Alongside the rise of the 'development process' and 'development studies' there has been a now longstanding major critique of development discourse and its designation of the condition of 'underdevelopment'. This critique was heavily inflected by Marxist methodology. Notwithstanding the demise of Marxism as a political ideology, economic and social system, or as a theory of history, it did deliver a very powerful analysis that still requires engagement if we are to understand the nature of newly

industrializing, still non-industrialized and neo-dysfunctional nations. Although it is unfashionable, much can still be learnt from past and present Marxist critique – for example Samir Amin, *Unequal Development* (trans. Brian Pearce), Hassocks: Harvester, 1976 or Michael Hardt and Antonio Negri, *Empire*, Cambridge, MA: Harvard University Press, 2000. Equally, it is also worth taking cognizance of what historical and cultural anthropology tells us about development (see, for example, Marshall Sahlins, *Culture in Practice*, New York: Zone Books, 2005).

3. The distinction between undevelopment and underdevelopment was powerfully made by André Gunder Frank in the late 1960s. See James Cockcroft, Andre Gunder Frank and Dale Johnson, *Dependence and Underdevelopment*, New York: Anchor Books, 1972.

4. Reported on 'Rural News', ABC Radio National (Australia), 8 September 2007.

5. Liang Congjie, *The Great Thoughts of China*, New York: Wiley, 1996, p. 254.

6. Manuel Castells, *The Rise of Network Society*, Cambridge, MA: Blackwell, 1996, pp. 17, 112.

7. Exploitation of crisis is one of the ways capital expands and regenerates – war being the most graphic example.

8. David Dickson, *Alternative Technology*, London: Fontana, 1974.

9. Victor Papanek, *Design for the Real World*, London: Thames & Hudson, 1972.

10. Tony Fry, 'Design Betwixt Design's Others', in Anne-Marie Willis (ed.), *Design Philosophy Papers Collection Two*, Ravensbourne, Queensland, Australia: Team D/E/S Publications, 2005 and *Design Philosophy Papers*, No. 6, 2003–4. www. desphilosophy.com

Chapter 7 Unpacking Futuring – The Self, Community, Culture and Ethics

1. The original concept of technological obsolescence as explored by people like Vance Packard in *The Waste Makers*, Harmondsworth: Penguin Books, 1961, was based on the notion of obsolescence being designed into a product's materials, construction and performance – things were created to prematurely fail so they had to be replaced. The contemporary approach is for a new product to make the prior one redundant by outperforming it (increasing the memory and speed of computers is an obvious example). The environmental impacts of such activity

can be overtly negative or more ambiguous. For example, an LCD flat panel display screen uses only 25 per cent of the energy of a CRT screen; at the same time it makes the latter technology obsolete and thus drives a massive surge in electronic waste.

2. In 2007 the Australian Government promised AUD200 million worth of aid to assist with the restoration of forests in the region. While this was welcomed it is but a 'drop in the bucket'.

3. On Future Studies see *Futures – The Journal of Policy, Planning and Future Studies*.

4. Jean-Luc Nancy, *The Inoperative Community* (trans. Peter Connor et al.), Minneapolis, MN: University of Minnesota Press, 1992, p. 3.

5. Mike Davis, *Planet of Slums*, London: Verso, 2006.

6. Nancy, *The Inoperative Community*, p. 9.

7. A very simple example that pulls tradition, community and environmental care together was the road-building of Africa's Ganda people – it was a traditional practice conducted by the community that went around obstacles like trees. This practice was condemned as 'lazy and backward' by Western road builders in Africa who swept all before them regardless, as they struck to their straight path. See Michael Adas, *Machines as the Measure of Men*, Ithaca, NY: Cornell University Press, 1989, pp. 153–65.

8. This claim is argued at length in Tony Fry, *A New Design Philosophy: An Introduction to Defuturing*, Sydney: University of New South Wales Press, 1999.

Chapter 8 Methods of Change I – Platforming, Return Briefs and New Teams

1. The company that has received most attention in respect of such change is Ray Anderson's international carpet-tile company Interface Inc. Founded in 1973 by Ray Anderson, it has the stated aim of being the world's leader in industrially led sustainability.

2. See Hilary Wainwright and Dave Elliot, *The Lucas Plan*, London: Allison & Busby, 1982.

3. This assessment was prior to the issue of global warming being identified, and thus recharging from a non-renewable energy source was not regarded as a problem.

4. The analysis may have been correct in terms of the arrival of bio-fuels, hydrogen fuel cells and hybrid power but was wrong on timing – currently a decade on, LPG is still a commercial prospect.
5. As a director of the sustain-ability design consultancy Team D/E/S Pty Ltd, I have been working with Gall & Medek on a variety of redirective projects for the past two years – although the relation with the practice is longer standing.
6. Initially, the acoustic performance of the Sydney Opera House was notoriously bad.

Chapter 9 Methods of Change 2 – Designing in Time

1. See the original discussion of topic, Tony Fry, 'The Scenario of Design' in *Design Philosophy Papers* No. 1, 2005, www.desphilosophy.com.
2. Ibid.
3. Ezio Manzini and François Jégou, *Sustainable Everyday: Scenarios of Urban Life*, Milan: Edizoni Ambiente, 2003.
4. Ibid.

Chapter 10 Futuring and Learning the New from the Past

1. Lother Ledderose, *Ten Thousand Things*, Princeton: Princeton University Press, 2000, p. 133.
2. Ibid., pp. 132–4.
3. S. Liang, *Yingzao Fashi,* Beijing: Zhu Shi Zhong Guo Jian Zhu Gong Ye Cu Ban She (in Chinese), 1983.
4. Design for disassembly is a significant but still underemployed technique of sustainable architecture.
5. A full and detailed exposition of this is given by Ledderose in *Ten Thousand Things*, pp. 132–7. The conventional wisdom among scholars is that the Greeks overtook the Chinese because they had geometry, whereas the Chinese did not – see G. E. R. Lloyd, *Adversaries and Authorities: Investigations into Ancient Greek and Chinese Science*, Cambridge: Cambridge University Press, 1996. Certainly, much of the detail of the *Yingzao Fashi* brings that claim into question – the practical could not have existed without a conceptual dimension.

6. Ibid.

7. See Michael Adas, *Machines as the Measure of Men*, Ithaca: Cornell University Press, 1989.

8. Pig iron/cast iron consists of iron, carbon and impurities; wrought iron is high in carbon, low in impurities and very malleable; and then there are a variety of processes, like direct reduction, which can bypass making iron in a blast furnace for steel making.

9. Electric arc furnaces are a favoured technology for recycling – recycled steel requires only half as much energy to manufacture as new steel, which of course means halving greenhouse gas emissions.

10. C. Secrett, 'Greater Carajás: Sustainable Development or Environmental Catastrophe?' in D. Treece (ed.), *Bound in Misery and Iron: The Impact of the Grande Carajás Programme on the Indians of Brazil,* London: Survival International, pp. 58–96; M. Simons, 'The Smelters' Price: A Jungle Reduced to Ashes', *New York Times,* 28 May 1987, p. 2.

11. P. M. Fearnside, 'The Charcoal of Carajás: Pig-iron Smelting Threatens the Forests of Brazil's Eastern Amazon Region', *Ambio* 18(2) (1989), pp. 141–3.

12. Jeb Blount, 'The Secret World of Modern Slavery', Bloomberg.com (see www.bloomberg.com/apps/news), 25 January 2007.

13. Walter Emrich, *Handbook of Charcoal Making*, Dordrecht: Reidel Publishing Company, 1985.

Chapter 11 Designer as Redirective Practitioner – New Roles beyond Design

1. Harold Nelson and Erik Stolterman address design as a service as follows: 'Design is, by definition, a service relationship. All design activities are animated through dynamic relationships between those being served – clients, surrogate clients (those who act on behalf of clients), customers and end users – and those in service, including designers. Design is about service on behalf of the other.' Harold Nelson and Erik Stolterman, *The Design Way,* Englewood Cliffs, NJ: Educational Technology Publications, 2003, p. 47.

2. The absorption of solar radiation by the thermal mass of dense materials like concrete, followed by the re-radiation of this heat as the sun goes down, has the

effect of significantly or totally eliminating the difference between day and night temperatures. Heat islanding is so severe in, for example, a city like Tokyo, that in some districts people are required to throw water on streets and pavements.

Chapter 12 Futuring against Sustaining the Unsustainable

1. On the pre-history of 'green design' see Victor Papanek, *Design For The Real World*, London: Thames & Hudson, 1972 and David Dickson, *Alternative Technology*, London: Fontana, 1974. For a contemporary view that situates design in relation to 'technology and sustainability' see Aidan Davison, *Technology and the Contested Meaning of Sustainability*, New York: SUNY Press, 2001.
2. William McDonough and Michael Braungart, *Cradle to Cradle*, New York: North Point Press, 2002, pp. 105–15.
3. Ibid., p. 150.
4. Buckminster Fuller, 'Earth Inc.', in James Meller (ed.), *The Buckminster Fuller Reader*, Harmonsdsworth: Penguin Books, 1972, pp. 231–51.
5. The broad agenda of the philosophy of technology is the development of a critical philosophical reflection upon what technology is and does. Ernst Kapp is often cited as the founder of this philosophical subdiscipline (his key text being *Grundlinien einer Philosophie der Technik,* published in 1877). Of course, this whole tradition was predated and influenced by Aristotle's consideration of making and by the Enlightenment's engagement with technology and the mechanical, not least by Frances Bacon and René Descartes. On the history of the philosophy of technology see Carl Mitcham, *Thinking Through Technology*, Chicago: University of Chicago Press, 1994.
6. On building performance see, for example, N. Henderson and M. Rosenberger, 'Building Green: How to Make the Most of Your Green Building', *Seattle Daily Journal of Commerce*, 11 March 2004 and Alex Hartmann, 'Green Buildings: Getting the Ratings You Need', *Property Australia*, July 2006. The topic is also covered regularly in the US journal *Environmental Building News* and the UK *Building Services Journal*.
7. McDonough and Michael Braungart, *Cradle to Cradle*.
8. For a substantial and critical reading of this issue see C. B. Christensen, 'What is so Sustainable about Services? The Truth in Service and Flow', *Design Philosophy Papers*, No. 3, 2007.

9. See Tim Jackson (ed.), *Sustainable Consumption*, London: Earthscan, 2006.
10. Tony Fry, 'Dwelling in Streamlined America', in *A New Design Philosophy: An Introduction to Defuturing*, Sydney: UNSW Press, pp. 105–45.
11. This area of the study of consumption links to recent developments of the study of material culture. It is being especially associated with the work of Elizabeth Shove – see, for example, Elizabeth Shove, *Comfort, Cleanliness, and Convenience: The Social Organization of Normality*, Oxford: Oxford University Press, 2003.
12. Bruno Latour, 'Where are the Missing Masses? The Sociology of Mundane Artefacts', in W. Bijker and J. Law (eds), *Shaping Technology/Building Society*, Cambridge, MA: MIT Press, 1992.
13. For example see the website www.Superuse.org.
14. For example see Arthur P. J. Mol, *Globalisation and Environmental Reform: The Ecological Modernization of the Global Economy*, Cambridge, MA: MIT Press, 2001.
15. Martin Heidegger, 'The Thing', in *Poetry Language Thought* (trans. Albert Hofstadter), New York: Harper Row, 1971; and François Jullien, *The Propensity of Things* (trans. Janet Lloyd), New York, 1995.
16. See for example, a sampler collection like David B. Clarke, Marcus A. Doel and Kate M. L. Housiaux, *The Consumption Reader*, London: Routledge, 2003.
17. The literature of the past it lags behind includes, for instance: on political economy – Jean Baudrillard, *For a Critique of the Political Economy of the Sign* (trans. Charles Levin), St Louis: Telos Press, 1981; on the 'nature' of artefacts' – Martin Heidegger on 'The Thing' in *Poetry Language Thought* (trans. Albert Hofstadter), New York: Harper & Row, 1971 and Elaine Scarry, *The Body in Pain*, Oxford: Oxford University Press, 1985. On ontological design see – Anne-Marie Willis, 'Ontological Designing – Laying the Ground', *Design Philosophy Papers Collection Three*, Ravensbourne, Queensland, Australia: Team D/E/S Publications, 2007, pp. 80–98.
18. Architecture for Humanity (ed.), *Design Like You Give a Damn*, London: Thames & Hudson, 2006.
19. There is a profound relation between the failure of humanitarianism and unsustainability laid out in the repetition of the history of genocide (from Germany and the holocaust in the 1940s to the likes of Cambodia, Bosnia and Rwanda). The 1944 publication of Adorno and Horkheimer's seminal text *Dialectic of Enlightenment* gave considerable impetus to philosophical arguments that the Holocaust brought the humanist dimension of the Enlightenment project to its end, not least

because of the damage done to the human spirit. See Edith Wyschogrod, *Spirit in Ashes: Hegel, Heidegger and Man Made Mass Death*, New Haven, CT: Yale University Press, 1985.

20. World Commission on Environment and Development (Brundtland Report), *Our Common Future*, Oxford: Oxford University Press, 1987.

21. See Martin Heidegger, *The Essence of Human Freedom* (trans. Ted Sadler), London: Continuum, 2005.

Chapter 13 Sustainment and a New Epoch of Humanity

1. These events are presented in detail by Brian Fagan in *The Long Summer: How Climate Changed Civilisation*, New York: Basic Books, 2004.

2. Theodor Adorno and Max Horkheimer, *Dialectic of Enlightenment* (trans. John Cumming), London: Verso, 1979, p. 41. First published in 1944.

3. Deconstructive theory got near to making this apparent, but was stymied by its propensity towards academicism and the anti-intellectual recoil it engendered. The power of deconstruction was especially associated with Jacques Derrida who came as near as anyone to traversing the fault lines of reason – see, for example, his reading of Emmanuel Levinas in Chapter 4 of 'Violence and Metaphysics: An Essay on the Thought of Emmanuel Levinas' in *Writing and Difference* (trans. Alan Bass), Chicago: University of Chicago Press, 1978). Such thought also cast a much wider net – to take two very different examples: Arkady Plotnitsky's survey text *Ecofigurations* (Gainesville: University of Florida Press, 1993) built around Georges Bataille's notion of General Economy in the *The Accursed Share* (volume 1, trans. Robert Hurley, New York: Zone Books, 1988) and Bernard Stiegler's writing on philosophy, technology and the human in *Technics and Time 1* (trans. Richard Beardsworth and George Collins), Stanford: Stanford University Press, 1998).

4. Theodor Adorno, *Negative Dialectics*, London: Routledge, 1990, p. 5.

5. This common description does not grasp the movement of 'knowledge knowing itself' (the knowing return of foundational thought to itself) as a basic trait of 'the other of the one' (the contradiction of critical reflection), the thing and the human, the ontic and the hermeneutic. See, for example the account given by Werner Marx in *Heidegger and the Tradition*, Evanston: Northwestern University Press, 1971, p. 59.

6. See David L. Hall and Roger T. Ames, *Thinking Through Confucius*, New York: SUNY, 1987.
7. The reduction of freedom to market choice directly connects to the notion of 'consumer sovereignty' wherein democracy simply becomes a market mechanism. See C. B. Macpherson, *The Life and Times of Liberal Democracy*, Oxford: Oxford University Press, 1977, pp. 79–80.

Chapter 14 Picturing Economic and Cultural Futures

1. Georges Bataille, *The Accursed Share*, Volume 1 (trans. Robert Hurley), New York: Zone Books, 1988, pp. 3–4. First published 1967.
2. In relation to change, as I have stated elsewhere: 'We, as organic forms, are thus deeply implicated in what is sought to be understood, we are part of the exchange, the material in transit, the inventors of the explanation of process. More than this, we are the site of the dynamic that "flows" from living the experience of exchange within economy, as changing matter ... Relations are thus kinetic, exchange is dynamic and the vectors that transport, move in all directions, through all elements, between the inert, the live, the decaying, the emergent, the scare and the excessive.' Tony Fry, *Remakings: Ecology, Design, Philosophy*, Sydney: Envirobook, 1994, pp. 158–9.
3. 'Changing from the perspectives of restrictive economy to those of general economy actually accomplishes a Copernican transformation: a reversal of thing – and of ethics.' Bataille, *The Accursed Share*, p. 25.
4. David Frisby cited this remark by Kracauer (made in an essay in 1920). See *Preface to the Second Edition* of Simmel's *Philosophy of Money* (trans. Tom Bottomore and David Frisby), Routledge: London, 1990, p. xxvi.
5. Simmel, p. 82.
6. Francis Fukuyama, *The End of History*, Penguin: New York/London, 1992. His claim being that the 'victory' of capitalism and liberal democracy could be taken as a full realization of humanity's historical destiny.
7. The *Stern Review on the Economics of Climate Change* by Nicholas Stern commissioned by the United Kingdom government and published in 2006 is so limited that it does not even begin to start this calculation.
8. For a more developed exposition of care see Fry, *Remakings*, pp. 101–40.

Chapter 15 Sustainment by Design – 'Dig Where You Stand'

1. Karl Marx, *Capital,* Vol. 1 (trans. Samuel Moore and Edward Aveling), London: Lawrence & Wishart, 1977, p. 174. First published 1887.
2. Details are available from: teamdes@teamdes.com.au.
3. Maria Cecelia Loschiavo dos Santos, 'Spontaneous Design, Informal Recycling and Everyday life in Postindustrial Metropolis', *Design Research: Proceedings of the Politechnico di Milano Conference*, 18–20 May 2000, pp. 458–66.
4. Maria Cecelia Loschiavo dos Santos, 'The Vital Package Living on the Streets in Global Cities: Sao Paulo, Los Angeles and Tokyo', *Visual Sociology*, 15, 2000, pp. 101–18.
5. Mike Davis, *Planet of Slums*, London: Verso, 2006.
6. The details of this case study are based on circumstances up to October 2007.

Chapter 16 Challenges of Sustainment and Futuring – A Review of Change Agents

1. Ludwig Wittgenstein, *Tractatus Logico-Philosophicus*, London: Routledge & Kegan Paul, 1961, para. 5.6, p. 56. First published 1921.

Select Bibliography

Adas, Michael, *Machines as the Measure of Men*, Ithaca, NY: Cornell University Press, 1989.

Adorno, Theodor, *Negative Dialectics*, London: Routledge, 1990.

Adorno, Theodor and Max Horkheimer, *Dialectic of Enlightenment* (trans. John Cumming), London: Verso, 1969.

Amin, Samir, *Unequal Development* (trans. Brian Pearce), Hassocks: Harvester, 1976.

Architecture for Humanity (ed.), *Design Like You Give a Damn*, London: Thames & Hudson, 2006.

Aristotle, *The Nicomachean Ethics* (trans. David Ross, 1925), Oxford: Oxford University Press, 1991.

Aristotle, *The Politics* (trans. Benjamin Jowett) in *The Basic Works of Aristotle* (ed. Richard McKeon), Chicago: University of Chicago Press, 1941.

Barthes, Roland, *Mythologies*, London: Paladin, 1973.

Bataille, Georges, *The Accursed Share* (trans. Robert Hurley), New York: Zone Books, 1988.

Bateson, Gregory, *Steps to an Ecology of Mind*, London: Paladin, 1973.

Baudrillard, Jean, *For a Critique of the Political Economy of the Sign* (trans. Charles Levin), St Louis: Telos Press, 1981.

Bijker, W. and J. Law (eds), *Shaping Technology/Building Society*, Cambridge, MA: MIT Press, 1992.

Castels, Manuel, *The Rise of Network Society*, Cambridge, MA: Blackwell, 1996.

Clarke, David B., Marcus A. Doel and Kate M. L. Housiaux, *The*

Consumption Reader, London: Routledge, 2003.

Clastres, Pierre, *Archaeology of Violence* (trans. Jeanine Herman), New York: Semiotext(e), 1994.

Cockcroft, James, Andre Gunder Frank and Dale Johnson, *Dependence and Underdevelopment*, New York: Anchor Books, 1972.

Congjie, Liang, *The Great Thoughts of China*, New York: Wiley, 1996.

Davis, Mike, *Planet of Slums*, London: Verso, 2006.

Davison, Aidan, *Technology and the Contested Meaning of Sustainability*, New York: SUNY Press, 2001.

Derrida, Jacques, *Writing and Difference* (trans. Alan Bass), Chicago: University of Chicago Press, 1978.

Dickson, David, *Alternative Technology*, London: Fontana, 1974.

Fagan, Brian, *The Long Summer: How Climate Changed Civilisation*, New York: Basic Books, 2004.

Foster, Hal, *Recodings: Art, Spectacle, Cultural Politics*, Seattle, WA: Bay Press, 1985.

Fry, Tony, *Remakings: Ecology, Design, Philosophy*, Sydney: Envirobook, 1994.

Fry, Tony, *A New Design Philosophy: An Introduction to Defuturing*, Sydney: UNSW Press, 1999.

Fukuyama, Francis, *The End of History*, New York/London: Penguin, 1992.

Fuller, Buckmister, *The Buckminster Fuller Reader* (ed. James Meller), Harmondsworth: Penguin Books, 1972.

Gramsci, Antonio, *Prison Notebooks* (trans. Quintin Hoare and Geoffrey Nowell Smith), London: Lawrence & Wishart, 1971.

Hall, David L. and Roger T. Ames, *Anticipating China*, New York: SUNY Press, 1995.

Hall, David L. and Roger T. Ames, *Thinking Through Confucius*, New York: SUNY Press, 1987.

Hardt, Michael and Antonio Negri, *Empire*, Cambridge, MA: Harvard University Press, 2000.

Hebdige, Dick, *Hiding in Light*, London: Routledge, 1988.

Heidegger, Martin, *Poetry Language Thought* (trans. Albert Hofstadter), New York: Harper & Row, 1971.

Heidegger, Martin, *The Essence of Human Freedom* (trans. Ted Sadler), London: Continuum, 2005.

Hester, Randolph, *Design for Ecological Democracy*, Cambridge, MA: MIT Press, 2006.

Huxley, Julian, *TVA Adventure in Planning*, London: Architectural Press, 1943.

Jackson, Tim (ed.), *Sustainable Consumption* (Earthscan Reader), London: Earthscan, 2006.

Jullien, François, *The Propensity of Things* (trans. Janet Lloyd), New York, 1995.

Kropotkin, Peter, *Fields, Factories and Workshops Tomorrow* (1899), London: George Allen & Unwin, 1974.

Latour, Bruno, *Politics of Nature* (trans. Catherine Porter), Cambridge, MA: Harvard University Press, 2004.

Latour, Bruno and Peter Weibel (eds), *Making Things Public: Atmospheres of Democracy*, Cambridge, MA: MIT Press, 2005.

Lloyd, G.E.R., *Adversaries and Authorities: Investigations into Ancient Greek and Chinese Science*, Cambridge: Cambridge University Press, 1996.

Lother, Ledderose, *Ten Thousand Things*, Princeton: Princeton University Press, 2000.

Macpherson, C.B., *The Life and Times of Liberal Democracy*, Oxford: Oxford University Press, 1977.

Manzini, Ezio and François Jégou, *Sustainable Everyday: Scenarios of Urban Life*, Milan: Edizoni Ambiente, 2003.

Marx, Karl, *Capital* Vol. 1 (trans. Samuel Moore and Edward Aveling), London: Lawrence & Wishart, 1977.

Marx, Werner, *Heidegger and the Tradition*, Evanston, IL: Northwestern University Press, 1971.

McDonough, William and Michael Braungart, *Cradle to Cradle*, New York: North Point Press, 2002.

Mitcham, Carl, *Thinking Through Technology*, Chicago: University of Chicago Press, 1994.

Mol, Arthur P.J., *Globalisation and Environmental Reform: The Ecological Modernization of the Global Economy*, Cambridge, MA: MIT Press, 2001.

Nancy, Jean-Luc, *The Inoperative Community* (trans. Peter Connor *et al.*), Minneapolis, MN: University of Minnesota Press, 1992.

Nelson, Harold and Erik Stolterman, *The Design Way*, Englewood Cliffs, NJ: Educational Technology Publications, 2003.

Papanek, Victor, *Design for the Real World*, London: Thames & Hudson, 1972.

Plotnitsky, Arkady, *Ecofigurations*, Gainesville: University of Florida Press, 1993.

Ranciere, Jacques, *Hatred of Democracy*, London: Verso, 2006.

Sahlins, Marshall, *Culture in Practice*, New York: Zone Books, 2005.

Scarry, Elaine, *The Body in Pain*, Oxford: Oxford University Press, 1985.

Schmitt, Carl, *The Crisis of Parliamentary Democracy* (trans. Ellen Kennedy), Cambridge, MA: MIT Press, 1998.

Shove, Elizabeth, *Comfort, Cleanliness, and Convenience: The Social*

Organization of Normality, Oxford: Oxford University Press, 2003.

Simmel, Georg, *Philosophy of Money* (trans. Tom Bottomore and David Frisby), Routledge: London, 1990.

Skinner, B. F., *Walden Two*, New York: Macmillan, 1976.

Stiegler, Bernard, *Technics and Time 1* (trans. Richard Beardsworth and George Collins), Stanford, CA: Stanford University Press, 1998.

Wainwright, Hilary and Dave Elliot, *The Lucas Plan*, London: Allison & Busby, 1982.

Walter, Emrich, *Handbook of Charcoal Making*, Dordrecht: Reidel, 1985.

Weber, Max, *Economy and Society* (trans./eds Guenther Roth and Claus Wiltich), New York: Bedminster, 1968

Willis, Anne-Marie (ed.), *Design Philosophy Papers Collection One*, Ravensbourne, Queensland, Australia: Team D/E/S Publications, 2004.

Willis, Anne-Marie (ed.), *Design Philosophy Papers Collection Two*, Ravensbourne, Queensland, Australia: Team D/E/S Publications, 2005.

Willis, Anne-Marie (ed.), *Design Philosophy Papers Collection Three*, Ravensbourne, Queensland, Australia: Team D/E/S Publications, 2007.

Wittgenstein, Ludwig, *Tractatus Logico-Philosophicus*, London: Routledge & Kegan Paul, 1961.

World Commission on Environment and Development (Brundtland Report), *Our Common Future*, Oxford: Oxford University Press, 1987.

Worldwatch Institute (The), *The State of the World 2006*, New York: W.W. Norton, 2006.

Wyschogrod, Edith, *Spirit, in Ashes: Hegel, Heidegger and Man-made Mass Death*, New Haven, CT: Yale University Press, 1985.

Illustration Credits

Figure 1 courtesy of Tony Fry.
Figure 2 courtesy of Marianne Cini/EDF.
Figure 3 courtesy of Tony Fry.
Figure 4 courtesy of S. Herbert.
Figure 5 courtesy of Tony Fry collection.
Figure 6 courtesy of Anne-Marie Willis.
Figure 7 courtesy of Tony Fry.
Figure 8 courtesy of Jason Haigh.
Figure 9 courtesy of Jason Haigh.
Figure 10 courtesy of Jason Haigh.
Figure 11 courtesy of Tony Fry.
Figure 12 courtesy of Tony Fry.
Figure 13 courtesy of Tony Fry.
Figure 14 courtesy of Tony Fry.
Figure 15 courtesy of Tony Fry.
Figure 16 courtesy of Tony Fry.
Figure 17 courtesy of Tony Fry collection.
Figure 18 courtesy of Tony Fry.
Figure 19 courtesy of Tony Fry.

Figure **20** courtesy of Marianne Cini/EDF.
Figure **21** courtesy of Tony Fry.
Figure **22** courtesy of Tony Fry.
Figure **23** courtesy of Tony Fry.
Figure **24** courtesy of Tony Fry.
Figure **25** courtesy of Tony Fry.
Figure **26** courtesy of Jim Gall.
Figure **27** courtesy of Tony Fry photo collection.
Figure **28** courtesy of Tony Fry photo collection.
Figure **33** courtesy of Patrick Joseph.
Figure **34** courtesy of W. G. Briggs.
Figure **36** courtesy of Marianne Cini/EDF.
Figure **37** courtesy of Anne-Marie Willis.
Figure **38** courtesy of Tony Fry collection.
Figure **39** courtesy of NASA.
Figure **40** courtesy of Keith Armstrong.
Figure **41** courtesy of Tony Fry.
Figure **42** courtesy of Tony Fry.
Figure **43** courtesy of Tony Fry collection.
Figure **47** courtesy of Ricardo Carreon.
Figure **48** courtesy of XSProject.
Figure **49** courtesy of Ken Straiton.
Figure **50** courtesy of Tony Fry.

Index